LIGHTER THAN AIR

LIGHTER THAN AIR

AN ILLUSTRATED HISTORY OF BALLOONS AND AIRSHIPS

TOM D. CROUCH

THE JOHNS HOPKINS UNIVERSITY PRESS, BALTIMORE

IN ASSOCIATION WITH

THE SMITHSONIAN NATIONAL AIR AND SPACE MUSEUM, WASHINGTON, D.C.

For Nancy, Bruce, Abigail, Nathan, John, Emma
and Alex

Who are ever willing to put up with a husband,
father, and grandfather who lives part of his life with
them, and part with the men and women who
inhabit long-vanished times and places

© 2009 The Johns Hopkins University Press
All rights reserved. Published 2009
Printed in China on acid-free paper

The Johns Hopkins University Press
2715 North Charles Street
Baltimore, MD 21218-4363
www.press.jhu.edu

Library of Congress Cataloging-in-Publication Data

Crouch, Tom D.
 Lighter than air : an illustrated history of balloons
and airships / Tom D. Crouch.
 p. cm.
 Includes bibliographical references and index.
 ISBN-13: 978-0-8018-9127-4 (hardcover : alk.
paper)
 ISBN-10: 0-8018-9127-2 (hardcover : alk. paper)
 1. Airships—History. 2. Balloons—History.
3. Ballooning—History. I. Title.
 TL605.C76 2009
 629.133′209—dc22 2008027268

Copy-edited and proof-read by David Rose
Designed by Mercer Design, London
Produced by GILES, an imprint of D Giles
Limited, London

*Special discounts are available for bulk
purchases of this book. For more information,
please contact Special Sales at 410-516-6936 or
specialsales@press.jhu.edu.*

The Johns Hopkins University Press uses
environmentally friendly book materials,
including recycled text paper that is composed
of at least 30 percent post-consumer waste,
whenever possible. All of our book papers are
acid-free, and our jackets and covers are
printed on paper with recycled content.

ACKNOWLEDGMENTS

AS ALWAYS, THIS BOOK owes much to the kindness, generosity, and direct contributions of my colleagues. Pete D'Anna, now a volunteer at the National Air and Space Museum, shared his long experience as an engineer involved in the design of lighter-than-air craft. In addition to contributing the chronology to be found as Appendix 1, he read every word of the text and saved the author from any number of embarrassing gaffes. Trish Graboske, publications manager for the NASM, helped to conceive the project and played a key role in delivering this newborn babe to the world. Dan Giles sparked this project some years ago. His talented staff designed the book.

My thanks go to the librarians and archivists who supported the project: Bill Baxter, Carol Heard, Phil Edwards, and Leah Smith of the NASM Library; and to Marilyn Graskowiak, Allan Janus, Patti Williams, Brian Nicklas, and Dan Hagedorn of the NASM Archive. I owe a special debt to NASM archivists Kate Igoe and Melissa Keiser; and to Greg Bryant, Carl Bobrow, Mark Avino, Kathryn Fleming, Joanne London, and Eric Long, all of the NASM staff, for their support in providing the illustrations, a process that often involved considerable effort on their part. Thanks also to Len Bruno and the staff of the Manuscripts Division, Library of Congress. The author has been drawing on the riches of their collection for more than three decades.

Peter Jakab and Bob van der Linden, who chaired the NASM Aeronautics Division during the course of work on this volume, provided the kind of atmosphere that encourages research and publication. As always, my colleagues in the Aero Division supplied collegial support and encouragement.

Dr Marilee Nason, of the Anderson-Abruzzo Albuquerque International Balloon Museum, shared her friendship, ideas and information from the archives of that institution. Some of the most important figures in the history of twentieth-century ballooning helped to shape this volume in ways that they scarcely imagined; they include Jim Winker, Col. Joseph Kittinger, and the late Paul Edward Yost. In spite of all their assistance, any errors in the book are mine alone.

CONTENTS

CLOUDS IN A BAG

The invention of the balloon and the great events that opened the air age

THE NEWBORN BABE COMES OF AGE

The Great Balloon adventures of the late 18th and 19th centuries, Europe and America, and the early military applications of the balloon

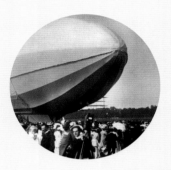

NAVIGATING THE AIR

The early history of the dirigible airship, from the 18th-century dream, through the experiments of the 19th century, to the birth of the rigid airship in the early 20th century

INTRODUCTION

THE INVENTION OF THE BALLOON struck the men and women of the late eighteenth century like a thunderbolt. In the fall of 1783, half of the citizens of Paris, one of the largest cities on the globe, flocked to witness two of their fellow beings leave the surface of the earth aboard a wondrous craft that was the product of human brains and hands. The crowds were the same everywhere a balloon flew. The spectators who gathered in such huge numbers were just becoming accustomed to the idea of change. The old certainties of their grandparents' world were giving way to an expectation that the twin enterprises of science and technology would provide the foundation for "progress." In an age when human beings could fly, what other wonders might the future hold?

And if men and women could break the chains of gravity, could they not also cast off the shackles of tyranny? Across the Atlantic, Americans were demonstrating that ordinary men and women were perfectly able to govern themselves without the assistance of a king. In France and England, popular discontent was bubbling away just beneath the surface. The balloon seemed to be the harbinger of a new age.

This book offers a concise overview of the history of lighter-than-air flight from antiquity to the space age. For two and a quarter centuries, buoyant flight has played a role in science, war, and commerce. In addition to exploring those themes, I hope that these pages convey some sense of the excitement that greeted the sight of a balloon in the sky or a giant airship cruising low and slow overhead.

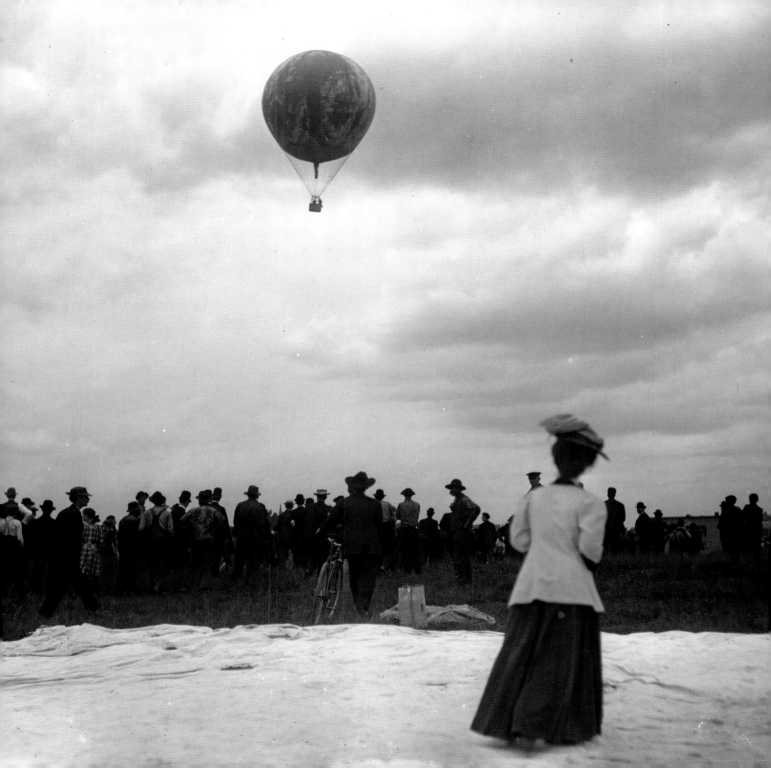

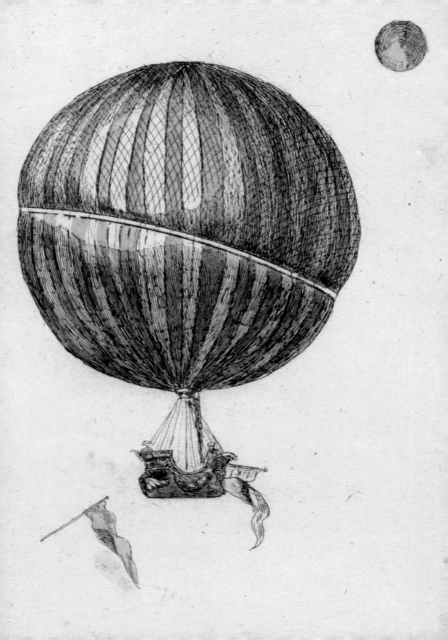

CLOUDS IN A BAG

THE INVENTION OF THE BALLOON AND THE GREAT EVENTS
THAT OPENED THE AIR AGE

WHY DID IT TAKE SO LONG to learn to fly? The Greek philosopher Archimedes (287–212 BC) explained the basic principle of buoyant flight more than twenty centuries before human beings first took to the sky aboard balloons. If an object immersed in a fluid weighs less than the amount of fluid displaced, it will rise. That's all there is to it. Ancient peoples dreaming of flight did not even have to understand Archimedes' principle to grasp the possibility of buoyant flight. They knew that hot air rises, and many cultures around the globe produced relatively lightweight containers that could be filled with the stuff and carried aloft right along with it. Some of them did just that.

Consider the case of Asian paper lanterns. Nineteenth-century travelers reported that farmers in China's Hunan province celebrated the approach of the rainy season by launching small hot air balloons made of homemade paper stretched over a frame constructed of bamboo slivers. With bundles of burning pine splinters dangling beneath an opening at the bottom, the little craft would rise into the night sky before eventually bursting into flames and falling back to earth. The practice apparently spread to Southeast Asia, as well. It does not take a great mental leap to imagine a link between traditional paper lanterns and these little balloons.[1]

Further evidence that buoyant flight was within the grasp of our remote ancestors came in 1975, when a balloon constructed using only materials equivalent to those available to the Inca carried two researchers to an altitude of 380 feet over Peru's Nazca plain. The project began when Bill Spoher, an American living in Peru, became intrigued by decorations on Inca pottery resembling kites and balloons. Enlisting the aid of James Woodman and Julian Nott, an internationally known aeronaut, he commissioned the construction of *Condor I*, a balloon shaped like an inverted pyramid. Manufactured of fabric matching the weight and porosity characteristics of Inca materials, the 80,000 cubic foot envelope was sealed with smoke and filled with superheated air from a specially prepared fire on the ground. With the two-man crew seated astride a reed "gondola," the balloon climbed rapidly to altitude then sank back to earth as the air in the envelope cooled. Nott repeated the flight in 2002 with the help of balloonists Peter Cuneo and Barbara Fricke.[2]

While these experiments did not prove that ancient South Americans flew, they do suggest that they could have done so had they but tried. Why didn't they try? It simply did not occur to them that the age-old dream of flight could be achieved in such an unexpected fashion with such relative ease. Birds and insects inspired the desire to fly with wings, but nature offered no examples of lighter-than-air flight, other than rising smoke. In the end, science would inspire the birth of the balloon.

PHLOGISTICATED AIR

AN EXTRAORDINARY ERA of discovery began in 1640, when Otto von Guericke, the mayor of Magdeburg, Germany, invented the vacuum pump. The realization that the atmosphere could be pumped out of a closed vessel like any other fluid launched two decades of experimentation, culminating in 1660, when the English researcher Robert Boyle explained the relationship between volume, pressure, and temperature in gases, and demonstrated the essential role of air in the propagation of sound and for combustion and respiration.[3]

The pioneering work of the pneumatic physicists had profound technological consequences. New instruments, including the barometer and thermometer, were both the product of research and the tools that opened the door to new discoveries. In similar fashion, the development of the steam engine resulted from an improved understanding of the physical properties of air and suggested further research that led to the birth of thermodynamics.

The new science also inspired the earliest useful speculations on buoyant flight. In 1670, Francesco Lana de Terzi, an Italian Jesuit, suggested that if the air, which had weight, was pumped from a large, thin-walled copper sphere, it might then weigh less than the amount of air it displaced, and rise into the sky. Four such globes, each twenty feet in diameter, might carry a human being aloft (fig. 1). Theoretically, Lana was on the right track. In practical terms, however, it was not possible to construct globes that were sufficiently large, light, and strong.[4]

The public debut of a more practical device came on August 8, 1709, when Father Bartolomeu Lourenço de Gusmão (1685–1724), a Jesuit priest from the Brazilian town of Santos, flew a small balloon in the presence of the King of Portugal at the Sala das Embaixadas in the Casa de Indias, Lisbon. The young priest had absorbed elements of the "new science" while studying at Portugal's Coimbra University. Only twenty-three, he received permission to construct an "instrument to move in the air" from King João V, along with a grant to support the project.[5]

Fig. 1 An 18th-century print of Francesco Lana de Terzi's proposed craft of 1670. (NASM, Gift of Constance Morss Fiske in memory of Gardiner H. Fiske)

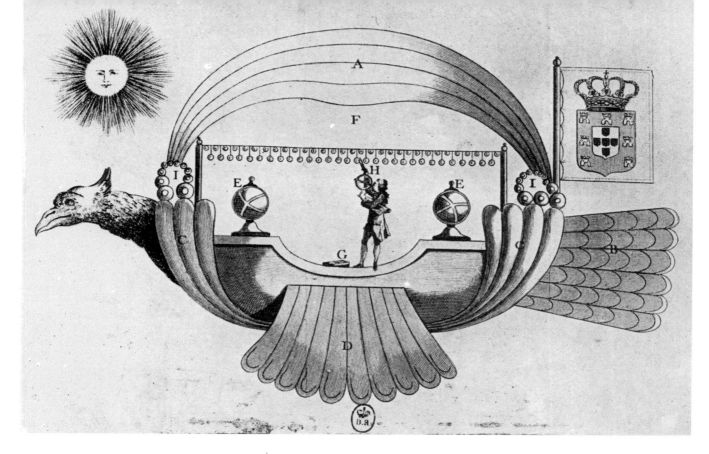

Fig. 2 The *Passarola* of Bartolomeu Lourenço de Gusmão. (NASM, SI 90-3230)

As a result of the effort, Father Bartolomeu inspired satirical verse, and was waggishly identified as "O Voalor" ("the Flying Man"). The joking came to an end on August 3, 1709, when he unveiled his creation. The little craft consisted of an envelope constructed of thick paper, filled with hot air from the "fire material contained in an earthen bowl encrusted in a waxed-wood tray." On this occasion, the balloon caught fire during inflation and was destroyed. Undaunted, Father Bartolomeu returned for his second trial on August 8. With King João, Queen Maria Anna, members of the court and Cardinal Conti, a papal nuncio who would become Pope Innocent III, looking on, the little aerostat rose twelve feet into the air before being destroyed by nervous courtiers who feared that it would set fire to the drapery. The inventor provided a second demonstration in a palace courtyard. Rather than forging ahead to the next step, building and testing a full-scale balloon, Gusmão seems to have ceased his work and destroyed his papers in a panic when the Portuguese Inquisition took note of his theological eccentricities.[6]

Lourenço de Gusmão is the first man whose name is on record as having flown a lighter-than-air craft. Why don't we recognize him as the inventor of the balloon? The details of his work were not well understood in his own time. Lisbon was far from the intellectual center of eighteenth-century Europe. When word of his experiments did begin to spread, it was misunderstood. As early as the spring of 1709, prints of his *Passarola* began to appear from Austria to England. Rather than showing a buoyant craft, however, this "flying ship" was shaped like an eagle, complete with outstretched wings and a tail (fig. 2). The occupant rode on the bird's back, protected by a billowing overhead canopy.[7]

Was *Passarola* an artist's inaccurate portrait of a balloon that he had never seen? Perhaps, but most Europeans saw it as a wildly fanciful design for a heavier-than-air craft. Lourenço faded from the scene, dying from a fever in 1724, with his important balloon experiments forgotten or misunderstood and his *Passarola* dismissed as an idle fantasy. A bit more intellectual conditioning was required before the technology of buoyant flight would fully take root.[8]

If seventeenth-century studies of pneumatic physics inspired the notion of buoyant flight, the eighteenth-century effort to analyze the constituent gases of the atmosphere led directly to the invention of the balloon. The Scottish chemist Joseph Black identified the first constituent gas, "fixed air," or carbon dioxide, in 1754. Eleven years later, Henry Cavendish announced the discovery of "phlogisticated" or "inflammable" air, a gas (from the German *geist*, "spirit") that was "at least seven times lighter than common air." The balloon would be seven years old before Antoine-Laurent Lavoisier applied the name hydrogen to Cavendish's gas.[9]

It occurred to Black that "a vessel might be made, which, when filled with inflammable air, might ascend into the atmosphere, in consequence of its being altogether lighter than an equal bulk of common air." Over the next several years he considered conducting the experiment with a calves' bladder as a demonstration for his students, but never did so. Tiberius Cavallo (1749–1809) took the next step. Son of a Neapolitan physician, he immigrated to England in 1771 and turned his back on a career as a merchant in order to pursue his interest in science. Within a decade his books on electricity and atmospheric gases had earned him Fellowship in the Royal Society. Early in 1782, he finally got around to filling thin animal membranes with hydrogen, none of which could lift themselves from the workbench. Even when scraped thin almost to the breaking point, the weight of the little envelopes was too great for so small a volume of gas. While Cavallo did blow soap bubbles filled with hydrogen, he was forced to admit that "they do not seem applicable to any philosophical purpose."[10]

LES FRÈRES MONTGOLFIER

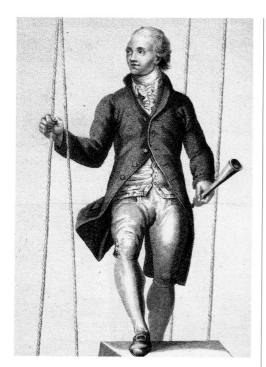

Fig. 3 Joseph-Michel Montgolfier (August 26, 1740–June 26, 1810). (NASM, Gift of Harry F. Guggenheim)

JOSEPH-MICHEL (1740–1810) AND JACQUES-ÉTIENNE MONTGOLFIER (1745–1799) were the twelfth and fifteenth of sixteen children born to Pierre and Anne Duret Montgolfier. A medieval ancestor launched the family business when he brought the art of paper-making back from Damascus in the twelfth century. Two hundred years later, representatives of the family moved from Germany to France. In the mid-seventeenth century a pair of Montgolfier brothers married the daughters of another paper-making family, and settled in Annonay in the Languedoc region of Southern France. Joseph and Étienne's grandfather, Raymond, transformed the centuries-old traditions of the artisan and craftsman into an industrial operation carried out at two family-owned paper mills. Their father, Pierre, earned the patronage of the king of France, and identification of the family firm as a Royal Paper Manufactory.

For two brothers who would work closely together, Joseph and Étienne were very different men. The elder brother was an absent-minded maverick, an imaginative dreamer with no head for business (fig. 3). As a youngster, Joseph rejected the strict discipline of a Jesuit school in favor of a program of self-education with an emphasis on mathematics and natural philosophy. The black sheep of the family, he spent a great deal of his young adult years away from the family circle in Annonay.

Étienne, the youngest male in his generation, studied architecture at the Collège Sainte-Barbe in the capital. During his years in Paris he made important friends in the scientific establishment and cemented family relations with the leading paper-makers of Paris, notably Jean-Baptiste Réveillon, the first native wallpaper manufacturer to challenge the dominance of English firms. He abandoned his own architectural career upon the death of his brother Raymond in 1772 and returned to Annonay. With his older brothers either dead, in holy orders, suffering ill health or, like Joseph, temperamentally unsuited for business, Étienne became head of the firm (fig. 4).

Yet it was Joseph Montgolfier who would write the family name in the history books. Was the balloon inspired by the billowing of his wife's pantaloon, drying before a fire; or was it a discarded conical paper sugar cone caught in the hot air rising up the chimney? Whatever the moment of inspiration, the years of intellectual preparation were far more important. Joseph dated his own interest in the subject from the 1776 appearance of the French edition of *Experiments and Observations on Different Kinds of Air*, by the brilliant English experimenter Joseph Priestley.

Joseph Montgolfier must have attempted to fill a paper or fabric bag with "inflammable air" at some point, for he remarked that the gas immediately escaped through the pores. He then set out to generate a lightweight gas that could be contained. Convinced that the new gases were distinguished from one another by the varying amounts of heat ("phlogiston") in their make-up, Joseph concluded that additional new gases could be produced in the smoke generated by burning various materials.

Initially, he decided that a combination of wet straw and chopped wool would produce the ideal lightweight "air" with which to inflate a balloon. Over time, he turned to less appealing materials. Commenting on a launch from the palace at Versailles in September 1783, one observer noted that the Montgolfiers "caused all of the old shoes that could be collected to be brought here, together with pieces of decomposed meat, for these are the substances which supply their gas." On this occasion, King Louis XVI and Queen Marie Antoinette were escorted to the inflation area, but "the noxious smell thus produced obliged them to retire at once."[12]

Patriotism also played a role in the timing of Joseph's earliest experiments. Drawn into conflict with England on behalf of their American allies, the French and Spanish tried and failed to capture Gibraltar in 1782. "I possess," Joseph remarked, "a super-human means of introducing our soldiers into this impregnable fortress. They may enter through the air; the gas produced by the combustion of a little straw or a few rags should not pass, like inflammable air, through the pores of a paper bag." A big enough bag, he concluded, and the right wind, would drop an entire army down on the heads of the defending Redcoats.[13]

Joseph built his first balloon in mid-November 1782, while he was living away from the family in Avignon. Made of silk, it stood four feet tall and had an internal capacity of only forty cubic feet. The device was a six-faced polyhedron, probably because it was easier to construct than a round envelope. Burning paper supplied the heat source. Joseph assumed that the buoyancy was the result of his having filled the little balloon with a new gas.[14] In fact, when the process of

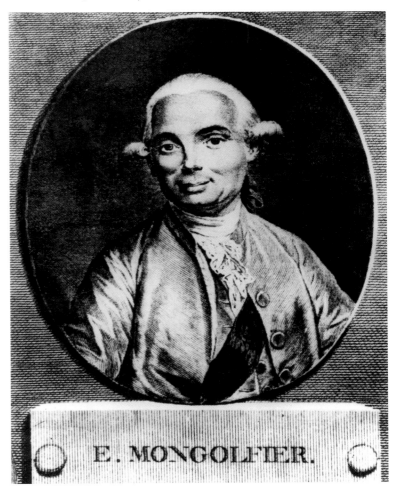

Fig. 4 Jacques-Etienne Montgolfier (January 6, 1745– August 2, 1799). (NASM, Gift of Harry F. Guggenheim)

E. MONGOLFIER.

heating forced a sufficient amount of air out of the envelope, the first *montgolfière* bumped up against the ceiling. He immediately wrote to Étienne, "Get in a supply of taffeta [silk] and of cordage, quickly, and you will see one of the most astonishing sights in the world."[15]

Joseph's note reached his businessman-brother at a propitious moment. For several years, Étienne, with the support of the government, had been adopting advanced paper-manufacturing technologies pioneered in Holland. His laborers felt threatened by the prospect of change, however, and opposed the introduction of new machines. The situation reached a crisis in the fall of 1781, when the Montgolfier workmen went out on strike. Étienne locked the strikers out. Having alienated his labor force, he found little support from other paper-makers, who were threatened by the Mongolfiers' shift to new machines and processes. Facing a serious business problem on two fronts, Étienne grasped at his brother's invention, at least in part as a means of improving the public and business image of the family firm.[16]

When Joseph demonstrated his balloon to the family at Annonay in December 1782, the little polygon rose seventy feet into the air and remained aloft for a minute. The brothers then constructed a balloon with nine times the capacity of the original. Flown on December 14, 1782, the aerostat broke its tether, rose completely out of the hidden ravine where the test was conducted, and flew a considerable distance, only to be destroyed by a passer-by. Anxious to protect their priority, Étienne wrote to urge an influential friend in Paris to announce their creation of an ascending machine to the Academy of Sciences. Puzzled, the fellow asked for more information.

The Montgolfiers spent the next six months preparing their first public demonstration. Étienne calculated the lift to be produced by envelopes of various sizes. They immediately abandoned the original polygon shape in favor of a round balloon that would provide maximum internal volume. Recognizing that silk was not an optimum material for containing their "gas," they decided to back the fabric with paper.

They built and flew one balloon with an internal capacity of 650 cubic feet, which reached an altitude of 600 feet. Their next experimental craft was constructed of spindle-shaped fabric and paper gores, producing the classic round shape. Measuring thirty-five feet in diameter, it covered a distance of three-quarters of a mile over the ground and was the first balloon to reach an altitude of 1,000 feet. The brothers were now prepared to introduce their creation to an unsuspecting world. The balloon for the first public demonstration was the largest to date, with a circumference of 110 feet. Determined to make their latest craft as strong as possible, the overlapping seams were both glued and secured

with 1,800 buttons. A metal brazier filled with burning material dangled beneath the mouth of the envelope.[17]

The Montgolfiers tested the new balloon several times before its public debut on June 4, 1783 (fig. 5). The crowd of curious spectators gathered in the town square that morning included members of the Etats Particuliers, a provincial assembly meeting in Annonay. The inflation began when workmen positioned the empty balloon over a hole cut in a short wooden platform. Next, they lifted part of the weight of the envelope by means of lines running over the top of two tall poles, in order to reduce the danger of setting the balloon on fire once the alcohol-soaked wool and straw was set ablaze in the iron furnace hidden beneath the platform.[18]

Within a few minutes, the aerostat was tugging at the restraining lines held by eight men. When released it rose rapidly to an altitude estimated at between 3,000 and 6,000 feet. It traveled roughly a mile and a half, landing on a stone fence, where the hot coals set the envelope on fire. "The discordant minds of the spectators," Tiberius Cavallo noted, "were instantly brought to an equal state of silent astonishment, which ended in loud and unfeigned acclamations."[19]

Fig. 5 The public debut of the balloon, Annonay, France, June 4, 1783. (NASM)

A RACE FOR THE SKY

Ｎ EWS OF THE EVENTS in Annonay did not reach Paris until July 10. The leaders of the Academy of Sciences immediately appointed a committee to study the matter. The members of the group, including Antoine-Laurent Lavoisier, who had now emerged as the leader of the on-going chemical revolution, decided to take no action until Étienne Montgolfier arrived in Paris. Barthélemy Faujas de Saint-Fond, a pioneering geologist, was less patient. Unwilling to wait for the Montgolfiers, he sold tickets to a promised ascension and turned the money over to Jacques Alexandre-César Charles

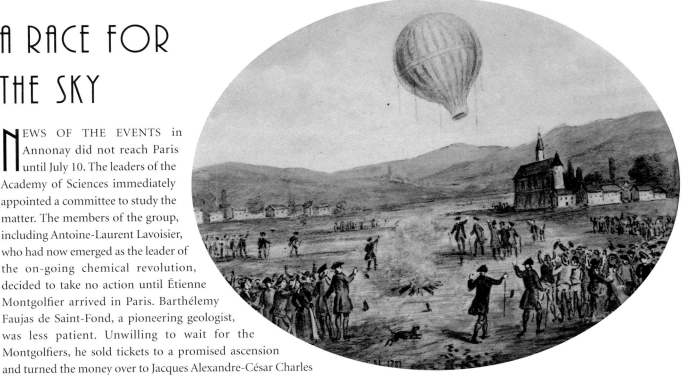

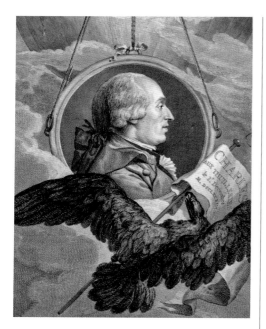

Fig. 6 Jacques Alexandre-César Charles (November 11, 1746–April 7, 1823). (NASM, Gift of Harry F. Guggenheim)

(1746–1823), the man he selected to handle the design, construction and launch of a balloon (fig. 6).

A gifted musician, well read in the law, Charles had settled into a comfortable career as a government bureaucrat when he read Benjamin Franklin's *Experiences and Observations on Electricity*. Franklin, who had arrived in Paris in 1776 to take up his duties as the American envoy to France, took an interest in Charles, and urged him to dedicate himself to "experimental philosophy." In 1781, the thirty-five-year-old functionary opened a laboratory in the Place des Victoires and began selling tickets to experimental demonstrations. Impressed by Charles' performances, Franklin reported to a friend: "Nature cannot say no to him."[20]

When he accepted Faujas' challenge, Charles knew almost nothing about the Montgolfiers beyond the fact that they had sent a large bag rising into the air. He simply assumed that they had filled their balloon with hydrogen. Far from regarding himself as an inventor, he thought that he was repeating the original experiment. In fact, he was establishing the elements of an entirely new technology that would remain virtually unchanged for over a century.

Charles hired a pair of instrument-makers, the brothers A. J. and M. N. Robert, to construct the balloon, which would measure only twelve feet in diameter. They

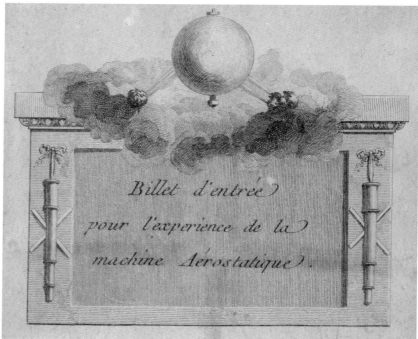

Fig. 7 A ticket to the first flight of a gas balloon, August 27, 1783. (NASM, Gift of William A. M. Burden)

would employ the services of a M. Bernard, who had mastered the art of impregnating taffeta with *gomme elastique*, or natural rubber, to reduce the porosity of the fabric.

Devising a method for generating the thousands of cubic feet of hydrogen required to fill the balloon proved a more daunting task. Up to this point, the volatile stuff had only been produced in laboratory quantities. Their first hydrogen generator resembled a chest of drawers, with the chemical reaction between oil of vitriol (sulfuric acid) and iron filings taking place in a series of lead-lined drawers. The hydrogen gas bubbled up through a washer then passed through a metal pipe and into the balloon. When that device proved leaky and ineffective, the Roberts substituted a simple lead-lined barrel, which proved far more efficient.

Inflation of the world's first gas balloon began on August 23, 1783, in the courtyard of the Robert workshop near the Place des Victoires (fig. 8). The process of inflation proceeded much slower than with a *montgolfière*. Things threatened to get out of hand when the exit pipe at the top of the barrel, through which the volatile gas entered the balloon, grew so hot that it had to be kept wrapped with wet cloth. The extraordinary heat caused the acid to vaporize and re-condense on the interior of the envelope, creating blisters that quickly grew into holes in the fabric. Workers also discovered that, in spite of being treated with natural rubber, the fabric remained fairly porous. The little balloon had to be repeatedly topped off with a fresh charge of lifting gas.

Early on the morning of August 25, workmen allowed the tethered balloon to ascend 100 feet into the air. At 2 a.m. on August 27, the partially inflated aerostat was carefully tied down in the bed of a wagon and transported through the dark streets, over the Pont Royal, past Les Invalides, and on to the Champ-de-Mars, a military parade ground facing the École Militaire (near the present site of the Eiffel Tower). Dark clouds and an occasional mid-afternoon shower did not discourage a crowd that grew to an estimated 50,000 people (fig. 7).

Plagued by gout, Benjamin Franklin watched from

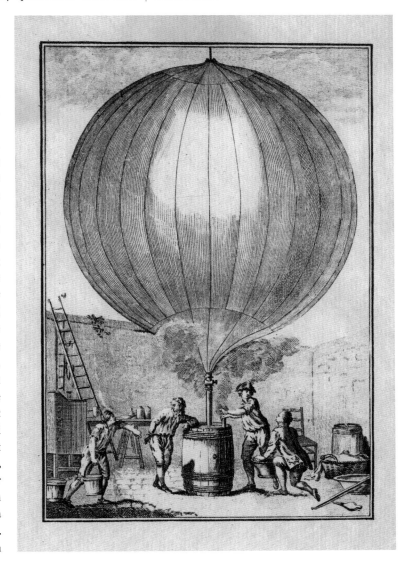

Fig. 8 Inflating the first gas balloon. (NASM, Bequest of Melvin Buchner)

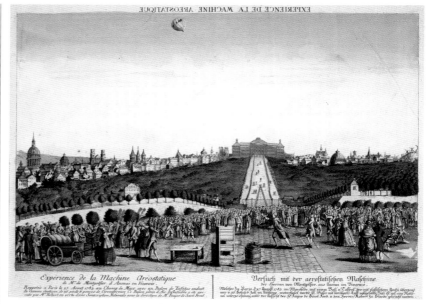

the comfort of his carriage as the balloon was released at 5 p.m. (fig. 9). "It diminished in Apparent Magnitude as it rose," he remarked to a friend, "till it enter'd the Clouds, when it seem'd to me scarce bigger than an orange." Preparing to leave the scene, he heard someone in the crowd remark that, while interesting, the new invention was of no practical value. "Of what use," Franklin responded, "is a new born babe?" With the assistance of the good doctor himself, the comment spread across Europe, taking its place as one of Franklin's most famous bon mots.[21]

In order to keep the hydrogen from being forced out of the open appendix, or neck, as the balloon rose, Charles completely sealed his little aerostat. As a result, the expanding gas burst the envelope forty-five minutes after take-off. The balloon fell onto the village of Gonesse, where the local farm folk, astounded by this rippling, burbling demon from the sky, attacked it with scythes, flails and pitchforks, then tied it to a horse for a triumphal procession through the village (fig. 10). A week later, court officials issued a proclamation to be read in parish churches across France, assuring the citizens that, should a similar event occur in their community, there was no cause for alarm. The balloons, "far from being an alarming phenomenon … cannot cause any harm, and will someday prove serviceable to the wants of society."[22]

Rumor had it that, for want of a ticket, Étienne Montgolfier was refused entry to the area where the first *charlière* was inflated. In any case, he was determined to recapture public attention with the launch of a much larger and more spectacular balloon. The Academy of Science and the Ministry of Finance had jointly agreed

to fund the construction of a new *montgolfière*, and to arrange for its demonstration before the court at Versailles. The new balloon, constructed at the Réveillon factory, was a gorgeous thing. Standing seventy feet tall and measuring forty feet in diameter, its lavish blue and gilt exterior reflected much credit on its builders, the craftsmen employed by a master wallpaper manufacturer. Unfortunately, that aerial masterpiece was destroyed in a rainstorm during the course of a trial flight at the factory. In an effort to meet his promised deadline of a flight at Versailles on September 19, Étienne and his workmen hastily constructed a new and smaller, although no less splendidly decorated, balloon standing fifty-one feet tall with a capacity of 37,500 cubic feet.

Fig. 10 The good people of Gonesse attack the first gas balloon. (NASM, Gift of Harry F. Guggenheim)

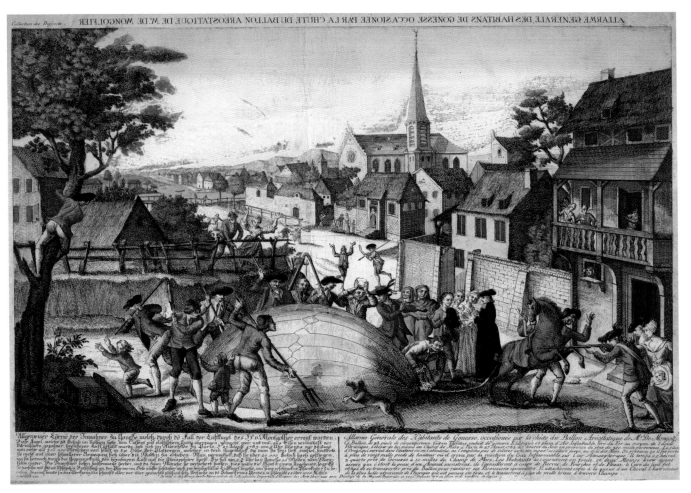

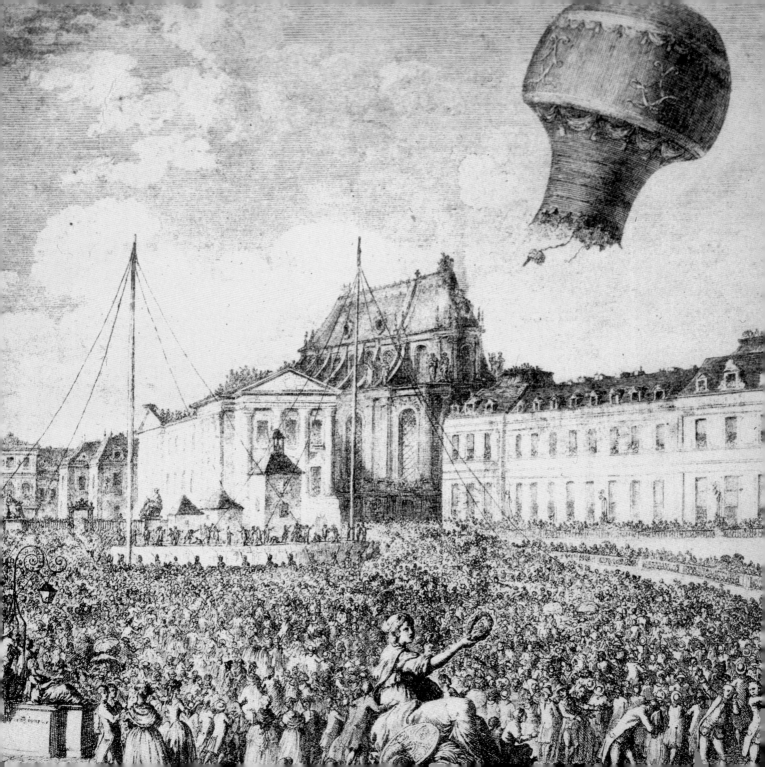

The great day began well for Étienne, who was privileged to explain the preparations to the royal family. This time the launch went smoothly, with the balloon taking to the air just after 1 p.m. (fig.11). A square wicker cage containing the first living aeronauts—a duck, a rooster, and a sheep—dangled beneath the envelope. The flight was a short one, covering only two miles. King Louis invited Étienne to observe the landing through the royal spyglass.

FIRST TO FLY

W HEN THE PARTY FROM VERSAILLES reached the balloon, they found Jean-François Pilâtre de Rozier already on the scene. Twenty-six years old, De Rozier earned his living giving lectures and demonstrations on chemistry and physics that seem to have been especially appealing to young ladies (fig. 12). He had earned considerable fame for constructing and personally testing a protective suit and breathing apparatus designed for use by Parisian sewer workers. After greeting the party from the launch site, he pointed out that the animals had survived their aerial journey without injury, except that the sheep apparently kicked the duck, and announced his own determination to become the first human being to fly.

When the possibility of sending someone aloft was first mentioned at court, the king suggested that the experiment be undertaken with condemned criminals, just in case. De Rozier immediately objected to offering such an honor to men who were bound for the gallows. An acquaintance, François Laurent, the marquis d'Arlandes, admired the young man's nerve, and offered to present his case at court, providing he could accompany him on the flight. In addition, it was D'Arlandes who approached Étienne, suggesting that sending human beings aloft would seal the fame and the priority of the Montgolfier brothers.

With preparations underway for men to take to the sky, a wave of balloon enthusiasm swept across France, then spread to the rest of Europe. Hair and clothing styles, jewelry, snuffboxes, wallpaper, chandeliers, bird cages, fans, clocks, chairs, armoires, hats, and other items, were designed with balloon motifs (fig. 13). Party guests sipped Crème de l'Aérostatique liqueur and danced the 'Contredanse de Gonesse' in honor of the Charles globe.

The Americans who were living in Paris to negotiate a successful conclusion to their Revolution were especially fascinated by the balloons. It seemed only fitting that, at a time when their countrymen were launching a new nation, human beings were throwing off the tyranny of gravity. The oldest and youngest members of the diplomatic community were the most seriously infected with "balloonamania." "All conversation here at present turns upon the Balloons . . . and

Fig. 11 The sheep, duck, and rooster climb away from the Palace of Versailles, September 19, 1783. (NASM, Gift of Harry F. Guggenheim)

Fig. 12 Jean-François Pilâtre de Rozier (March 30, 1754–June 15, 1785). (NASM, Gift of Harry F. Guggenheim)

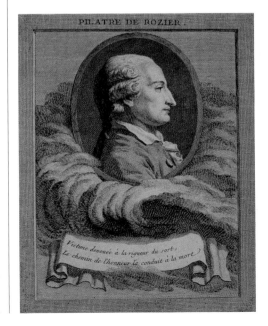

Fig. 13 An ivory plaque with a painted scene of the September 19, 1783 ascent. (NASM)

the means of managing them so as to give Men the Advantage of Flying," Benjamin Franklin informed an English friend, Richard Price. Baron Grimm, another Franklin acquaintance, concurred. "Among all our circle of friends," he wrote, "at all our meals, in the antechambers of our lovely women, as in the academic schools, all one hears is talk of experiments, atmospheric air, inflammable gas, flying cars, journeys in the sky."[23]

Franklin noted that small balloons, made of scraped animal membranes, were sold "everyday in every quarter." He was invited to visit a friend's home for "tea and balloons," and attended a fête at which the duc de Chartres distributed "little phaloid balloonlets" to his guests. At another memorable entertainment, staged by the duc de Crillon, Franklin witnessed the launch of a hydrogen balloon some five feet in diameter that kept a lantern aloft for over eleven hours.[24]

The senior American diplomat in Paris purchased one of the small balloons as a present for his grandson and secretary, William Temple Franklin. Released in a bed chamber, "it went up to the ceiling and remained rolling around there for some time." Franklin emptied the membrane of hydrogen and forwarded it to Richard Price so that he and Sir Joseph Banks might repeat the experiment. The delightful little toy was thus not only the first balloon to be owned by an American but also the first to reach England. Both Franklins were soon supplying little balloons to friends across Europe.[25]

Sixteen-year-old John Quincy Adams also took note of the small balloons offered for sale by street vendors. "The flying globes are still very much in vogue," he wrote on September 22. "They have advertised a small one of eight inches in diameter at 6 livres apiece without air [hydrogen] and 8 livres with it … several accidents have happened to persons who have attempted to make inflammable air, which is a dangerous operation, so that the government has prohibited them."[26]

Franklin, J. Q. Adams and a good many of their American colleagues joined the "vast multitude" gathered under threatening skies in the garden of the Château de La Muette on November 21, 1783, when Pilâtre de Rozier and the marquis d'Arlandes made the first free flight. Franklin had not traveled far. The Château, a royal hunting lodge complete with a pheasant preserve, was located on the Bois de Boulogne, in the suburb of Passy, very close to Franklin's residence, the Hôtel de Valentinois.

Fig. 14 The Montgolfier balloon of November 21, 1783. (NASM, Gift of Harry F. Guggenheim)

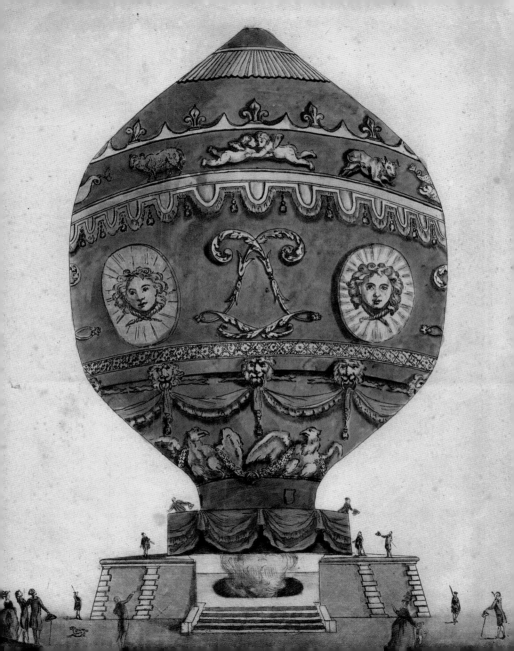

A mortar fired at precisely 12:08 p.m. signaled the beginning of the inflation. Unlike a gas balloon, the hot air *montgolfière* took shape very quickly. Eight minutes after the process had begun, the balloon was fully inflated with hot gases, and tugging at the restraining rope. The great balloon stood a little more than seventy-five feet tall and measured almost fifty feet in diameter.[27] Like its predecessors, it bore the rich decorative touches supplied by the Réveillon workmen. Red and gilt figures were applied to a deep blue background. Rings of gold fleur-de-lis and signs of the zodiac circled the crown of the balloon. Golden suns alternated with the royal monogram on the central section. Swags of red drapery and a circle of golden eagles, with their wingtips touching, ran around the lower section of the envelope (fig. 14).

The great balloon had already made a number of tethered flights with men on board. It was only fitting that Étienne Montgolfier had been first into the air, making at least one tethered flight from the yard of the Réveillon workshop in the Faubourg Saint-Antoine, probably on October 15. A few minutes later, Pilâtre de Rozier rose to an altitude of 80 feet, the length of the tether. Étienne sent his young friend aloft again on October 17 and on October 19, accompanied by Giroud de Villette, a Réveillon workman. The Montgolfiers placed a note in a Paris journal on October 11, announcing that these preliminary flight tests would be of little interest to the public, who were advised to wait for the planned free flight. As might have been expected, some 2,000 spectators tried to push their way into the courtyard on October 19.

Tiberius Cavallo remarked that "a vast multitude" gathered in the neighborhood of the Château to witness the first free flight on November 20, 1783. Gusty winds and rain forced a postponement to the next day. Once again, the weather was uncertain. When the wind dropped at 12:20 p.m. on November 21, the Montgolfiers insisted on a final tethered test ascent. The craft had just begun to rise from the platform when a fresh gust tilted it to a dangerous angle, allowing the restraining ropes to chaff and damage the envelope. With

Fig. 15 A Louis XVI poudreuse (dressing table), mahogany, French, c. 1783–84. Inlaid with amaranth, satinwood, and tulip woods, the marquetry depicts the launch of the Montgolfier balloon of November 21, 1783. (NASM, Gift of William A. M. Burden)

the balloon in danger of catching fire, volunteers swarmed onto the platform to drag the bag clear of the flames rising up through the aperture in the platform from the specially drafted iron furnace.

Losing patience, some spectators began to jeer. Within an hour and a half, however, volunteer seamstresses had completed makeshift repairs. De Rozier and D'Arlandes scrambled into the wicker baskets that were part of a gallery running around the orifice at the base of the balloon. They would make the flight safely harnessed into positions on opposite sides of the gallery, in order to balance the craft. Each man stood in front of a square opening in the neck of the balloon. They could see one another, and communicate by shouting through the apertures. Between them, suspended inside the neck of the envelope, was a small brazier. Throughout the flight, they would feed straw from the floor of the gallery into the burner to maintain the temperature inside the balloon.

The breeze died, and, following another quick inflation, Rozier and D'Arlandes finally rose into the air in free flight at 1:54 p.m. (fig. 15). "I was surprised at the silence and the absence of movement which our departure caused among the spectators," the marquis noted. A cautious wave of his kerchief brought the crowd to life. The balloon slowly spun 180 degrees as it rose. De Rozier now faced the direction of travel, while his companion spent the rest of the trip looking at where they had been. As D'Arlandes enjoyed the view, his companion exhorted him to begin forking straw into the brazier to arrest a descent that was already underway. Minutes later, the aeronauts heard a popping sound from the interior of the balloon. The cords carrying the weight of the gallery and the airborne heat source were giving way. Even more worrisome, the pair noticed that rising sparks were burning holes in the envelope. They immediately went to work dousing hot spots in the interior of the balloon with sponges mounted on the end of long poles, supplied for just such an emergency.

What with feeding the fire in the burner and putting out the fires on the balloon the pair had little time for sightseeing as they flew along the Seine, passing between the École Militaire and Les Invalides (fig. 16). Twenty-five minutes after take-off they

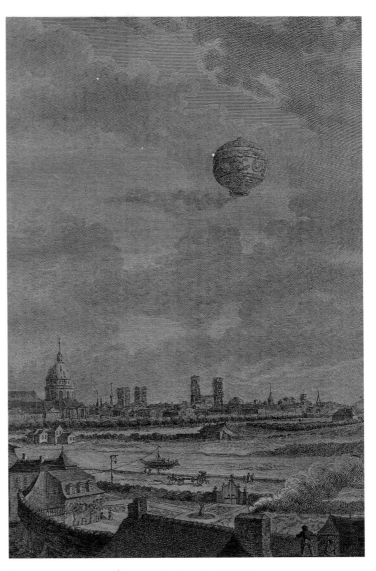

Fig. 16 On November 21, 1783, the view from the terrace of the home rented by Benjamin Franklin. (NASM, Gift of the Estate of Constance Morss Fiske in memory of Gardiner H. Fiske)

made a gentle descent into an open area near a pair of windmills known as Croulebarbe. D'Arlandes leaped out of the gallery as the envelope was collapsing into a heap of fabric. He was relieved to see De Rozier crawling out from under the envelope. They had launched the air age with a flight of only five miles.

Less than two weeks later, J. A.-C. Charles and Marie-Noël Robert, the elder of the two brothers who had built the first gas balloon large enough to carry human beings aloft, prepared to make their first flight from the Jardin des Tuileries. Incredibly, the technology embodied in the first gas balloon has remained fundamentally unchanged from that day to this. When he wanted to rise, the pilot of a *montgolfière* had to feed combustible material into the brazier hanging inside the neck of the balloon. To rest was to descend. Charles' balloon, on the other hand, was fitted with a wooden valve at the crown. A line dangling down through the center of the balloon, out the appendix and into the car allowed the aeronaut to open the valve, releasing a quantity of hydrogen so that the balloon would descend. To climb, he or she simply dropped a handful of sand ballast, reducing the total weight of the craft.

Just before 1 p.m. on December 1, 1783, Charles invited Joseph Montgolfier to begin the proceedings by cutting the line tethering a small gas balloon that would enable the aeronauts "to discover the course of the wind." Charles and Robert would make their aerial voyage seated in an elaborate wickerwork car decorated to resemble a mythical chariot and furnished with champagne, blankets and furs to ensure that they would face whatever dangers awaited them in comfort. The balloon that would carry them aloft was twenty-seven and a half feet in diameter and constructed of gores of alternating red and yellow rubberized silk. The members of the Charles and Robert team had refined their inflation procedures, arranging a series of lead-lined, hydrogen-generating barrels in a large circle around the balloon. The gas passed through leather pipes leading from the top of each barrel, and was exhausted into a tub of water, allowing it to cool and de-acidify as it bubbled up through a chimney and into the balloon. On the day of the flight, recognizing that the long and tedious process of inflating a gas balloon would either bore or anger the crowd, the crew undertook that operation in a grove of trees near the launch site, moving the balloon into the public viewing area only when it was fully inflated and ready for flight.

A cannon fired at 1:40 p.m. was the signal for launch. Unlike a ponderous, slow-moving, smoke-belching *montgolfière*, the candy-striped gas balloon literally leaped into the air, carrying Charles and M.-N. Robert to an altitude of 1,800 feet in a matter of minutes (fig. 17). As in the case of the November 21 ascent, the crowd initially watched in stunned silence, then burst into wild cheers. The sight of human beings climbing into the sky in such fine style was a deeply emotional experience. If the savants could achieve such a miracle, what might they not accomplish! One old

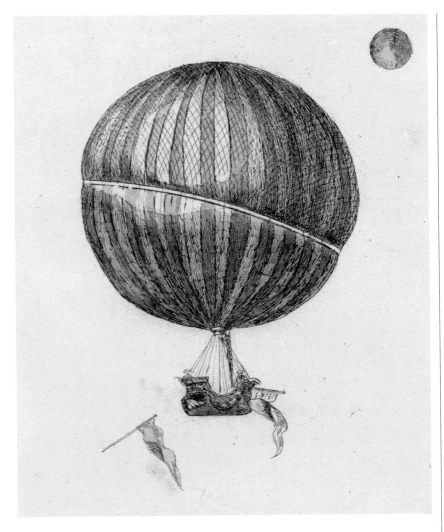

Fig. 17 The Charles balloon of December 1, 1783. (NASM, Gift of Harry F. Guggenheim)

woman, tears in her eyes, was heard to remark: "Alas! When they shall have discovered the means of escaping death, I shall not be able to take advantage of them."[28]

Jacques Charles remarked that the sensation of rising into the air was "perfect bliss." Fifty-six minutes after take-off they heard a gunshot from the direction of the Tuileries, indicating that they could no longer be seen by the spectators at the launch site. Several times during the flight they dipped low enough so that they could make themselves heard by people on the ground. "The country people pursued us," Charles remembered, "as children do a butterfly."[29]

The pair covered twenty-seven miles in two hours, landing near the village of Nesle-la-Vallée. The sun was setting, but Charles announced that he would re-ascend alone. When Robert stepped out, the balloon shot back up to an altitude that the aeronaut calculated to be 10,000 feet based on a reading of his barometer. "I stood up in the gondola," he remarked, "and lost myself in the spectacle offered by the immensity of the horizon." Having taken off at sunset, he watched the sun rise a second time, "for me alone … and gild the balloon and gondola with its rays." Developing a sudden pain in his right inner ear, caused, he recognized, by the sudden drop in pressure, he valved gas, landing three miles from Nesle-la-Vallée after a thirty-five-minute flight.[30]

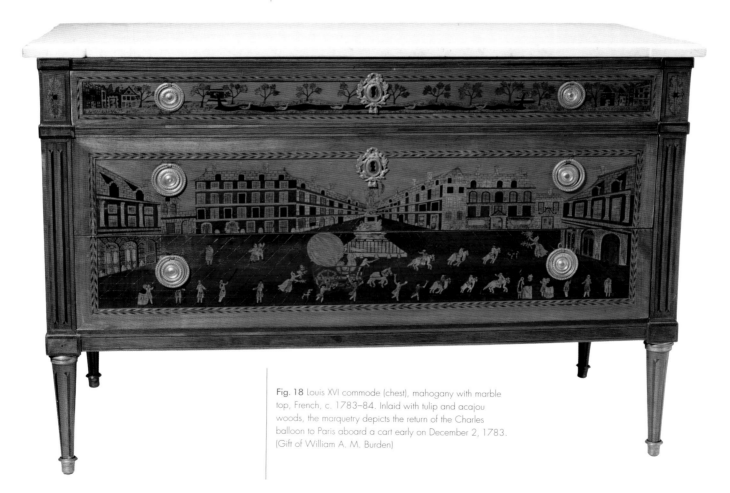

Fig. 18 Louis XVI commode (chest), mahogany with marble top, French, c. 1783–84. Inlaid with tulip and acajou woods, the marquetry depicts the return of the Charles balloon to Paris aboard a cart early on December 2, 1783. (Gift of William A. M. Burden)

Jacques Charles had joined the Montgolfier brothers as one of the heroes of a year that many would remember as the *annus mirabilis*—1783 (fig. 18). The king granted him apartments and a laboratory in the Tuileries palace, the scene of his greatest triumph. Nor was his fame soon forgotten. On August 10, 1792, when the authorities arrived to take him before a revolutionary tribunal and almost certain death, Charles pointed to the gondola that had carried him into the air, now hanging from the ceiling of his room. "The crowd," a nineteenth-century chronicler explained, "remembering with delight the impression which his bold attempt had made upon them, left him, not only without doing him personal injury, but also respecting his property."[31]

What was it about the balloons that sparked this tidal wave of interest and enthusiasm in all levels of society? Throughout the spring, summer and fall of 1783, the crowds gathering to witness the ascents had grown ever larger. As many as 400,000 people—literally half of the population of Paris—gathered in the narrow streets around the Château des Tuileries to watch Charles and Robert disappear into the heavens. The wealthy and fashionable purchased tickets of admission to the circular enclosure surrounding the launch site. Guards had a difficult time restraining the crush of citizens swarming the nearby streets, and crowding the Place de Louis XV (now the Place de la Concorde) and the garden walkways leading toward the balloon. People climbed walls and clambered out of windows onto roofs in search of good vantage points. Like the balloon, the enormous, seething crowd was something new under the sun.

There was a general sense that the colorful globes marked the beginning of a new age in which science and technology would effect startling change. The results and the implications of the revolution in physics and chemistry underway for over a century were largely unknown outside an elite circle of privileged cognoscenti. The balloon was unmistakable proof that a deeper understanding of nature could produce what looked very much like a miracle. What else was one to think of a contrivance that would carry people into the sky?

If human beings could break the age-old chains of gravity, what other restraints might they cast off? The invention of the balloon seemed perfectly calculated to celebrate the birth of a new nation dedicated, on paper at any rate, to the very idea of freedom for the individual. In the decade to come the balloons and the men and women who flew them came to symbolize the new political winds that were blowing through France. While some might question the utility of the "air globes," flight was already reshaping the way in which men and women regarded themselves and their world.

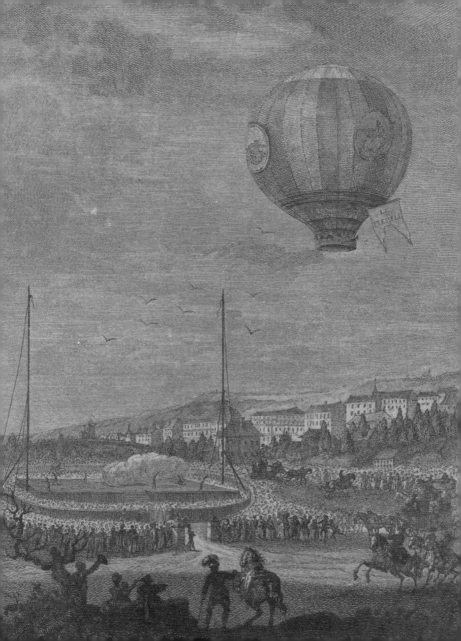

THE NEWBORN BABE COMES OF AGE

THE GREAT BALLOON ADVENTURES OF THE LATE 18TH AND 19TH CENTURIES, EUROPE AND AMERICA, AND THE EARLY MILITARY APPLICATIONS OF THE BALLOON

THE EXCITEMENT SPREADS

T HE MONTGOLFIERS LED THE WAY, but the hydrogen balloons of Jacques Charles flew higher, farther, and stayed in the air longer. Still, the pioneers of the hot air balloon were not yet ready to abandon the field to a superior technology. During the two months following the flight of De Rozier and D'Arlandes, the Montgolfiers built a huge aerostat in the Lyons suburbs. Named *Le Flesselle*, in honor of the mayor of the city, the balloon stood 130 feet tall and measured 105 feet in diameter. As with most *montgolfières*, the envelope was two layers of taffeta with paper sandwiched in between.

The wicker gallery was furnished with stacks of straw briquettes to be fed into a large brazier in the neck of the balloon. Experience had taught the builders to equip their craft with safety harnesses, buckets of water and sponges mounted on long poles to be used in extinguishing fires on the inside of the envelope. Fearing that the damp winter weather had weakened the envelope, Joseph Montgolfier announced that he would be making his first flight with only two companions, De Rozier and M. Flesselle (fig. 19).

As 100,000 spectators waited for the balloon to lift off on January 19, 1784, however, four noblemen drew their pistols and rushed the craft. Three members of the group threatened to shoot anyone who attempted to prevent them from making the flight, while the fourth individual threatened to shoot himself. When the pleas of assorted dignitaries failed to resolve the stand-off, Joseph ordered the balloon released. The overloaded craft bumped across the platform, struck the fence surrounding the launch area and slowly rose into the air (fig. 20). Less than fifteen minutes later, a section of the envelope gave way at an altitude of 1,500 feet. The seven fortunate passengers survived a rapid descent and a very hard landing.

Ballooning was no longer the sole province of the French. Paolo Andreani was the first to fly outside of France, ascending from his estate near Milan, Italy, on February 25, 1784, with the brothers Augustine and Charles Gerli, who had built the *montgolfière* (fig. 21). Elisabeth Thible became the first woman to make a free flight, ascending from Lyons on June 4. James Tytler, an impoverished Scot who had failed to launch his

Fig. 19 A silver medal to commemorate the flight of the balloon *Le Flesselle*, January 19, 1784. (NASM, Gift of the American Institute of Aeronautics and Astronautics)

balloon on several previous occasions, finally made the first two short flights in Great Britain, reaching an altitude of 500 feet or so from Edinburgh on August 25 and again on September 1, 1784.[1]

James Sadler, an Oxford baker and confectioner, made his first flight on October 4, 1784, aboard a home-built *montgolfière*. Sadler made five more ascents with hydrogen balloons in 1785, including a famous flight that ended with a drenched aeronaut struggling to reach the shore following a landing near the mouth of the River Midway. He abandoned ballooning after accepting a post as a chemist with the Board of Naval Works, but resumed flying with his two sons in 1810.

Excitement over the balloons crossed the Atlantic with surprising speed. A great many Americans living in France or England, including members of the Benjamin Franklin, John Adams and John Jay households, as well as Thomas Jefferson, who arrived in Paris as the new U.S. envoy in August 1784, wrote to inform the folks at home that, as Jay put it, "all the people here are running after air globes."[2]

As early as November 17, 1783, the *Salem* [Massachusetts] *Gazette* described the launch of the first small *charlière* and the *montgolfière* animal flight, which had occurred only a month before. Within a few weeks such articles were appearing in publications from New England to South Carolina. Franklin dispatched a copy of Faujas de Saint-Fond's *Description des expériences de la machine aérostatique*, the first detailed book on the balloons, to his colleagues at Philadelphia's American Philosophical Society in December 1783. By the spring of 1784, just a year after the first public balloon flight at Annonay, Dr. John Foulke, a physician who had witnessed the events in Paris, sent the first small hot air balloon aloft from a Philadelphia garden.

Apparently inspired by an article on balloons in the *Maryland Journal and Baltimore General Advertiser*, Peter Carnes, a lawyer and tavern keeper residing in Bladensburg, Maryland, announced that he would "ascend above the clouds" in an "American Aerostatic Balloon" from a field near Baltimore on June 24, 1784. Carnes's balloon was a hot air model, constructed of "silk of various colors." Standing only thirty-five feet tall and measuring just thirty feet in diameter, it was too small to lift a grown man. Carnes first sent the empty balloon aloft on tethered ascents from Bladensburg on June 19, and followed up with the promised tethered exhibition in Baltimore on June 24. At the conclusion of the Baltimore event, thirteen-year-old Edward Warren stepped out of the crowd and asked if he could ascend in the basket. Carnes allowed the young man the honor of becoming the first American to leave the ground. Peter Carnes returned to his legal career when his balloon caught fire in the air and fell to earth during a Philadelphia exhibition on July 4. It would be nine years before another human being took to the air from American soil.

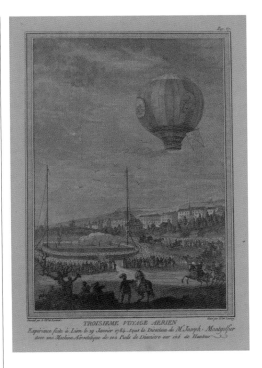

Fig. 20 The flight of *Le Flesselle*. (NASM, Gift of the Estate of Constance Morss Fiske in memory of Gardiner H. Fiske)

Fig. 21 A silver medal commemorating the flight of Paolo Andreani from Milan, February 25, 1784. (NASM, Gift of the American Institute of Aeronautics and Astronautics)

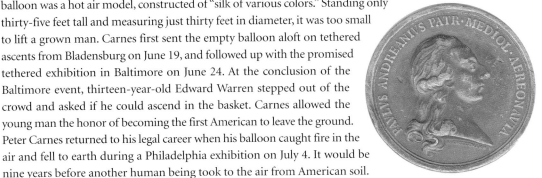

THE FIRST PROFESSIONALS

Fig. 22 Vincenzo Lunardi (1759–1806). (NASM, Gift of the Kamen Corporation)

THE FIRST OF THE GREAT EXHIBITION BALLOONISTS who would dominate aeronautics for the next century made their debut in 1784. Vincenzo Lunardi, secretary to Prince Caramanico, the Neapolitan ambassador to the Court of St. James in London, took to the air from the Honourable Artillery Company training ground at Moorfields on September 15, 1784, in a lovely red and blue striped balloon (fig. 22). The unruly crowd of 150,000 Londoners gathered to witness the event included the Prince of Wales, Lord North, Charles James Fox, Edmund Burke, William Pitt the Younger, and Georgiana, Duchess of Devonshire. Lunardi remained in the air for two and one-half hours, traveling across North London to a landing in Hertfordshire.

A master of public relations, Lunardi commissioned a larger balloon decorated with the Union Jack to demonstrate his "regard and attachment to everything that is English."[3] On June 29, 1785, he was scheduled to fly from the Artillery Ground with a Colonel Hastings, Mr. George Biggin, and Mrs. Letitia Sage (fig. 23). The party was too large, even for the new balloon. Lunardi persuaded Col. Hastings to step out of the car, offered a minute or two of flight instruction, and allowed Biggin and Mrs. Sage to ascend alone.

In this age before the appearance of illustrated newspapers and magazines, Europeans became familiar with the appearance of foreign places and newsworthy events and personalities through the medium of widely distributed single-sheet printed images. During the last two decades of the eighteeenth century, no subject was more popular with those who engraved, printed and distributed these images than the balloons that were rising over the rooftops of European cities, and the aeronauts they carried aloft. As a result, the handsome face of Vincenzo Lunardi, and the story of the flight of George Biggin and Letitia Sage, became familiar across the continent.

By the summer of 1786, Lunardi had flown from London, Liverpool, Edinburgh, Glasgow, York, and Newcastle. While a jealous Tiberius Cavallo regarded the handsome young Italian as a spoiled and egotistical youth, British ladies, from

Fig. 23 Vincenzo Lunardi, George Biggin, and the lovely Letitia Sage, June 29, 1784.

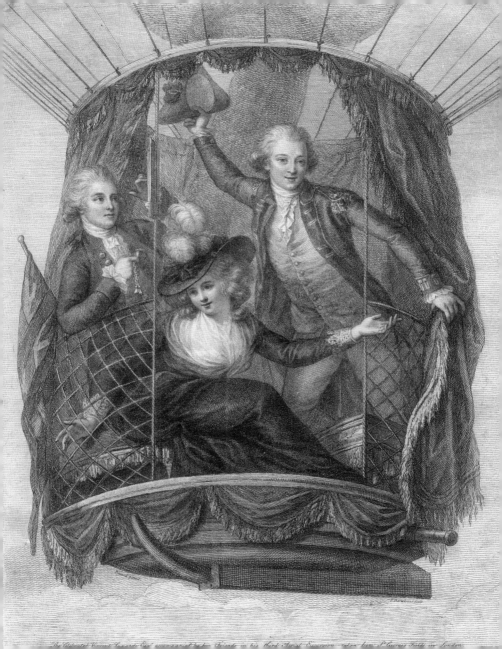

The Celebrated Vincent Lunardi, Esqr. accompanied by two friends in his third Aerial Excursion, taken from St. Georges Fields in London.

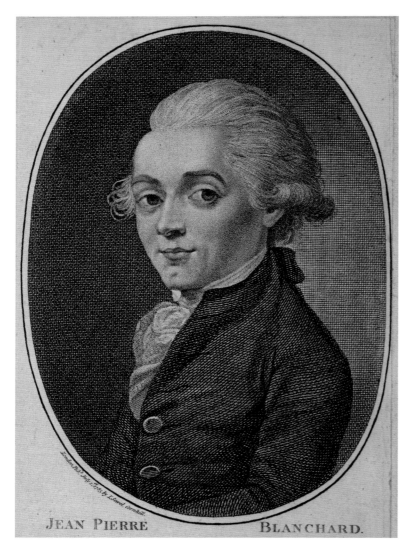

Fig. 24 Jean-Pierre-François Blanchard (1753–1809). (Gift of the American Institute of Aeronautics and Astronautics)

duchesses to barmaids, took a very different view. Bonnets and garters bearing his image and celebrating his deeds graced heads and legs across Great Britain. But fame is fleeting. Public opinion turned against Lunardi in August 1786, when a young volunteer assistant fell to his death after becoming entangled in the handling lines and carried aloft by a partially inflated balloon. The aeronaut abandoned England in the wake of the tragedy, setting off on an aeronautical Grand Tour that included flights in Rome, Palermo, Naples, Spain and Lisbon, Portugal, where he fell ill and died on July 21, 1806.

During the course of his long aeronautical career, Jean-Pierre-François Blanchard earned a reputation as the world's most experienced balloonist (fig. 24). Born in Petit Andelys, Normandy, in 1750, he was described as "an unpleasant creature—a petulant little fellow, not many inches over five feet, and physically suited for the vaporish regions." He was also short-tempered, occasionally rude, and courageous to the bone.[4]

Blanchard first came to public attention in 1779, when he demonstrated a human-powered carriage near the Champs-Elysées before setting off on a twelve-mile journey to Versailles. When investors failed to beat a path to his door, he constructed the *Vaisseau Volant*, a heavier-than-air craft in which a combination of foot and hand pedals operated a series of flapping wings. Having failed to row his way into the air, Blanchard decided to hitch his fortunes to aerostatic technology.

Blanchard's first flight, from the Champ-de-Mars in March 1784, was followed by two more ascents from Rouen on May 23 and July 18 and another from Bordeaux on July 26. Convinced that his countrymen were becoming jaded, he traveled to Great Britain, where he flew from Chelsea on October 16 with Dr. John Sheldon, who paid all of the expenses. A medical colleague of Sheldon's, Boston-born Dr. John Jeffries (1744–1816), an American Loyalist who had served as a British naval surgeon during the Revolution, purchased a seat on Blanchard's next flight, from Mayfair on November 30.

A physician and surgeon with degrees from both Harvard and the University of

Aberdeen, Jeffries maintained a thriving medical practice among the American Loyalist community in London (fig. 25). Following his initial trip aloft with Blanchard, he commissioned a tailor to produce the world's first flight suit (a warm fur hat with leopard's spots, cork jacket, shirt with puffed sleeves and tight cuffs, heavy duty trousers and fur-lined gloves), equipped himself with the best thermometer and barometer that money could buy, and agreed to fund Blanchard's next venture, the first aerial crossing of the English Channel. Although Blanchard grudgingly agreed that

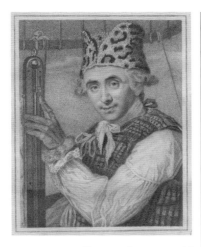

Fig. 25 John Jeffries, M.D. (1745–1819). (NASM)

Jeffries could accompany him, he adopted one stratagem after another to avoid sharing the glory with his patron. The determined Jeffries was able to counter every ploy adopted by the man whom he described as "my gallant captain."

The pair launched from an area near Dover Castle on the morning of January 7, 1785. Dipping close to the water with the French coast in sight, they pitched a load of extraneous gear over the side. "As we did not yet ascend," Jeffries explained, "we began to *strip ourselves*, and cast away our clothing." Blanchard jettisoned two coats and his trousers, while Jeffries sacrificed his only coat, at which point they both donned cork jackets and "prepared for the event."[5]

Ascending now, they crossed the coast safely, but were quickly blown over a forest. In an effort to remain in the air until they could reach a safe landing spot, they tossed their cork jackets overboard. Unwilling to jettison his precious scientific instruments, Jeffries was desperate for something else to discard. "Happily," he recalled, "it almost instantly occurred to me that probably we might be able to supply it from within ourselves, from the recollection that we had drunk much at breakfast … and from the severe cold little or no perspiration had taken place, that probably an extra quantity had been secreted by the kidneys, which we might now avail ourselves of discharging." Indeed, the pair was able to produce "between five and six pounds of urine; which circumstance, however trivial or ludicrous it may seem … was of real utility in our then situation." Having thus lightened the load, the pair continued on to a clearing some twelve miles from the coast, where Jeffries caught the top of a tree, enabling them to make "a most beautiful entrée into France."[6]

The flight captured the public imagination in England and France. The two aeronauts entered Paris in triumph, and were invited to dine with the King and Queen, who awarded Blanchard a 12,000 livres prize and a pension. Jeffries, the

Fig. 26 A walnut balloon back chair with an embroidered seat, French, c. 1785; the embroidered seat illustrates the tragic death of Pilâtre de Rozier and Jules Romain. (NASM, Gift of William A. M. Burden)

patron, was apparently above such things. He delivered a letter from his friend and fellow Loyalist, William Franklin, to his patriot son, William Temple Franklin, and his estranged father, Benjamin. Overlooking their political differences, the senior American diplomat welcomed the first of his countrymen to fly into his home.

Surprised to discover that he had been upstaged by his American passenger, a relative upstart, Pilâtre de Rozier was determined to become the first man to pilot a balloon from France to England. He commissioned Jules Romain to construct a new balloon, combining the advantages of both hydrogen and hot air designs. The lower hot air portion of the balloon would regulate altitude, conserving both hydrogen gas and ballast. Since the valve line could no longer be dropped through the open appendix into the basket, it was run all the way along the outside of the envelope. Shortly after launch on June 15, 1785, the line whipping over the silk created a static discharge that ignited the hydrogen. Pilâtre de Rozier, one of the first men to make a free flight, and Jules Romain fell to their deaths, the first victims of an aircraft accident (fig. 26).

Blanchard's aeronautical career blossomed in the wake of the Channel crossing. Before the end of 1785 he made the first flights in Belgium, Germany, and Holland. He introduced the citizens of Switzerland to the balloon with a flight from Basle in 1788, and made the first flights in Prague and Poland the following year. Shortly after his forty-fourth ascent, from Lübeck on July 2, 1792, Blanchard was arrested and imprisoned by Austrian officials in the Tyrol who feared that he was spreading the pernicious doctrines of the French Revolution, as he probably was.

Anxious to escape European politics and find a new crop of paying spectators, he sailed for America following his release. Landing in Philadelphia, Blanchard announced the sale of tickets for a flight from the yard of the city's new jail on January 9, 1793. The aeronaut, with his reputation as a supporter of Revolutionary France, was as controversial in America as he had been in Europe. Political factions in the new nation were already beginning to coalesce around Thomas Jefferson and his Democratic Republican colleagues, and the Federalist followers of Alexander Hamilton. During the weeks leading up to his flight, J.-P.-F. Blanchard was celebrated by the Jeffersonians and attacked by the Federalists as a harbinger of Revolution. On January 3, 1793, his Republican friends hosted a dinner for the visitor in which they offered fifteen toasts to the aeronaut and "the friends of equality and the French Revolution," while Federalists grumbled that Blanchard

was "intruding into regions where he has no business," and accused him of offering, "a cheap performance."[7]

As promised, Blanchard lifted off from behind the fence of Philadelphia's "new jail," near Independence Hall, at 10:10 on the morning of January 19, 1793, accompanied by his small black dog (fig. 27). The leaders of the new United States joined the huge crowd gathered to witness the event. President George Washington stepped forward to offer the aeronaut a "passport" guaranteeing his safe conduct wherever he landed. Fortunately, Blanchard would not need the document. He and his dog landed safely near Woodbury, in Gloucester County, New Jersey, some fifteen miles from his starting point. A decade after the invention of the balloon, a human being had finally made a free flight from American soil.[8]

Blanchard's plans for an extended American tour were thwarted at every turn. He failed to raise the funds with which to make another full-scale flight from Philadelphia, and had no better luck in either Charleston, South Carolina or New York. John Jeffries had returned to the United States for good in 1790. Upon hearing that his old companion was accusing him of having been falling down drunk during their first flight, the good doctor sued Blanchard for repayment of an old debt. Tragedy stuck in the fall of 1796, when Blanchard's sixteen-year-old son was killed in an accident.

The aeronaut finally gave up and sailed for Europe in May 1797, having left the ground only once in more than four years. He resumed his career, completing a total of sixty flights before suffering a heart attack during a February 1808 ascent from The Hague. He never fully recovered, dying at the age of fifty-nine in Paris in March 1809. His second wife, Marie Madeleine-Sophie Armant, carried on the

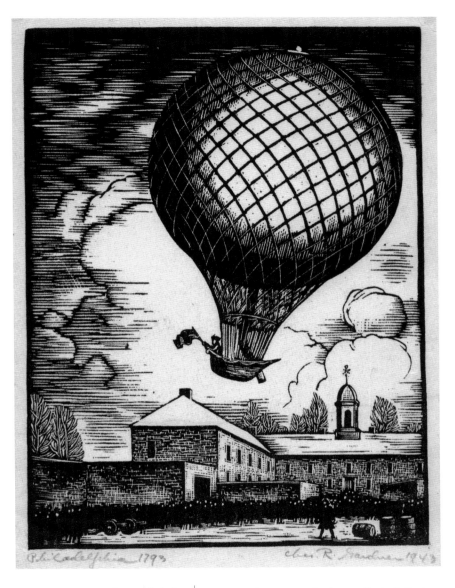

Fig. 27 A 20th-century woodcut by artist Charles R. Gardner illustrates J.-P.-F. Blanchard's flight from Philadelphia, January 19, 1793. (NASM)

family tradition. She married the aeronaut in 1804, following the death of his first wife, and took up ballooning the following year.

André-Jacques Garnerin began his aeronautical career with an ascent from Metz in 1787 (fig. 28). Enlisting in the army of Revolutionary France, he was captured by the English and turned over to the Austrians, who imprisoned him in a Hungarian fortress for three years, where he gave considerable thought to an aerial stunt with which to reignite his career. In December 1783, Sébastian de Normand had successfully parachuted from the tower of the Montpellier Observatory. Two years later, Blanchard parachuted a dog to earth from his balloon. Released from prison, Garnerin took the next logical, if somewhat foolhardy, step, parachuting himself from an altitude of 3,000 feet over Monceau on October 22, 1797. He continued to improve the design of his parachute over the next decade, thrilling crowds with his drops from altitudes as high as 10,000 feet.

Jeanne-Geneviève Labrosse Garnerin, the aeronaut's nineteen-year-old wife, became the first woman to make a parachute drop in 1798. The following year she made history as the first woman to make a solo balloon ascent. In spite of the war spreading across Europe, the Garnerins flew in Italy, Germany, England, and Russia. By 1815, Garnerin's niece, Elisa, had launched her long career as a full-fledged member of the family firm (fig. 29). Garnerin's career peaked on December 16, 1804, when, as the official *Aérostière des Fêtes Publiques*, he launched a large unmanned balloon, decorated in gold and topped with a gold crown, in honor of the coronation of the Emperor Napoleon. Everything went well until the following morning, when the balloon descended over Rome and deposited the gold crown on the tomb of Nero. Napoleon was not amused. Garnerin survived his embarrassment, however, continuing to fly until his death in 1823. Elisa completed her twenty-third and twenty-fourth drops during an engagement at Milan in 1824.

With Garnerin's temporary disgrace, Napoleon named Marie Madeleine-Sophie Blanchard official aeronaut to the Emperor. Described as small and "bird-like," Madame Blanchard avoided fast carriages and was frightened by loud noises, yet she was fearless in the air, ascending while standing in balloon baskets so small that there was scarcely room to sit down (fig. 30). She flew on June 24, 1810, to celebrate the marriage of the Emperor to

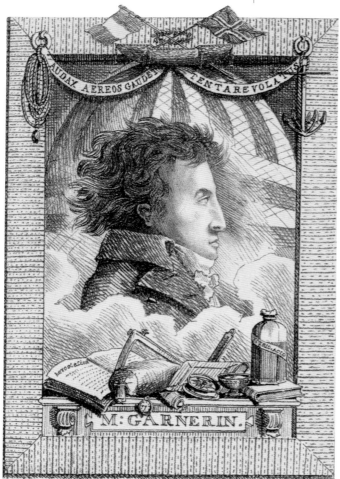
Fig. 28 André-Jacques Garnerin (January 31, 1769–August 18, 1823). (NASM, Gift of Harry F. Guggenheim)

Marie-Louise of Austria, and again on August 15, 1811 in honor of a *Fête de l'Empereur*. Surviving the shifting political winds, she was appointed Official Aeronaut of the Restoration, and flew in honor of the coronation of Louis XVIII in 1814.

Madame Blanchard's trademark was to drop parachute loads of fireworks, which trailed sparks on the way down before exploding into bursts of vivid color. It was a dangerous stunt. On the evening of July 7, 1819, she ascended from the Tivoli pleasure garden, Paris, trailing fireworks as she rose. The balloon caught fire and descended so rapidly that the flames were extinguished. She dropped ballast to slow the descent, but struck a steeply pitched roof, fell from the basket, and died when she hit the ground.

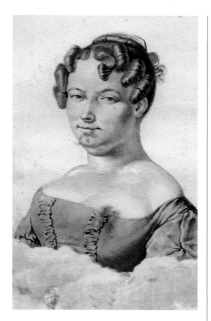

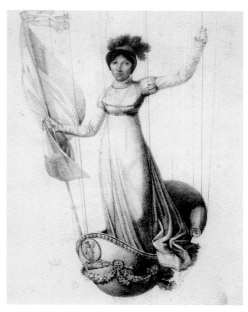

Fig. 29 Elisa Garnerin. (NASM, Gift of Harry F. Guggenheim)

Fig. 30 Marie Madeleine-Sophie Blanchard (March 25, 1778–July 6, 1819). (NASM, Gift of Harry F. Guggenheim)

EUROPEANS ALOFT

IN EUROPE AND AMERICA, the nineteenth century was the golden age of exhibition ballooning. Aeronauts scrambled to top the parachuting and fireworks demonstrations with ever more spectacular feats of aerial daring-do. Twelve years after he made the first night flight from Paris on June 18, 1786, Pierre Tétu-Brissy made two flights seated on a horse (fig. 31). In the years to come, other balloonists, notably the Poitevins and the Guilles, French husband and wife teams, offered variations on that theme. On one occasion, an intrepid aeronaut had to be restrained from ascending with a tiger.

Clearly, as indicated by the Poitevins, Guilles, Blanchards, and Garnerins, a talent for aerial showmanship ran in families. France also produced the Robertsons, Godards, Yons, Jules and Caroline Duruof and Gaston and Albert Tissandier. Margaret and George Graham and members of the Spencer family represented Great Britain, while Gottfried and Wilhelmine Reichardt earned aerial fame in their native Germany.

George Gale, Richard Gypsom and John Hampton emerged as leading British aeronauts during the first half of the nineteenth century. None of them, however,

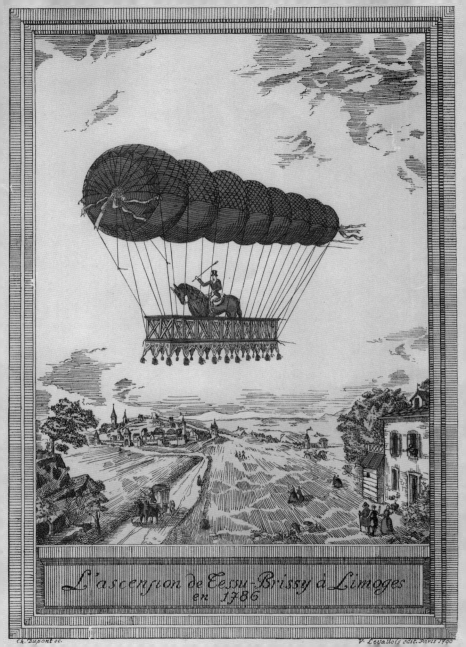

L'ascension de Tessu-Brissy à Limoges en 1786

V. Levallois édit. Paris 1890

could match the fame of Charles Green. Born the son of a London fruit-seller in 1785, Green, a large man who could have served as a model for John Bull, started at the top. The thirty-six-year-old novice made his first flight on July 19, 1821, in celebration of the coronation of George IV. It was also the first time anyone had flown with an envelope full of city illuminating gas, which quickly became common practice among aeronauts on both sides of the Atlantic.[9]

Initially, Green followed the lead of his predecessors, ascending seated on horseback and launching fireworks from on high. The newcomer quickly moved beyond most of his contemporaries, however. He learned to read the sky, and saw the possibility of rising into strong, steady winds at higher altitudes that would carry him long distances. Experience taught him where to drop down into lower currents that generally blew in a desired direction. On early solitary flights he gained the sort of experience with wind and weather that would mark the very best balloon and airship pilots in the decades to come. He flew at night, and learned to recognize surface features—crops, woods, open fields—by their reflective qualities.

Green was also an innovator, introducing the drag line, a thousand feet of stout rope that was dropped over the side of the basket when the balloon was close to the ground. The lower the balloon fell, the more rope was dragged along the ground, reducing the weight carried by the craft and slowing its descent. As the balloon rose, it carried more of the weight, slowing the ascent. The drag line allowed the aeronaut to maintain a measure of control close to the ground without having to waste either ballast or gas. It was one of very few technical improvements between the first flight of a gas balloon and the end of the nineteenth century.

By 1835, Green was a veteran of more than 200 flights in his *Royal Coronation* balloon, having traveled roughly 6,000 miles during the course of some 240 hours in the air. That year, the proprietors of London's Vauxhall pleasure gardens financed the construction of a new balloon for Green, the *Royal Vauxhall*, incorporating 2,000 yards of Italian silk, with seams that were glued, rather than stitched, for strength and durability. In return for this largesse, the aeronaut would make periodic ascents from within the garden to boost attendance, occasionally carrying a singer aloft with him to entertain the crowd with comic songs, such as "Hot Codlins" and "Pigs Pettitoes." On those occasions when he flew beyond the confines of Vauxhall, any mention of the new balloon in the press would serve to advertise the gardens. And Green did make news with his new craft. On the first flight, he carried nine passengers straight up to an altitude of 13,000 feet in less than ten minutes.[10]

On November 7, 1836, Green and two companions lifted off aboard the *Royal Vauxhall*, determined to travel as far as possible before returning to earth. Thomas Monck Mason, a musician and operatic impresario, had flown with Green before, as had the other passenger, Robert Holland, Member of Parliament for Hastings, who

financed the aerial voyage (fig. 32). The balloon, with a 70,000 cubic foot capacity, stood eighty feet tall. Green had packed the large basket with 400 pounds of ballast and 2,700 pounds of equipment and provisions, including 125 pounds of meat, poultry, bread, preserves and sugar, and twelve gallons of brandy, sherry and port. The payload included a flameless cooking stove employing slaked lime.[11]

The trio passed over Dover Castle at dusk, and crossed the French coast an hour later. They ate their first meal after dark, while flying toward the bright glow of the iron furnaces at Liège, Belgium. As they flew into the European heartland, the night grew ever darker. "A black, plunging chasm was around us on all sides," Monck Mason reported. "[As] we tried to penetrate this mysterious gulf, we could not prevent the idea coming into our heads that we *were cutting a path through an immense block of black marble* by which we were enveloped, and which, a solid mass a few inches away from us, seemed to melt as we drew near, so that it might allow us to penetrate even further into its cold dark embrace."[12]

They moved forward under a canopy of "stars, increasing in their brilliance … like sparks sewn on the black vault." Occasional roaring noises rose up from beneath the clouds. At daybreak they watched cultivated fields unrolling beneath them, with the Rhine River rapidly approaching. Green brought the party safely back to earth at 7:30 a.m. near Weilburg, in the Duchy of Nassau, 340 miles and 18 hours after take-off.

Green hoped to do even better. During ascents to altitudes of over 10,000 feet he noted a strong air current blowing steadily from west to east. Once in 1839 and again in 1846 he offered to fly from the United States to Europe, provided that a wealthy patron would bankroll the venture. There were no takers, but the flurry of excitement over Green's proposal did inspire a classic piece of American fiction.

On April 13, 1844, the *New York Sun* announced that "the famous European balloonist" Monck Mason had crossed the Atlantic in "the steering balloon *Victoria*," accompanied by Robert Holland and seven companions. Oddly, Charles Green was not among those who were reported to have made the crossing. The news created a sensation. Crowds jammed the entrance to the newspaper office, until it was revealed that the story was a hoax concocted by Edgar Allan Poe, a thirty-eight-year-old poet, essayist and part-time employee of the *Sun*.[13]

Charles Green and his *Nassau* balloon, as it was renamed, made history of a less pleasant sort on July 24, 1837, when they carried Robert Cocking aloft to test his new

Fig. 32 Charles Green (seated right) and Robert Holland (seated center) discuss their record aerial voyage from England to the Duchy of Nassau with friends. (NASM, Gift of Harry F. Guggenheim)

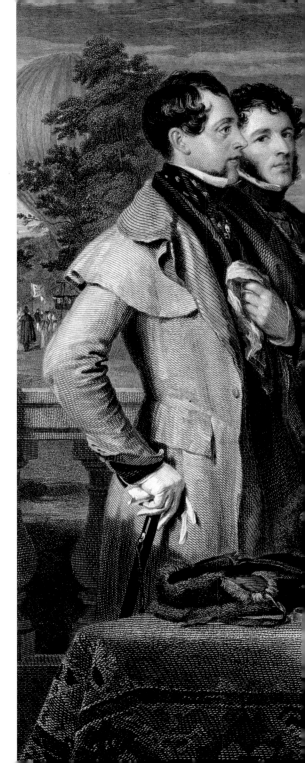

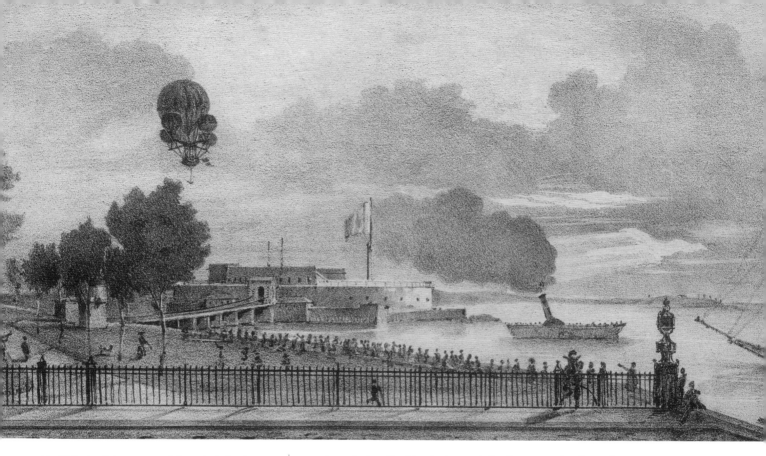

parachute design. Cocking had attended a demonstration by André-Jacques Garnerin in 1802, and never forgotten how the parachute oscillated wildly back and forth on its way to the ground. After considering the problem for over three decades, the sixty-one-year-old Cocking decided that a parachute in the shape of an inverted umbrella would be more stable. His finished product featured three metal hoops to maintain the shape of the fabric and weighed some 223 pounds.

Having persuaded the proprietors of Vauxhall Gardens that the initial test of his device would be just the thing to draw a large crowd into their pleasure ground, Cocking also obtained permission to be carried to altitude dangling beneath the famed *Nassau* balloon, still the property of the Garden. After protesting this dangerous enterprise, Green finally agreed to make the flight, but insisted that Cocking cut himself loose from the balloon. When the time came, the aeronaut and his friend Edward Spencer, the founder of a British balloon manufacturing dynasty, shouted down to Cocking, dangling below, that they were at 5,000 feet and could rise no higher.

Free of the weight of Cocking and his parachute, the *Royal Nassau* shot up to an altitude of over 15,000 feet. The two aeronauts, who had foreseen this possibility, breathed oxygen through tubes until they could descend. The unfortunate Cocking fell straight to earth trailing fabric streamers, struck the ground, and died the following day. Green made a number of ascents to raise money for Cocking's widow. The undisputed "king" of British aeronauts made his last flight on September 12, 1852. He was uncertain how many flights he had made, but was sure the number was over 500.

THE FIRST AMERICAN BARNSTORMERS

Fig. 34 John Steiner prepares to ascend from Erie, Pennsylvania. in June 1857. This ambrotype is the oldest known photograph of a balloon. (NASM, SI 2001-5358)

Bdrop ALLOONING WAS SLOW to take root in America. In 1819, over a quarter of a century after J.-P.-F. Blanchard's Philadelphia ascent, Louis-Charles Guille, another visiting French aeronaut, ascended from New York City, and parachuted back to earth. Guille and his wife then set off on an extended American tour. Another Gallic airman, Eugène Robertson, arrived in the summer of 1825 (fig. 33). Fascinated, Charles Ferson Durant, a New York businessman and amateur scientist, signed on with Robertson as an apprentice aeronaut.

Durant made his first solo ascent in the U.S. on September 9, 1830, before 20,000 spectators at New York's Castle Garden. He made only thirteen flights during his career as an aerial showman, but inspired a generation of American balloonists. During the 1830s, Baltimore produced a group of native aeronauts: James Mills, Nicholas Ash, Jane Warren, and George Elliot. On December 15, 1834, Thomas Kirkby introduced the citizens of Cincinnati, the Queen City of the West, to the sight of a human being rising into the sky. Richard Clayton followed suit early the next year.

By the middle of the century, a handful of itinerant aeronauts set out each spring to barnstorm the nation, flying at pleasure grounds, fairs and celebrations, and making occasional forays into Canada and Latin America (fig. 34). William Paullin, Louis A. Lauriat, Silas Brooks, Samuel Archer King, and the members of the James Allen family would become familiar names to the readers of American

Fig. 35 John Wise (February 24, 1808–September 1879). (NASM, SI 90-6536)

Fig. 36 An idealized image of T. S. C. Lowe's *City of New York*. (NASM, Gift of Richard A. Forman)

newspapers. Alexander De Morat and Charles Cevor usually remained south of the Mason-Dixon Line. A few, including Ira Thurston and Timothy Winchester, paid the ultimate price for their feats of aerial daring-do.

John Wise, of Lancaster, Pennsylvania, emerged as the best-known and most successful of American aeronauts (fig. 35). Between his first flight from Philadelphia on May 2, 1835, and his disappearance during a flight in the fall of 1879, the nation's senior airman completed 450 ascents. Like Charles Green, he was fascinated by meteorology, corresponding with Smithsonian Secretary Joseph Henry, the nation's unofficial chief scientist, on topics ranging from weather phenomena to meteor showers. He was an innovator, as well, introducing the ripping panel, a lightly stitched section of fabric that could be pulled loose to empty the envelope quickly upon landing to avoid being dragged over the ground.[14]

Wise discovered a steady stream of air blowing from west to east at high altitudes. The Atlantic beckoned. Before undertaking such a dangerous venture, however, Wise organized a shakedown cruise from the Mississippi Valley to the east coast. Launching from St. Louis on the afternoon of July 1, 1859, he was accompanied by John La Mountain, a balloonist he had trained; O. A. Gager, who financed the voyage; and reporter William Hyde. Their balloon, the *Atlantic*, measured 180 feet in circumference, and employed six miles of rope in the netting. A specially constructed boat, insurance for the ocean crossing, dangled beneath the large wicker basket that housed the crew. Rather than flying due east to a coastal city, as they had hoped, the aeronauts were blown to the northeast, making the first aerial crossing of Lake Erie. They came to earth in Henderson County, New York, having flown some 809 miles in twenty hours and forty minutes. While they had established a distance record that would stand until 1910, the envelope of the *Atlantic* was badly damaged in landing, dashing any hope of a transoceanic flight.[15]

With Wise and La Mountain out of the picture for the moment, a new Transatlantic aspirant appeared on the scene. Thaddeus Sobieski Constantine Lowe, born in 1832 in Jefferson Mills, New Hampshire, took to the road giving public science demonstrations at the age of twenty, and acquired his first balloon in 1856. Three years later, in mid-

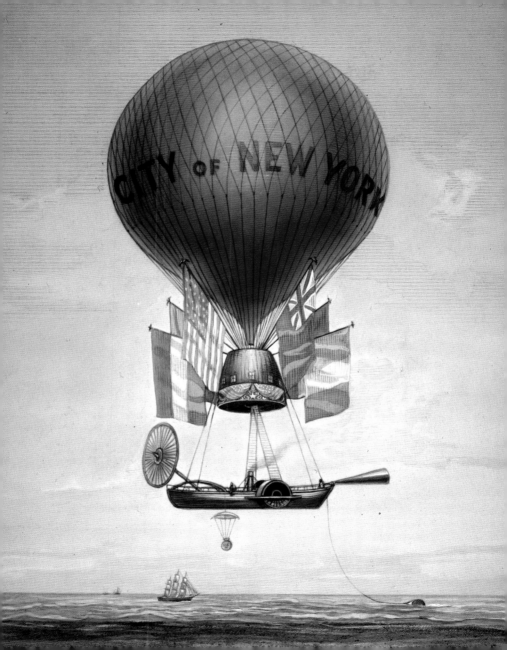

July 1859, he announced his own plan for a Transatlantic flight and began construction of a huge balloon, *The City of New York*, standing 200 feet tall from the top of the valve to the keel of the lifeboat hanging beneath the basket (fig. 36).

In spite of the fact that Lowe and his aerial behemoth were front page news over the next several months, the New York City gas works could not produce enough coal gas to inflate the balloon. Nor was Lowe able to raise enough money to cover expenses. That winter, he accepted the invitation of Philadelphia entrepreneurs to transfer his operations there, renamed his balloon *The Great Western*, and promised to fly the Atlantic before Isambard Kingdom Brunel's iron steamship, SS *Great Eastern*, docked in New York that spring. That day came and went without a flight. While Lowe did make a few ascents with the balloon in the summer of 1860, the project came to an end on September 8, 1860, when the giant envelope burst during inflation.

Unwilling to entirely abandon his dream of flying the ocean, Lowe borrowed an idea from John Wise. He would restart his Atlantic venture by making a long flight from an inland city to the east coast. He launched from Cincinnati aboard a new balloon, *Enterprise*, at 3:30 a.m. on April 20, 1861, one week after the Confederates had fired on Fort Sumter. He landed nine hours later, and was met by a less than friendly reception committee from nearby Unionville, South Carolina. The aeronaut with his Yankee accent was captured, released, recaptured and released again, finally returning to Cincinnati on April 26.

BALLOONS AT WAR

HAVING WATCHED THE FIRST HUMAN BEINGS take to the air in free flight on the afternoon of November 21, 1783, Benjamin Franklin wrote to his friend Sir Joseph Banks, head of Britain's Royal Society, predicting that the new invention would have considerable military value, "elevating an Engineer to take a view of an enemy's Army, Works, &c.; conveying Intelligence into, or out of, a besieged Town, giving Signals to Distant Places, or the like."[16]

A decade passed before Guyton Morveau, scientific advisor to the Committee of Public Safety, followed up on Dr. Franklin's thought, suggesting that the armies of revolutionary France be equipped with tethered observation balloons. Charles Coutelle and Nicholas Conté constructed the balloon *L'Entreprenant* ("Enterprise"), with government funds and staged a demonstration that led French officials to create the world's first military aviation unit, the Compagnie d'Aérostiers, on April 2, 1794. The balloonists saw action with General Jean-Baptiste Jourdan's Army of the North facing the Austrians and the Dutch in a battle fought near the village of Maubeuge on June 2. The aeronauts took

a general officer aloft during the fighting at Charleroi, between June 23 and June 25. At the Battle of Fleurus, on June 26, Coutelle was in the air for some nine hours, once again taking senior officers aloft to observe the fighting.

The Corps d'Aérostiers grew to include three balloons by 1796, and saw service on several fronts. One unit accompanied the armies on the Egyptian campaign. They saw little action, however, and lost their equipment in the Battle of Aboukir Bay in 1798. Their combat record failed to impress Napoleon, who disbanded the balloon operation following the return of the armies to France in 1799.[17]

Experiments with military observation balloons continued through the early nineteenth century. French aeronauts made flights in Algeria in 1830 and during Napoleon III's Italian campaign of 1859. Russian balloonists conducted observations during the siege of Sebastopol. Both the Danes and the Milanese scattered propaganda leaflets from balloons, while the Austrians tried unsuccessfully to attack Venice with small balloon-born bombs in 1848.

American interest in the military potential of the balloon began in 1840, when the War Department considered using nocturnal aerial observers to locate Seminole campfires in the Everglades. Six years later, John Wise suggested the use of balloons in the Mexican War.

When Civil War broke out in the spring of 1861, a number of aeronauts who had built reputations as aerial showmen stepped forward with proposals to form an observation balloon unit. On July 21, John Wise tied a fully inflated balloon down in a wagon and set out from Washington, D.C., bound for Centreville, Virginia, near the spot where the Union and Confederate armies were massing for the first major battle of the war along the banks of a creek known as Bull Run. He was close enough to hear the artillery that afternoon, when the balloon became caught in tree branches and was destroyed. When a Union officer complained of the failure to get a balloon to the battlefield, where the federal army was soundly defeated, Wise suggested that "the balloon part" of the disastrous affair was just about as good as "the fighting part."

In the aftermath of Bull Run, most of the early candidates for the honor of organizing a Union balloon corps dropped out of the running. Of these earliest volunteers, only John La Mountain, who was based at Fort Monroe, at the tip of the Virginia peninsula separating the York and James Rivers, operated as a balloonist with the federal army for any length of time.[18]

In the end, the opportunity to organize a balloon reconnaissance organization for the federal army went to Thaddeus Lowe, who arrived in Washington, D.C., with the balloon *Enterprise* in June 1861. Smithsonian Secretary Joseph Henry introduced Lowe to the Secretary of War and President Lincoln, and arranged for the aeronaut to make a tethered demonstration flight from the National Mall. Lowe carried a

telegrapher aloft with him, and sent a message to the White House describing the circle of military camps surrounding Washington, "nearly fifty miles in diameter." By the end of June, he was making tethered observation flights from advanced federal positions near Falls Church, Virginia.

After considerable bureaucratic foot-dragging requiring the intervention of the President, Lowe finally received permission to organize a "corps" of civilian balloonists to operate with various federal armies. The *Union*, the first of the new military balloons, went into service in August 1861. By the following spring, he commanded a total of seven new balloons. He had also designed and built a series of portable hydrogen generators, mounted on wagons, to keep his balloons inflated in the field, and had recruited a team of nine experienced aeronauts to pilot the balloons.

Workers at the Washington Navy Yard transformed a 122-foot coal barge into a floating aircraft carrier, the *George Washington Parke Custis*, that permitted Lowe to make observations up and down the tidal Potomac. He also dispatched a balloonist to operate with federal forces on the Mississippi River. The members of the balloon corps first saw real action during the fighting on the Virginia Peninsula in the spring of 1862. Lowe made significant contributions to the survival, if not the victory, of the Army of the Potomac at the Battle of Fair Oaks (fig. 37).

Unwilling to surrender the skies to the Yankees, Confederate officials sponsored several balloon projects of their own, none of which could match the scale, or even the limited success of the Union balloon corps. The first Confederate balloon, a primitive hot air model, entered service near Yorktown, Virginia in the spring of 1862. Observing the newcomer from his side of the lines on April 13, Lowe noted that the enemy craft had "neither shape nor buoyancy," and predicted that it would "burst or fall apart after a week."[19] A Confederate soldier who had a much closer view agreed. "It was made of cotton cloth inflated with pinewood smoke," J. T. Scharf, a Maryland artillery private, remarked. "It went up for a minute, and then came down much faster."[20]

Pressed into service as a self-trained aeronaut, Captain John R. Bryan operated this shaky aeronautical platform until early May. A new and much more colorful rebel balloon went into action a month later, during the fighting on the Virginia Peninsula. Dubbed "the silk dress balloon" by Confederate General James Longstreet, the envelope was constructed of multi-colored bolts of dress silk. Like Lowe's balloons, it was designed to be filled with lifting gas, either hydrogen or the illuminating gas that lit the streets and homes of nearby Richmond. The balloon had been in service only a few weeks when it was captured by Union forces on July 4.[21]

General Beauregard, commander of the Department of South Carolina and Georgia, commissioned yet another balloon from Charles Cevor, a well-known pre-war aeronaut. Completed in the fall of 1862, the operational career of the Cevor

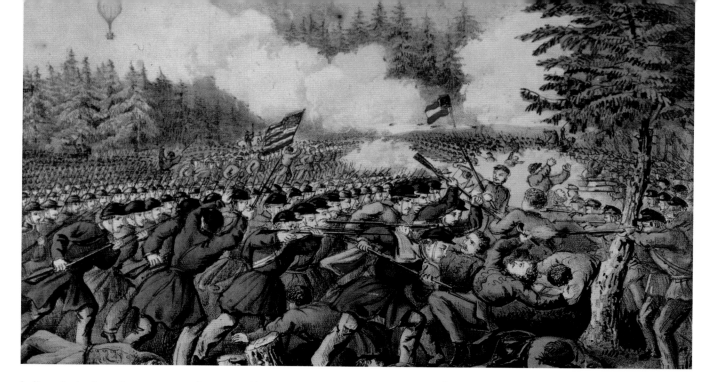

Fig. 37 The Battle of Fair Oaks, May 31, 1862. (NASM, Gift of Paul E. Garber)

balloon is shadowy. It was apparently captured by Union troops during the Siege of Charleston, South Carolina in 1863 and was shipped to Washington, D.C., where it was cut into small pieces that were distributed as souvenirs.

Lowe's status as a civilian contractor, and his need for considerable transport and logistical assistance, were serious problems. The balloon corps missed the Battle of Antietam in September 1862, but did see action at Fredericksburg that December and at Chancellorsville in early May 1863. Convinced that Army officials failed to appreciate his services, Lowe resigned shortly thereafter when his request for increased funding was refused. The Union balloons continued to be operated by members of Lowe's corps for some months more, but would never again see action.

Several factors contributed to the demise of the Civil War experiment with observation balloons. While Lowe and his balloonists had their enthusiastic supporters among high-ranking federal officers, it was never possible to fully integrate the aerial activities into the structure of the army. Communications were also a problem. Lowe and his men were supplying real-time battle field intelligence. Processing their raw information, and communicating it to officers in combat in a timely fashion, proved next to impossible.

European military leaders were more intrigued by Lowe's experiment than their American counterparts. Both sides made good use of observation balloons during

the Franco-Prussian War of 1870–71. The use of balloons to carry political leaders and messages over the Prussian lines and out of besieged Paris was one of the few operations in which the defeated French could take genuine pride (fig. 38).

It began on September 23, 1870, just four days after 150,000 German troops had closed a circle fifty miles in circumference around the French capital. Some of the most experienced French aeronauts were trapped inside, along with their balloons. Jules Durouf was the first to fly over the Prussian lines, his basket filled with outgoing mail and carrier pigeons that could fly microform messages back into Paris. One by one, the experienced aeronauts trapped in the city escaped by air. Many of them would continue to serve as observation balloonists with the French armies in the field. Once all of the trained balloonists had departed, city officials set seamstresses and tailors to work in the large open areas of the great train stations, cutting and sewing fabric into new balloons that would be flown out of Paris by soldiers and sailors who had been hastily trained to fly. During the four months of siege that preceded the French defeat, balloonists carried nine tons of mail and 163 people, including Minister of the Interior Léon Gambetta, over the Prussian lines to safety.

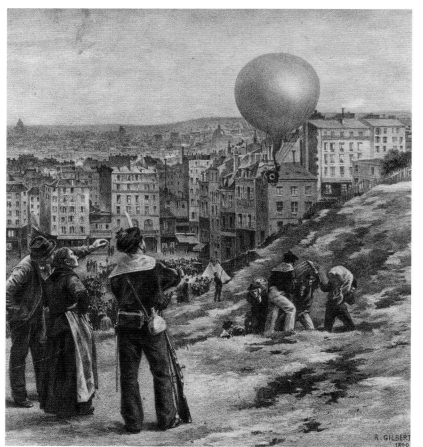

Fig. 38 A balloon leaves Paris during the Siege of 1870. (NASM, Gift of Harry F. Guggenheim)

The French army employed observation balloons in Southeast Asia and North Africa during the last two decades of the century; the British used them to good advantage during the South African campaigns. The U.S. Army Signal Corps reinstituted balloon experiments in the 1890s. General Adolphus Greeley, Chief of the Signal Corps, believed that an observation balloon would have been of great value in suppressing the Pullman Strike of 1894. "The fact that the war balloon is simply indispensable for observing and checkmating the operations of marauding bands within the limits of great cities," he remarked, "has not been recognized."[22]

Perhaps so, but the limited use of balloons during the campaign in Cuba in 1898 did little to bolster military confidence in aerial observations. The one balloon dispatched to the front became trapped in the trees on the morning of the attack on Kettle and San Juan Hills, drawing Spanish

artillery fire down on Lieutenant John Pershing and the African American troopers of the Tenth Cavalry. Observation balloons appeared above both sides of the lines during the Russo-Japanese War. Italian experiments in aerial bombing during the Tripoli campaign in 1911–12 violated an 1899 Hague Peace Conference ban on the "discharge of any … explosive from balloons."

While the use of observation balloons had not revolutionized warfare to the extent that Benjamin Franklin had predicted, military leaders refused to give up. British and French officials invested in permanent technical facilities to produce aeronautical equipment for their military forces. In the early years of the twentieth century, those "balloon factories"—Farnborough in Britain and Vincennes in France—emerged as world centers of aeronautical research and development. The much smaller balloon unit maintained by the U.S. Army Signal Corps into the early years of the twentieth century became the entry point for both the powered airship and the airplane into U.S. service.

The spherical balloons that had served as observation platforms since the wars of the French Revolution were unstable and uncomfortable for observers when tethered in the wind. The notion of a tethered kite balloon, with an elongated shape and fins at the rear to keep it pointed into the wind, was first suggested in 1844–45. The first such balloon, called a Drachen (German for kite), was designed and built by Major August von Parseval and Captain Rudolph Hans Bartsch Sigsfeld of the Prussian Balloon Detachment. The French countered with the ultimate kite balloon, developed by Lt. Albert Caquot and introduced in 1916. Other items of equipment, notably the powered winch systems employed to pull the balloons back to earth, appeared during the years leading up to World War I.

When World War I broke out in 1914, nations on both sides of the Western Front employed kite observation balloons tethered close behind the trenches, spotting targets for the artillery and keeping an eye on movement behind enemy lines. Much more stable than reconnaissance airplanes, they could produce high-quality aerial photographs. Germany alone produced some 1,870 balloons during the course of the war, and lost 655 to enemy action or the weather.

The kite balloons produced such valuable intelligence that they became preferred targets for enemy airmen. Medal of Honor winner Lt. Frank Luke was among those fighter pilots who earned special fame as "balloon busters." Dangling beneath their hydrogen-filled gas bags at altitudes of up to 6,000 feet, the intrepid observers were equipped with parachutes to avoid going down in flames when enemy fighter planes attacked. By 1918, it was clear that the airplane had brought the long history of manned observation balloons to an end.[23]

LES GÉANTS

JOHN WISE HAD DREAMED of flying the Atlantic since the beginning of his long aeronautical career. Undeterred by his failure to achieve that goal in 1859, the aging veteran announced in 1873 that he was planning to try again, accompanied by a newcomer, Washington Harrison Donaldson. A daredevil showman, Donaldson launched his theatrical career in 1857, displaying a range of talents as a tightrope walker, magician and ventriloquist. He crossed both the Schuylkill River and the Genesee Falls on tightropes and earned fame as the first performer to ride a velocipede across a high wire.

He added ballooning to his repertoire in 1871, performing on a trapeze bar dangling beneath a gas bag. Wherever the novice aeronaut traveled, newspapers reported a series of collisions with walls, chimneys, buildings and roofs, followed by precipitous landings in lakes, rivers, trees, and muddy fields. Wise and Donaldson planned to cross the ocean in a balloon measuring 130 feet tall and 100 feet in diameter containing 600,000 cubic feet of lifting gas. The two-man crew would be housed in a two-story gondola. A lifeboat suspended at the bottom of this extraordinary assemblage would contain enough equipment and supplies to sustain the crew for a month. The pair planned to climb two or three miles up into the high-speed air currents that would carry them to Europe in less than three days.

With testimonials from both the Smithsonian Institution and the Franklin Institute in hand, the two aeronauts enlisted the aid of J. H. and C. M. Goodsell, owners and publishers of the *Daily Graphic*, who agreed to fund the project, provided the balloon was named in honor of their newspaper. Wise soon withdrew, convinced that the Goodsell brothers were willing to risk anything, including his life, to milk the last ounce of publicity from the flight.

The huge balloon burst when first inflated in the fall of 1873. Donaldson salvaged enough of the envelope to create the *New Graphic*, exactly half the size of its predecessor. Accompanied by two volunteers from the *Daily Graphic* staff, he set out on October 6, 1873. Encountering heavy winds and rain, the trio wisely abandoned their craft before they reached the American coast.[24]

Donaldson returned to the life of an itinerant aerial showman, signing on with P. T. Barnum's "new moral show." On one occasion in 1874, he carried a young couple aloft for an aerial wedding in the basket of the *Barnum*. His luck finally ran out in July 1875, when he lost his life while attempting to fly across Lake Michigan. Ironically, seventy-one-year-old John Wise disappeared in September 1879, like his one-time partner, while attempting to cross Lake Michigan by air.

The *Daily Graphic* was only one of a series of giant balloons built and flown in Europe and America during the last half of the nineteenth century. The compulsion to venture aloft in ever-larger aerostats began in France in 1863, when Gaspard-Félix Tournachon launched *Le Géant*, which stood 196 feet tall. One of the most colorful and influential cultural figures of the age, Tournachon was universally known as Nadar, a nickname derived from the phrase "tourne à dard," or "bitter sting," a commentary on his trademark caricatures. A pioneering photographer, he suggested the use of balloons to make aerial photographic maps as early as 1858. Nadar suggested the idea, but the American photographer J. W. Black took the first aerial photo on April 18, 1861, when he ascended with Samuel Archer King over Boston.

A firm believer in the possibility of heavier-than-air flight, Nadar founded one of the world's first aeronautical societies in 1863, and built *Le Géant* to raise funds with which to pursue his research. A two-story wicker cottage, complete with two cabins, a bathroom, printing press and photographic dark room, served as the gondola. Assisted by the aeronaut brothers Jules and Louis Godard, Nadar welcomed twelve passengers aboard for the inaugural flight on October 4, 1863, which came to a disappointing end after a journey of only fifteen miles.

Just two weeks later, the Godards, Nadar, his wife, and five passengers lifted off to the applause of a crowd of perhaps 500,000 spectators, including Emperor Napoleon III and his guest, the King of Greece. Returning to earth in Germany the next morning, the giant balloon was caught in the wind and carried the screaming passengers bumping across the landscape, through trees and fences, finally coming to rest just in time to avoid a collision with a locomotive. One of the most spectacular crash landings in the history of ballooning, the flight ended with broken bones, but no fatalities.

Engineer Henri Giffard went one better on Nadar in 1867, introducing a balloon large enough to carry twenty people up to the end of a 1,000-foot tether. Eleven years later, Giffard constructed *Le Grand Ballon Captif*. Standing taller than the Arc de Triomphe, it carried fifty-two passengers on a dizzying ascent up to the end of a 2,000-foot tether. By the end of the 1878 Paris Universal Exposition, 35,000 people had made the trip. The opportunity to venture aloft aboard more modest captive balloons would remain a crowd-pleasing attraction at amusement parks like Copenhagen's Tivoli Gardens for many years to come.

For a time, at least, the dream of crossing the Atlantic beneath a gigantic balloon was replaced by the notion of flying to extreme altitudes and traveling to the most remote locations on earth. Commander John P. Cheyne, RN, suggested the use of special balloons to search for the Sir John Franklin expedition, which disappeared in the Arctic in 1845. Gaston Tissandier—chemist, founder of the scientific journal *La Nature*, and the great French aeronautical hero of the late nineteenth century—tried

and failed to finance an Arctic expedition by selling tickets to witness the inflation and launch of his giant balloon *Le Pôle Nord* (1869).

The first serious balloon expedition aimed at the North Pole set off on July 11, 1897, when Swedish scientist Salomon August Andrée lifted off from the Norwegian island of Spitsbergen with two young companions, Knut Fraenkel and Nils Strindberg, aboard the balloon *Örnen* ("The Eagle"). The craft contained 170,000 cubic feet of hydrogen, and was constructed of three layers of silk in order to withstand strong winds and the possibility of icing. The closed wicker gondola was five feet deep, with plenty of room for survival gear. Andrée hoped that a sail would enable him to steer his craft to some extent. He had also ordered 3,300 feet of heavy drag line in three sections that could be screwed together.

Immediately after lift-off, *Örnen* dipped into the icy water and did not begin to rise until the crewmen pitched 450 pounds of supplies overboard. One third of the drag line was accidentally lost before the balloon vanished into the Northern mist. For decades, their fate was one of the great mysteries of the Arctic.

The mystery was solved on August 6, 1930, when the crew of a Norwegian sloop put ashore on White Island, a remote spot in the Arctic Ocean, in search of fresh water. Instead, they found the remains of Andrée and his companions, together with diaries and undeveloped photos that chronicled the tragic fate of the expedition. They had covered perhaps a third of the distance to the Pole in two and one-half days before they were forced down on the ice almost 200 miles from the nearest land. They reached tiny White Island after struggling across the ice for almost three months. Within a few weeks, they were dead, perhaps as a result of food poisoning.[25]

THE END OF AN ERA

DURING THE YEARS FOLLOWING the American Civil War, balloonists like Carl Myers, of Frankfort, New York, and his wife, Mary, who flew under the name "Carlotta," continued the antebellum tradition of the itinerant balloonist. For the most part, however, Americans were no longer willing to pay to watch an aeronaut inflate his craft and immediately fly out of sight. In their determination to provide ever more thrilling stunts, aerial performers turned to the most primitive variety of hot air balloon. Known as "smokies", they were simply large fabric bags filled with superheated air from a drafted heat source on the ground. With the balloon tugging at its tethers, a trapeze bar was attached to the bag and an acrobat, often a woman clad in tights, would be pulled up into the air to twist and twirl while the balloon cooled and dropped back toward the ground.[26]

As one might suppose, the casualty rate among these aerial acrobats was staggering. During the last quarter of the nineteenth century, American newspapers were filled with stories such as that of "Professor" Wilbur, who fell from a height of several hundred feet during a performance in Orange County, Indiana, on July 4, 1876. One observer noted that the body stuck the ground and bounced before finally coming to rest as "a mass of human jelly."[27]

These performances became even more dangerous when "Captain" Thomas Scott Baldwin reintroduced the parachute jump to the repertoire of aerial tricks. A native of Illinois, born in 1858, Baldwin began his career as a circus acrobat, gymnast and high-wire performer. An encounter with Ohioan Park Van Tassel in 1885 led to his taking up ballooning. Van Tassel was making a living giving traditional balloon ascents in smaller cities and towns in the far west where a simple balloon launch could still attract a crowd. That business strategy earned Van Tassel the distinction of making the first flights in Colorado, Utah, and New Mexico.

By the late 1880s, Van Tassel was looking for a new gimmick. When he met young Tom Baldwin in San Francisco the pair came up with an imaginative way to merge their talents. Parachuting, which had been so popular during the early history of ballooning, had disappeared following the death of Robert Cocking. On January 30, 1887, Tom Baldwin climbed to 1,000 feet over Golden Gate Park in one of Van Tassel's balloons, and parachuted safely to earth. When the pair parted company, Van Tassel established a new troop of aerial acrobats and continued touring the west before sailing to Hawaii.

With seven jumps to his credit, Tom Baldwin traveled to England in 1888, where he performed before Edward, the Prince of Wales, and the future Queen Mary. Baldwin stole the spotlight from other aerial performers active in Great Britain. There were those, however, who thought that he had gone too far. A letter to the London *Times* suggested that he be stopped "before he pays the penalty for daring." While the House of Lords considered banning parachute drops, Colonel J. L. B. Templer, head of the Army Balloon Factory at Farnborough, ordered three of Baldwin's parachutes for testing.

Baldwin's success drew others into the field, notably the English balloonists Percival, Arthur, and Stanley Spencer. In 1890, the brothers set off on a tour of the Far East, flying—and parachuting—in India, Southeast Asia, China and Japan (fig. 39). Tom Baldwin arrived in Japan in November 1890, accompanied by his brother Sam and an assistant, William Ivy, who would strike out on his own under the stage name, Ivy Baldwin. While the Spencers had already flown here, Tom Baldwin attracted record crowds to Tokyo's Ueno Park.

In the first decade of the twentieth century, Tom Baldwin would turn his attention to the development of powered flying machines. He trained younger aerial performers, including A. Roy Knabenshue and Lincoln Beachey, to operate primitive

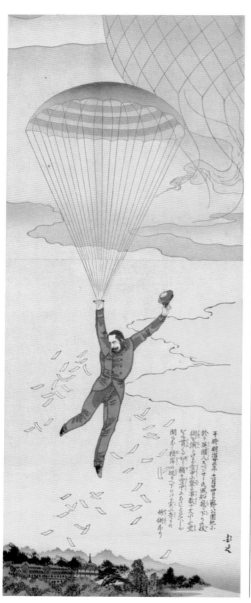

Fig. 39 Percival Spencer returns to earth via parachute following an ascent from Tokyo's Ueno Park, November 24, 1890. (NASM, Gift of the Estate of Constance Morss Fiske in memory of Gardiner H. Fiske)

one-man airships; produced the SC-1, the first powered flying machine in the U.S. Army inventory; and played a role in the early history of the airplane. Performers like "The Flying Allens," Captain Eddie Allen and his family, kept the tradition of balloon showmanship alive into the 1950s, performing at county fairs, stock car races and similar events in the American heartland. For the most part, however, the era of the itinerant balloonists came to an end with the dawn of a new century.

THE SPORT OF KINGS

B Y THE END OF THE NINETEENTH CENTURY, the free balloon was attracting an entirely new class of enthusiasts on two continents. Founded in 1898, the Aéro Club de France became a favorite gathering place for one of the wealthiest and most fashionable social circles in fin-de-siècle Paris. Ballooning, for over a century the preserve of aerial showmen, soldiers, and adventurers, now became a sport appealing to wealthy dilettantes. A short voyage aloft, dangling beneath a colorfully decorated bag of hydrogen, proved just the ticket for a jaded young man with money in his pocket and a taste for adventure.

A taste for ballooning quickly spread across the Atlantic to wealthy Americans. In the summer of 1905, a number of "perfect specimens of American humanity" banded together to organize the Aero Club of America. Their goal, Courtland Field Bishop, an early leader of the club, explained, was "the popularization of ballooning, as a sport, especially among the leisure and more wealthy class."[28]

The organization acquired two club balloons, and the services of A. Leo Stevens, an experienced professional aeronaut, who taught them to fly. Aero clubs quickly sprouted across the northeast. By January 1909, there were seven clubs in New England alone, with 400 members. As early as 1908 clubs had sprouted in St. Louis; Indianapolis; Canton, Ohio; Chicago, Milwaukee, Denver, Baltimore and San Francisco. The following year Michigan, Utah, Nebraska, Cleveland, Jacksonville, Atlantic City, Memphis, Washington, D.C., and Buffalo each acquired an aero club. Students at Columbia, Amherst, Harvard, Cornell, Notre Dame, and the University of Pennsylvania organized balloon clubs.

Competition was the lifeblood of sport ballooning. Races and tests of pilot skill brought the members of various clubs together. The era of international competition began in 1906, when James Gordon Bennett, a New York press baron who stood out even in an age dominated by eccentric entrepreneurs, donated an ornate silver trophy to the Fédération Aéronautique International (FAI), organized just a year before to validate international records and oversee competitions.

The rules governing the Gordon Bennett race could not have been simpler. The race was for balloons from 22,000 to 80,000 cubic feet. Any FAI member nation could enter a team. The cup went to the team that traveled the farthest from the take-off point. The nation that won a race had temporary possession of the cup, and the honor of hosting the next competition. A nation that won three successive races earned permanent possession of the cup. The original trophy went to Belgium in 1924, and the second to the U.S. in 1927. The third cup remained in use until the end of the competition.

An American team, Lt. Frank Purdy Lahm of the U.S. Army and a friend, Henry Hersey, won the first competition with a flight of 402 miles on September 30, 1906. Between 1906 and 1939 the race would be held twenty-six times in six different nations. The U.S. won ten of those contests, Belgium seven, Poland four, Germany and Switzerland two each and France one. A total of 351 aeronauts participated over the years. The record holder was the Belgium Ernest Demuyter, who participated in eighteen competitions.

The Gordon Bennett races kept the spirit and excitement of sport ballooning alive in the age of the airplane. Once a year, gas balloons recaptured headlines around the world as aeronauts wafted across two continents, overcoming enormous obstacles in their pursuit of national honor and the pleasure of pure sport in the air.

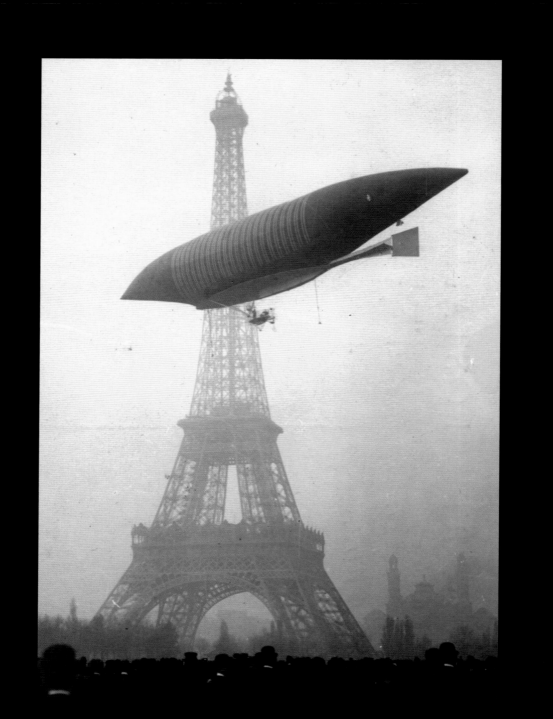

NAVIGATING THE AIR

THE EARLY HISTORY OF THE DIRIGIBLE AIRSHIP, FROM THE
18TH-CENTURY DREAM, THROUGH THE EXPERIMENTS OF THE
19TH CENTURY, TO THE BIRTH OF THE RIGID AIRSHIP
IN THE EARLY 20TH CENTURY

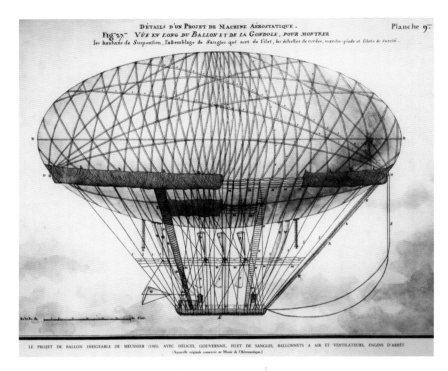

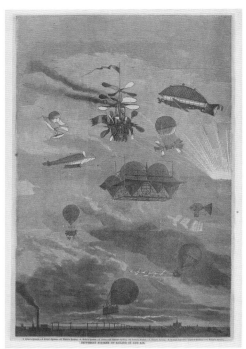

Fig. 40 Jean-Baptiste-Marie Meusnier's airship. (NASM, 86-14852)

Fig. 41 18th-century dreams of aerial navigation. (NASM, Gift of the Estate of Constance Morss Fiske in memory of Gardiner H. Fiske)

THE PRECURSORS

F ROM THE OUTSET, people dreamed of navigating the air, traveling through the sky, over mountains and oceans, to a safe landing at a chosen destination. The acerbic pundit Samuel Johnson summed the matter up in 1784, noting that balloons "can serve no use till we can guide them."[1]

The first generation of aeronauts attempted unsuccessfully to row, sail or paddle across the sky. It remained for Jean-Baptiste-Marie Meusnier, a young lieutenant of engineers, and one of the best mathematical minds of the age, to give the first serious thought to the design of a navigable balloon.

Meusnier and the aging mathematician Leonhard Euler used careful observations of the ascent of balloons to develop a mathematical model verifying the laws of motion. The Corps of Engineers granted Meusnier a year's leave to continue his aeronautical studies with the savants of the French Academy of Sciences, to which he was soon elected. An extended paper, presented to the Academy on November 13, 1784,

included an analysis of balloon design, information on the motion of balloons, and a study of the stresses encountered in flight.

Lt. Meusnier then applied the lessons learned to produce the first rational design for a powered airship. He proposed beginning with an experimental six-man craft, capable of cruising over Europe, demonstrating the effectiveness of his stability calculations and the methods of propulsion and control. He would then move on to the construction of an airship housing thirty crewmen who would operate a crankshaft turning the single-bladed helical propellers.

The airships would feature a streamlined, ellipsoid envelope 260 feet long and 130 feet across. Meusnier was the first to recognize the need for a ballonet, a large bladder inside the envelope that could be filled or emptied of air to maintain a constant pressure inside the gas bag. The gondola would double as a boat in the event the craft was forced down over water (fig. 40).

J.-B.-M. Meusnier deserves to be recognized as the first aeronautical engineer. He combined the best contemporary engineering methods and analytical tools with a brilliant design sense. He calculated the lift, resistance, and stability of his craft, as well as the force required to propel it to a maximum speed of four kilometers per hour (2.5 mph). While the young engineer realized that without an improved propulsion system his aerial craft would remain only lines on paper, his insistence on careful design methods, as well as his introduction of such landmark ideas as the ballonet and the propeller, pointed to the future.

During the decades that followed, there was no shortage of plans for aerial navigation (figs. 41 and 42). Propulsion was the great problem. Many experimenters persisted in experimenting with muscle-powered airships. As late as 1872, the marine engineer Henri Dupuy de Lôme built a ballonet-equipped, egg-shaped balloon featuring a propeller powered by a crew of eight men operating hand-cranks! Mark Quinlan achieved a top speed of 3.5 miles per hour in 1878, flying a small, one-man, peddle-powered airship designed by Bridgeport, Connecticut, resident Charles F. Ritchel (see fig. 50). Beginning in the early 1880s,

Fig. 42 A stoneware jar decorated with a fanciful portrait of the "aerostatic locomotive" produced by the French aeronaut Ernerst Pétin in 1850–51. The decoration is probably by the French aeronaut/artist Albert Tissandier. (NASM, Gift of William A. M. Burden)

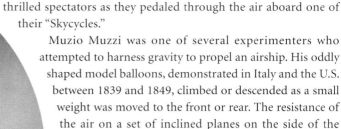

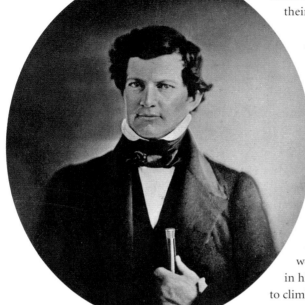

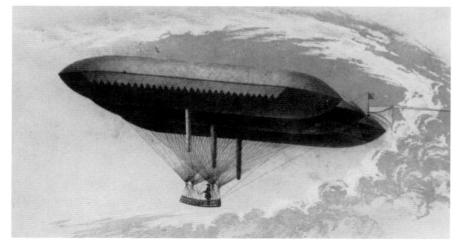

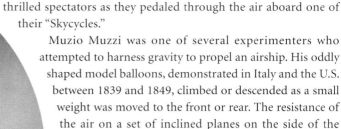
New Yorker Carl Myers and his wife "Carlotta" (Mary Hawley Myers) thrilled spectators as they pedaled through the air aboard one of their "Skycycles."

Muzio Muzzi was one of several experimenters who attempted to harness gravity to propel an airship. His oddly shaped model balloons, demonstrated in Italy and the U.S. between 1839 and 1849, climbed or descended as a small weight was moved to the front or rear. The resistance of the air on a set of inclined planes on the side of the model forced it to move forward as it ascended and descended.[2]

Solomon Andrews, the Mayor of Perth Amboy, New Jersey, based his *Aereon* airship on the same principle (fig. 43). The craft featured three "segar-shaped" gas bags, each eighty feet long and thirteen feet in diameter, tied together side-by-side to form an inclined plane, with a car for the operator slung underneath (fig. 44). Andrews would allow the craft to balloon up to altitude, walk forward in his car to nose the *Aereon* down, then walk to the rear again to climb. He made three flights with his craft from Perth Amboy in the summer of 1862, impressing the crowd with his ability to move forward through the air.

Demonstrations with a model of the craft conducted in the basement of the U.S. Capitol and the great hall of the Smithsonian Institution failed to attract government support. War Department officials apparently recognized that they were being offered a sort of aeronautical perpetual motion machine that would soon exhaust both the lifting gas and the ballast.[3]

In the 1840s and 1850s, a number of promoters, including Rufus Porter, the American folk artist and founder of the *Scientific American*, demonstrated scale-model airships to attract investors who would fund construction of a full-scale craft. Another experimenter, Pierre Jullien, flew his model at the Paris Hippodrome in 1850. Measuring twenty-three feet long, it

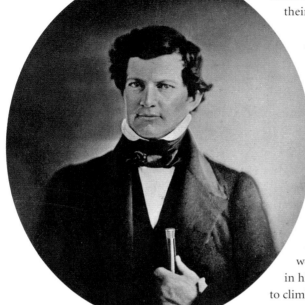
Fig. 43 Solomon Andrews (1806–1872). (NASM, 2003-35052)

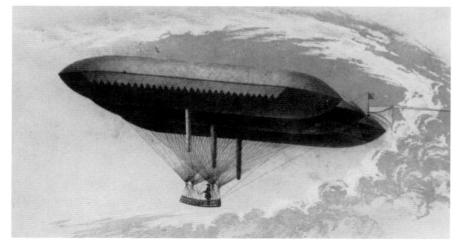
Fig. 44 Solomon Andrews's *Aereon* of 1860. (NASM, SI 90-6529)

was powered by a clockwork mechanism driving twin propellers.

Impressed by Jullien's demonstration, engineer Jules-Henri Giffard built a full-scale version measuring 144 feet from one sharply pointed end to the other. The aeronaut, dangling forty feet below the hydrogen-filled envelope, shared quarters with 500 pounds of coke to feed a 350 pound steam engine and boiler combination that generated all of 3 horsepower. If all went well, a large propeller would move the craft forward at 6 mph in calm air, a bit slower than a horse-drawn coach (fig. 45).

On September 24, 1852, Giffard, dressed in a top hat and frock coat, guided his dirigible up and away from the large crowd gathered at the Paris Hippodrome and flew seventeen miles to the village of Trappe. On a second flight he turned a complete circle in the air. When he attempted to fly an even larger craft without a ballonet, the envelope began to bend in the middle, escaped the netting and was destroyed. Fortunately, Giffard and his passenger, Gabriel Yon, escaped with minor injuries.

In 1881, the Tissandier brothers, Gaston and Albert, leaders of French aeronautics in the last quarter of the nineteenth century, succeeded in matching Giffard's top speed with a ninety-two-foot-long, battery-powered, propeller-driven airship. This limited success encouraged the efforts of two officers of the French Army Corps of Engineers, Charles Renard and Arthur Krebs.

The performance of the aeronauts during the Franco-Prussian War of 1870 was one of the few military activities in which the French government could take pride. As a result, officials of the Third Republic supported the disappointing efforts of Henri Dupuy de Lôme, and, in 1877, approved the creation of one of the world's first government-funded aeronautical research facilities, with Charles Renard in charge, on the grounds of the observatory at Chalais-Meudon. There were limits, however. When the Ministry rejected Renard's request for additional funding to support an airship construction program, Léon Gambetta, a Republican politician who had escaped from besieged Paris in a balloon, provided 40,000 francs from his own pocket.

The finished product, *La France*, offered a glimpse of what a practical airship might be like. The envelope was 165 feet long, with a maximum diameter of 27 feet.

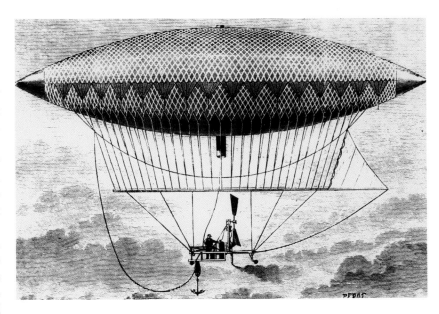

Fig. 45 Henri Giffard's steam-powered airship of 1852. (NASM, SI 73-5535)

A 106-foot-long bamboo frame slung beneath the gas bag housed the operator, batteries and an 8½ horsepower electric motor that would move the craft through the air at almost fifteen miles per hour. The airship featured a large four-bladed propeller at the nose, a rudder at the rear, a ballonet and a weight that could be moved fore and aft along a line to nose *La France* up or down. First flown on August 9, 1884, *La France* made seven flights during 1884 and 1885. On five of those occasions, the winds were light enough to allow the airship to return to the take-off point.

A superior power plant that would open the door to the future was at hand. German engineer Paul Hänlein was the first to fit an internal combustion engine, a Lenoir two-stroke model, to an airship. Tested in 1872, his craft proved too heavy to fly. A countryman, Karl Wölfert, employed a Daimler four-stroke engine to propel his 100-foot-long airship. After twelve years of experimentation, and with the support of the Kaiser, Wölfert finally tested his craft with the full cooperation of the Prussian Army Balloon Corps. Climbing away from Berlin's Tempelhof Field on the evening of June 12, 1897, an open flame issuing from the engine ignited escaping hydrogen. The airship was 3,000 feet in the air when it caught fire. Wölfert and his companion, mechanic Robert Knabe, lost their lives in the disaster.

On November 7, 1897, another airship rose from Tempelhof, and a very strange looking craft it was. The David Schwarz airship looked like a wrinkled tin can with a funnel on the nose to provide at least a suggestion of streamlining (fig. 46). Schwarz, an Austrian, worked in a pioneering aluminum factory and became fascinated by the potential of the metal.

The Danish physicist Hans Christian Oersted had first isolated metallic aluminum in 1825, but it was not until 1886 that the American Charles Martin Hall and the French experimenter Paul Héroult simultaneously developed a practical means of producing the metal in commercial quantities. While Schwarz was not aware of it, the American poet and critic Edmund Clarence Stedman suggested aluminum as a construction material for airships as early as 1879.[4] The Russian K. E. Tsiolkovsky proposed a metal-clad airship in 1885 and conducted wind-tunnel studies of his design in 1891.

All of the navigable balloons flown to date were "pressure airships," in which the internal pressure of the lifting gas maintains the shape of the envelope. When the gas is removed, the envelope is simply an empty fabric bag. David Schwarz envisioned a "rigid airship," a craft with an internal framework that held the envelope in place. The lifting gas was contained in separate fabric cells inside the framework. The internal frames of most later rigid airships were covered with fabric. Schwarz proposed to cover the wire-braced tubular aluminum girder and

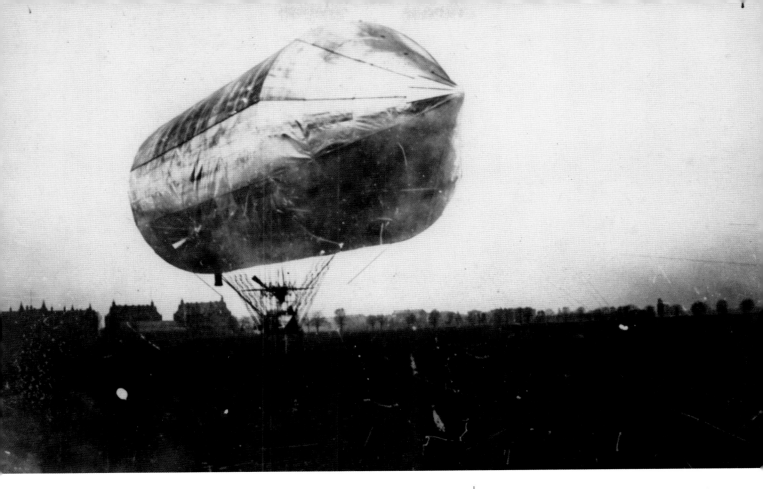

lattice frame of his airship with sheet aluminum only one-fifth of a millimeter (.008 inch) thick.

In 1892, with a contract in hand from the Russian government, Schwarz ordered the material for his first airship from Carl Berg, a German industrialist who pioneered the production of aluminum and aluminum alloys. Completed in 1893, the hull of the craft collapsed before it could be flown. Schwarz then submitted his design to a German government aeronautical commission, the members of which selected his plan over that of a competitor, Count Ferdinand von Zeppelin.

Work began at the government balloon shed at Berlin Tempelhof in 1895 and continued after the death of David Schwarz early in 1897. When the craft finally took to the air that fall, the 12 hp Daimler motor was unable to provide any headway against the gusty wind. The craft flew some four miles, rising to an

Fig. 47 Graf Ferdinand von Zeppelin
(July 8, 1838–March 8, 1917). (NASM, 90-3800)

altitude of over 800 feet before being destroyed in a hard landing from which the test pilot Ernst Jägels was lucky to escape with his life.[5]

THE COUNT

B Y THE END OF the nineteenth century, a number of airships had demonstrated a marginal ability to navigate the air in a dead calm. Internal combustion engines were growing ever more powerful and dependable. Lightweight aluminum held great promise for airship construction, but a more suitable alloy than Schwarz had employed would be required. The German metallurgist Alfred Wilm patented just such a material in 1909, an aluminum-copper-manganese alloy that led to Duralumin, five times stronger than pure aluminum for the same weight.

Graf von Zeppelin was the man who would combine the existing elements with a magnificent engineering vision to finally achieve the old dream of a practical dirigible airship. Undaunted by the problems that had frustrated others, he realized that the answer required the courage to think big. "If airships are to be of any real use for military purposes," he explained to the King of Württemberg in 1887, they must "be able to navigate against very strong currents [and] … remain in the air without landing for at least twenty-four hours, so that they can perform really long reconnoitering tours. [They] … must also carry a heavy weight of men, supplies and ammunition … In other words: *large* airships will be needed."[6]

Ferdinand Adolf August Heinrich, Graf von Zeppelin was a native of Konstanz, Baden, born on July 8, 1838 (fig. 47). An officer in the army of Württemberg, a small kingdom allied to Prussia, he traveled to the U.S. as an observer with the Union cavalry during the Civil War. In the summer of 1863, at the conclusion of his service,

he embarked on a tour of America. Arriving in St. Paul, Minnesota, he encountered John Steiner, a veteran of T. S. C. Lowe's Union balloon corps who had returned to the life of an itinerant aeronaut. Steiner treated the young officer to his first foray aloft, and regaled him with his plans for a new type of observation balloon, a long, thin shape with a large rudder at the rear to keep it pointed into the wind. Such a craft, Zeppelin suggested, "will reach its destination more smoothly and more surely."[7] Many years later he explained that it was while he was flying with John Steiner that "my first idea of aerial navigation [was] strongly impressed upon me and it was there that the first idea of my Zeppelin came to me."[8]

But the Zeppelin airship lay at the other end of a long and distinguished military career that included service in both the Austro-Prussian (1866) and the Franco-Prussian (1870–71) Wars. He had expressed a serious interest in airships as early as 1873, as a result of a pamphlet by German Postmaster General Heinrich von Stephan outlining plans for an airship postal service. More important, reports of the 1884 flights of *La France* convinced him of the real need for a German dirigible to counter the French craft.[9]

He announced his project in 1887, petitioning for the support of King Karl of Württemberg. Not until 1895, however, after enlisting the help of engineer Theodor Kober, an employee of an Augsburg balloon manufacturer, did the Count patent the design for an aerial train, made up of several elongated rigid airship sections linked together like railroad cars. While the official German commission rejected Zeppelin's design in favor of the Schwarz airship, the Count was able to enlist the assistance of the most talented member of the commission, Professor Georg Müller-Breslau, in the redesign of his airship.

A brilliant engineer, Müller-Breslau worked with Zeppelin and Kober to transform their unmanageable balloon-train into the classic pattern of a rigid airship. Long, thin aluminum beams running the length of the craft would link a series of internally braced transverse rings into a rigid skeleton. Separate gas bags would be suspended inside the framework, which would be covered with doped fabric. Gondolas slung beneath the envelope would house the crew, passengers, and engines. Müller-Breslau proposed one of the most brilliant structural designs in the history of aviation, a configuration enabling Zeppelin to construct a craft that was large enough to carry heavy loads over great distances at a time when airplanes were little more than frail, powered kites.

Zeppelin and Kober pushed ahead with detailed design work. The Kaiser offered the Count a small grant in 1895. While not yet willing to invest, both Carl Berg and the Daimler company expressed interest in the effort. The Union of German Engineers gave the scheme their stamp of approval in 1896. Zeppelin received a basic patent on December 27, 1897, established a joint stock company to build and operate

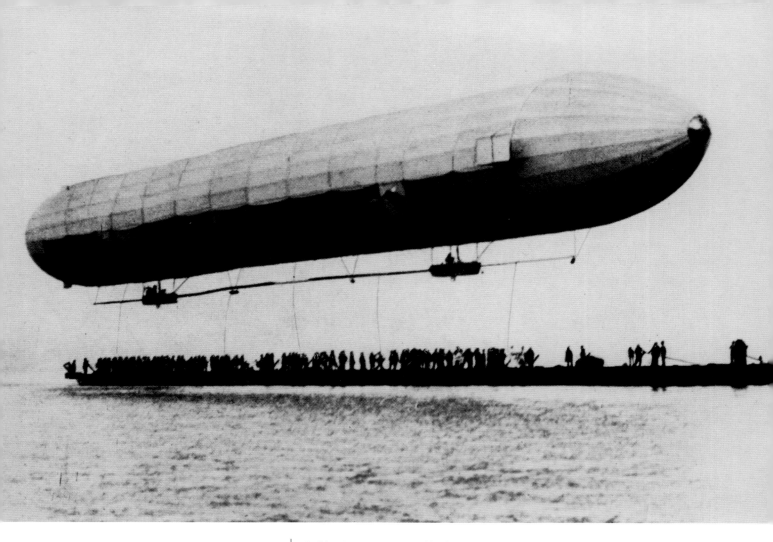

Fig. 48 Zeppelin LZ 1 is tethered to the barge that extracts it from the floating hangar, Lake Constance, Germany, July 2, 1900. (NASM, 74-3791)

airships in May 1898, and built a construction facility at Manzell, near his birthplace on Lake Constance. Bordered by Germany, Austria and Switzerland, the Bodensee, as it is also known, is forty miles long and eight and one-half miles wide. The company established on these shores at the end of the nineteenth century would write history in the sky during the decades to follow.

Kober hired twenty-one-year-old Ludwig Dürr in 1899 to perform the all-important stress analysis on the structure. Carl Berg provided engineering assistance and manufactured the aluminum frame. Actual construction of what would become the Luftschiff Zeppelin 1 (LZ 1) began in April of that year under the supervision of yet another engineer, Hugo Kübler.

Recognizing that a craft as large as his would be very difficult to launch in a wind, Zeppelin constructed an enormous floating shed on the Bodensee. When not in operation, the airship would be completely protected from the wind and elements. For take-off and landing, the shed could be turned into the wind, so that the craft could be backed in or out by small boats in the safest possible way (fig. 48).

Measuring 420 feet long and 38.2 feet in diameter, LZ 1 was the largest thing that had ever been built to fly—literally a ship of the sky. The seventeen gas cells tucked inside the frame contained almost 400,000 cubic feet of hydrogen that had been shipped from England in 2,200 cylinders. A system of shafts, universal joints and gears transmitted power from a pair of 16 hp Daimler engines (one in each of the two gondolas) to the four propellers extending out from the hull on brackets. The small rudders mounted on each side of the fuselage, fore and aft, were intended to provide yaw control. The pilot could move a weight back and forth along a long line to nose the airship up and down.

Twelve thousand citizens of three nations gathered on the banks of the Bodensee on the evening of July 2, 1900. The handling crew backed the LZ 1 out of its hangar as the Count, two friends, and a pair of mechanics—one for each of the gondolas—were rowed out to the airship, resting on a large float. The first Zeppelin took to the air shortly after 8 p.m. with the Count at the controls. LZ 1 covered three and one-half miles in eighteen minutes, barely making it back to the shed. Renard and Krebs had made better time with about the same degree of control in *La France*, fifteen years before.

Zeppelin took to the air twice on October 7, and again on October 10, with the King and Queen of Württemberg in attendance. While he pushed his top speed from the 8 mph of the July flight to 17 mph, LZ 1 proved structurally weak and difficult to control. The official observers reported that the airship was unsuited for either military or civilian use. Having sent a leading reporter to witness the first disappointing trial, the *Frankfurter Zeitung* assigned a part-time local stringer, Dr. Hugo Eckener, to attend the October trials. A thirty-two-year-old journalist, Eckener was intrigued, but reported that the airship was incapable of traveling any distance or operating under control in a wind.[10]

Zeppelin's hopes of government support were dashed. Given her poor performance and damage to her structure, LZ 1 would never fly again. He had her broken up and sold for scrap, along with the engines, equipment and all of the company buildings. He dissolved the company, and sold his carriage and household items to clear his debts. The Count retained the services of Ludwig Dürr, however, whom he had promoted to chief engineer when Kober refused to fly on the uninsured LZ 1. A fund-raising campaign intended to pay for a new airship failed to produce substantial revenue. With the passage of time, most men would have given up the dream. The Count was not most men.

LA BELLE FRANCE

Fig. 49 Caricature of Alberto Santos-Dumont aboard his airship *No. 6*. (NASM, Gift of the Estate of Constance Morss Fiske in memory of Gardiner H. Fiske)

AT 2:42 ON THE AFTERNOON OF OCTOBER 19, 1901, Alberto Santos-Dumont, a twenty-eight-year-old Brazilian living in Paris, guided a one-man airship, *No. 6*, up and away from a red and white striped circus tent pitched on the Aéro Club de France grounds at Saint-Cloud and set out for the Eiffel Tower, eleven kilometers away in the center of Paris. The son of a wealthy coffee planter, he had come to Paris in 1897 to study, and immediately fell in love with ballooning. Less than a year later, he was chugging across the city skyline in his first airship (fig. 49).

Le Petit Santos stood just over five feet tall, usually weighed around 110 pounds, and invariably dressed in a dark suit, bright white shirt with a high stiff collar, soft hat, and shiny boots. Legends swirled around him, including the story that Baron Cartier, the famed jeweler, noting that Santos had trouble extracting his watch from his pocket while in the air, provided him with the first wristwatch. Parisians were thrilled to catch sight of him flying low overhead along the boulevards. On at least one occasion, he descended from the sky, tied his aerial steed to a convenient railing near his favorite café, and ordered an aperitif.

Count Zeppelin, and Santos' French predecessors, sought to develop large flying machines with military and commercial utility. The young Brazilian simply wanted to share the thrill of flight with ordinary folk. His goal was to develop relatively small, lightly powered airships designed to carry a single pilot into the air.

The flight to the Eiffel Tower and back in just over half an hour earned Santos-Dumont a 100,000 franc prize. The announcement that he would split the award between his mechanics and the poor people of Paris captured the public imagination and established him as a figure epitomizing the *Belle Époque* in the City of Lights.

While Santos did not succeed in putting an airship in every garage, he did launch a short-lived gas bag era in the U.S. during which exhibition balloonists traveled the nation thrilling spectators with flights of one-man airships from fairgrounds and race tracks. A. Roy Knabenshue, T. S. Baldwin, Leo Stevens, Lincoln Beachey, Charles K. Hamilton and other pioneer airplane pilots cut their teeth on the small airships.[11]

Having constructed thirteen little craft between 1897 and 1906, Santos-Dumont began to lose interest in buoyant flight, remarking that trying to propel an airship against the wind was something like trying to push a candle through a brick wall. Inspired by what he understood of

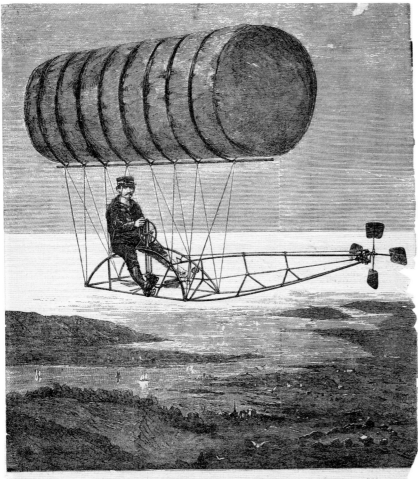

Fig. 50 Mark Quinlan aboard the one-man dirigible designed by Charles Francis Ritchel, at Hartford, Connecticut, June 1878. (NASM, Gift of Harry F. Guggenheim)

MACHINE AÉROSTATIQUE DIRIGEABLE
Expérimentée en Amérique, à Hartford, dans le Connecticut.

the Wright brothers, he turned his attention to experiments with heavier-than-air flight. Santos-Dumont made several short hops with his *No. 14* biplane in the fall of 1906—the first public flights of a winged aircraft in Europe—then moved on to build and fly the tiny *Demoiselle* monoplane, the winged equivalent of his one-man airships.[12]

The Germans scarcely raised an eyebrow over the aerial runabouts of Alberto Santos-Dumont. The work of Paul and Pierre Lebaudy, two sugar refiners from Mantes, was quite another matter. On November 13, 1902, Georges Juchmès made

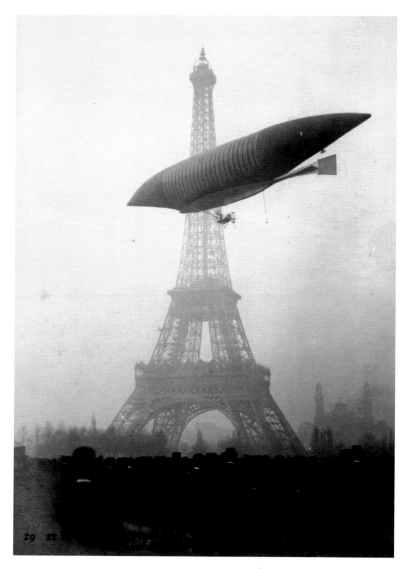

the first flight in an airship designed by Henri Julliot for the Lebaudy brothers. Measuring 173 feet long, *Le Jaune* was named for the calico envelope, sealed with a coat of yellow lead chromate. It featured a rigid keel that helped to distribute the weight of the gondola and engine car, and to which the control surfaces were attached. This type was soon identified as a semi-rigid airship.

Powered by a 40 hp Daimler engine, *Le Jaune* covered the thirty-two and one-half miles to Paris in an hour and forty minutes. With an average speed of 25 mph, *Le Jaune* could operate in at least a moderate wind, and deserves to be recognized as the first practical airship (fig. 51).

The French government bought the first Lebaudy airship, which remained in service until 1909, the first successful powered flying machine in the arsenal of any of the world's governments. By 1914, twelve Lebaudy airships were serving with the French, Russian, and British armies. A balloon manufacturing firm, the Société Astra des Constructions Aéronautiques, entered the airship business with a contract to rebuild *Le Jaune* for the French military.

Astra built perhaps a dozen airships of its own (fig. 52) before acquiring an envelope designed by the Spanish engineer Torres Quevedo, after which the products of the firm were known as Astra-Torres airships. A vertical cross-section through the envelope of an Astra-Torres craft revealed a distinctive trefoil shape. Production continued into the years after World War I with airships for the French Navy. The design was also employed in airships built for the British coastal patrol.

Beginning in 1912, the French State Airship Factory at the Chalais-Meudon research facility produced eleven airships for the Army and Navy. Maison Clément Bayard built eight airships, while the Zodiac firm produced a large number of what can best be described as motorized kite balloons for both military and commercial applications from 1909 into the early 1930s. Clearly the land of the Montgolfier was determined to retain world leadership in the air.

Fig. 51 The Lebaudy airship *Le Jaune* flies near the Eiffel Tower, 11:15 a.m., November 20, 1903. (NASM, SI 96-16166)

Fig. 52 A French Astra airship in flight. (NASM)

ZEPPELIN!

FRENCH RESURGENCE IN THE AIR forced the German government to reconsider its lack of enthusiasm for aeronautics. In 1904, King Karl of Württemberg approved a state lottery to support the construction of a new Zeppelin airship. As before, Carl Berg agreed to provide all of the aluminum components on credit. Daimler loaned a pair of engines. The War Ministry donated the hydrogen. A public appeal produced additional funds. Still, the Count had to mortgage his wife's estates to cover the cost of a new airship.

Work on LZ 2 began in April 1905. Chief engineer Ludwig Dürr applied the lessons learned with LZ 1 (fig. 53). The new airship was the same size as its predecessor, but had a much stronger frame and improved control surfaces. Most important, the twin 14½ hp Daimler engines that propelled LZ 1 were replaced by two 80 hp Daimlers. First flown on January 17, 1906, the airship proved difficult to control (fig. 54). It was able to maneuver in a gusty wind, however, and was traveling at 20 mph when an engine failure forced the Count to make an emergency landing on shore. Zeppelin and his associates were celebrating their return to earth that evening, when a storm destroyed LZ 2 on the ground.

The loss brought a temporary halt to Army interest in Zeppelin and his airships. Instead, the military invested in pressure airships developed by a trio of officers, Majors Gross, von Basenach and von Parseval. Convinced that he was close to success, however, the Count set to work on LZ 3 with scarcely a pause. Daimler was willing to supply even more powerful 85 hp engines, and Berg would continue to replace those elements of the aluminum framework that could not be salvaged.

Zeppelin launched the effort with the funds on hand. This time, the Kaiser himself approved a nationwide lottery, and provided an additional sum from his own coffers. Dürr conducted wind tunnel studies aimed at developing more effective control surfaces. When the craft was complete in October 1906, it sported four horizontal elevator surfaces beneath the nose on each side, and two slightly angled horizontal stabilizers fitted with three vertical rudders on each side of the tail.

The new craft was a turning point in the fortunes of the rigid airship. LZ 3 remained aloft for two hours on its first two days in the air, October 9–10, 1906. The new engines gave it a speed in excess of 27 mph. Dürr's altered controls enabled the Count to pilot the craft back to its hangar on both occasions. LZ 3 spent the remainder of 1906 and the spring and summer of 1907 being refitted and improved, while a new hangar was constructed. When flying resumed on September 30, 1907, the airship completed a non-stop flight of almost 220 miles (350 km). Five more flights followed in October, before the airship was retired for the winter.

Fig. 53 Ludwig Dürr (1878–1955). (NASM, 00105623, Zeppelin Luftschifftechnik GmbH & Co, KG)

While the official military commission charged with advising the government on aeronautical issues favored the Parseval pressure airships, the members did provide Zeppelin with half a million marks with which to keep LZ 3 in the air and to begin work on yet another craft. If the new LZ 4 could remain aloft for 24 hours without landing, the government would buy both of the airships.

On August 4, 1908, the new Zeppelin flew up the Rhine Valley in pursuit of the government contract, but an engine failure forced the craft down near the village of Echterdingen. The Count repaired to a nearby inn for some refreshment and rest while mechanics worked on the engines. Disaster, in the form of a wind squall, struck at 3 p.m. Carried off the ground, the nose of the airship brushed some trees, which ripped the envelope and opened one of the rubberized gas cells. The flapping rubber generated static electricity that ignited the escaping hydrogen.

When the Count reached the scene, his hopes for the future were reduced to smoldering wreckage. In future, Zeppelins would fly with non-rubberized cells lined with gold-beater's skin, small pieces of scraped cattle intestine patiently glued together to form a membrane that resisted the escape of hydrogen and would not generate static electricity.

Prepared at last to accept defeat, the seventy-year old Count was stunned by the public outpouring of support that would be remembered as "the miracle of Echterdingen." Almost without his noticing it, the Count, who had persevered in the face of overwhelming disappointments, emerged as a revered public figure. The old man and his airships decorated a wide range of consumer items, from children's candies to ladies' purses, hair brushes, cigarettes and jewelry cases. Copies of the soft white yachting cap that was the Count's sartorial trademark were sold in stores across Germany, along with an assortment of items from toys to harmonicas bearing Zeppelin's image. Schools, streets and town squares were renamed in his honor. And now, in his time of greatest need, the German people came to the support of the Count.

Fig. 54 LZ 2 in the air. (NASM, 76-13971)

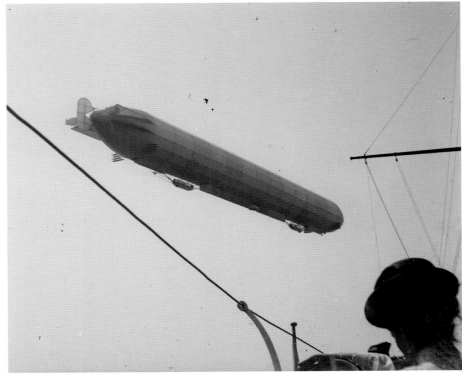

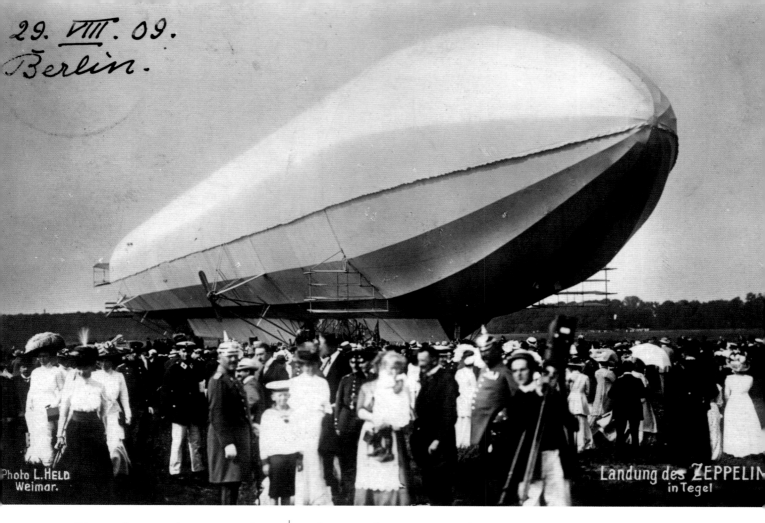

29. VIII. 09.
Berlin.

Photo L. HELD
Weimar.

Landung des ZEPPELIN
in Tegel

Fig. 55 LZ 3 attracts the attention of spectators at Tegel Airfield, Berlin, August 29, 1909. (NASM, 77-10193)

In an age of rampant nationalism, Germans looked to the Zeppelin airship as a symbol of national pride (fig. 55). From the Kaiser to the youngest schoolchild, Germans dispatched money to the Count, the sum eventually reaching 6.25 million marks. Those who could not afford to make a cash contribution sent farm products, home-made clothing, anything they thought might help. The ill-fated flight of LZ 4 up the Rhine, Zeppelin would later remark, had been his "luckiest unlucky trip" (see fig. 56).[13]

The Count established a new company to build his airships at Friedrichshafen, on Lake Constance. Within a few years, he stood at the head of an industrial empire made up of associated companies that built airships, airship engines, aluminum, hangars, the huge fabric gas cells lined with gold-beater's skin, and multi-engine

bombers that attacked Allied targets during World War I. Zeppelin acquired a monopoly over the production of virtually everything required to build, house and operate his giants of the sky.[14]

The Army reversed its position and purchased the refurbished LZ 3, as well as the LZ 5, which made a triumphal tour of Germany in 1909. When the pre-war market for military airships proved limited, the Count established a Zeppelin airline, an idea suggested by Alfred Colsman, son-in-law of Carl Berg and general manager of Luftschiffbau Zeppelin. In 1909, the Count created the first of his associated companies, the German Airship Transport Company (DELAG, for Deutsche Luftschiffahrts Aktien-Gesellschaft), which was in the business of buying airships from the main corporation and operating them.

The business got off to a rocky start. On June 28, 1910, the first DELAG airship, *Deutschland*, with twenty-three journalists and a cargo of gourmet comestibles on board, was caught in a storm and crash-landed in a forest. The reporters, all of whom escaped without injury, can scarcely have been expected to offer glowing reviews of the new service. A year later, the wind tugged *Deutschland II*, the replacement airship, out of the hands of the 300-man ground crew. The huge craft wound up with her nose resting on the roof of the hangar and her tail caught on a fence. Zeppelin's chief of flight operations, Hugo Eckener, the one-time journalist who had covered Zeppelin's early experiments, vowed that he would never again risk operating in inappropriate conditions. It was a lesson that would serve as the fundamental rule for all subsequent Zeppelin commanders.

Over the next four years, DELAG carried 10,197 passengers on 1,588 sightseeing flights over German cities in a series of four smaller airships: *Schwaben*, *Viktoria Luise*, *Hansa*, and *Sachsen*. For a substantial fee, passengers could cruise low and slow over the Fatherland. The passenger cabin was paneled in mahogany inlaid with mother-of-pearl. Uniformed waiters served gourmet delicacies, and the champagne with which to wash it down, to twenty passengers seated in comfortable wicker chairs. A lavatory complete with running water was available at the rear of the cabin. "Like streaks of mist," an advertising brochure promised, "anxiety and doubt will blow away."[15]

Zeppelin's time had come. His airships offered performance far beyond the capability of any airplane of the time. The stunning sight of a DELAG craft cruising majestically overhead was breathtaking, something close to a spiritual experience. With war clouds gathering on the horizon, Germany's potential adversaries grew ever more uncomfortable. The rigid airships, carrying dozens of sightseers over a German city today, might be dispatched on a much more deadly mission to their homeland tomorrow.[16]

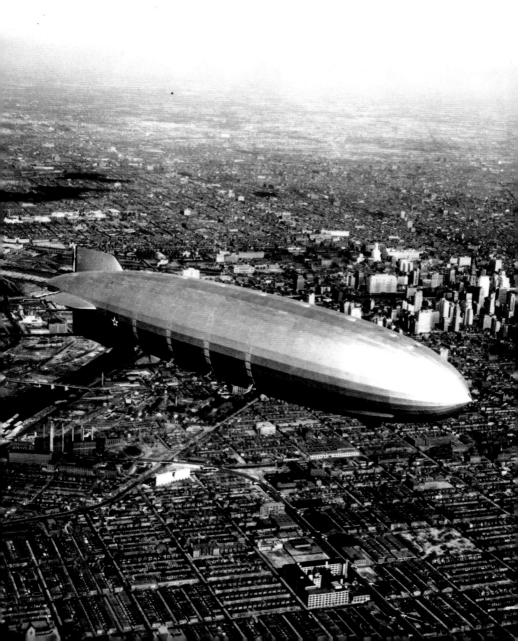

THE FABULOUS SILVERY FISHES

THE HISTORY OF RIGID AND
NON-RIGID AIRSHIPS, 1914–1945

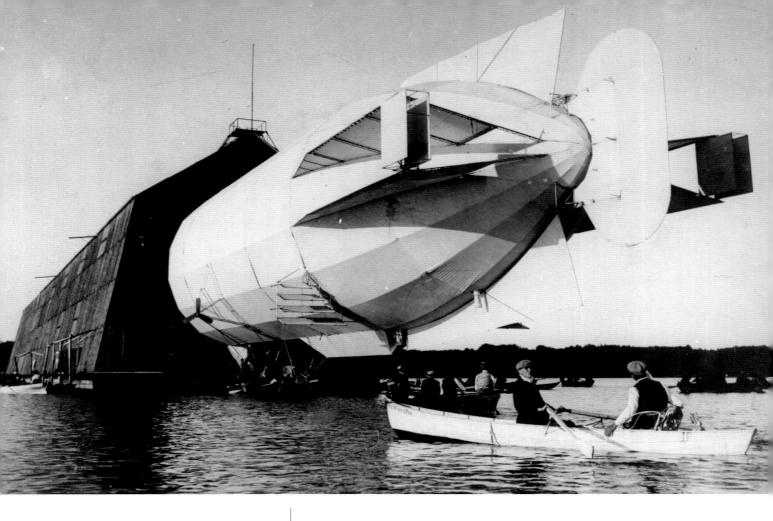

Fig. 56 *Zeppelin LZ 4 moving from its floating hangar on Lake Constance. (NASM, SI78-8031)*

"I WILL NOT CHASE THE HINDENBURG"

THEY WERE SHIPS IN THE SKY, and to watch one of the great craft pass majestically overhead was an emotional experience never to be forgotten. That was certainly the case for young John McCormick, an eight-year-old Iowa boy who stood with his grandmother as *Graf Zeppelin* flew directly over the family farm in the summer of 1929. The great dirigible was so low, he recalled six decades later, that they

could see "every crease and contour from nose to fins … so low that we could see, or imagined we could see, people waving at us from the slanted windows of its passenger gondola." Grandmother and grandson stood entranced. "Slowly, slowly the ship moved over us, beyond us, and at last was gone."[1]

Four-year-old David Lewis was on a Sunday outing in the family Dodge in 1935, when his mother suddenly exclaimed, "There's a Zeppelin!" "Its engines," he recalled, "hummed with a sound that reverberates in my memory seventy years later." As an adult, Lewis wondered if that misty memory had been only a dream, until he saw a photo of the craft he had seen that day, and it all came flooding back. "The sound … echoing as the dirigible disappeared in the west, reaches out to me across the gulf of time that separates me from the child, yet connects me to a life-altering experience."[2]

So it was for Anne Chotzinoff Grossman, of Ridgefield, Connecticut, who encountered the *Hindenburg* in the fall of 1936. The shy first-grader was waiting for the bell that would end recess, when the shadow of the airship passed across the schoolyard. With her older brother Blair and his friends leading the way, she set off in pursuit. "We ran across fields and brooks and over stone walls, trying to keep the airship in sight." Finally admitting defeat, "we made our way back to school, very late and very dirty, to face angry teachers." She was ordered to the blackboard to write one hundred times, "I will not chase the *Hindenburg*"—a pretty tall order for a six-year-old.[3]

Hugo Eckener, who guided the Zeppelin Company and its airships through the vagaries of politics and weather for four decades, understood the emotional experience evoked by the sight of a rigid airship cruising through the sky. "The mass of the mighty airship hull, which seemed matched by its lightness and grace," he noted, "never failed to make a strong impression on people's minds. It was … a fabulous silvery fish. Floating quietly in the ocean of air and captivating the eye … And this fairy-like apparition, which seemed to melt into the silvery-blue background of the sky, when it appeared far away, lighted by the sun, seemed to be coming from another world and to be returned there like a dream."[4]

Fig. 57 A Hamburg-Amerika Linie poster advertises flights of the *Viktoria Luise*, introduced in 1912 as a passenger-carrying airship. (NASM)

TERROR FROM THE SKY

B Y THE SUMMER OF 1908, the German airship had become England's bête noire. That July, a London newspaper reported that LZ 3 could carry fifty soldiers from Calais to Dover. Zeppelins then on the drawing board, the account continued, would soon be able to transport double that number a far greater distance. By the fall, newspapers were reporting a Berlin meeting in which a city official described plans for an invasion of England by a fleet of airships carrying soldiers who would "capture the sleeping Britons before they could realize what was taking place."[5]

The possibility of an attack from the sky spawned a series of apocalyptic novels in France, England, and Germany. The English writer H. G. Wells provided the master narrative of the genre, *The War in the Air* (1908), a fictional account of a German Zeppelin raid on New York City. "There is no place where a woman and her daughter can hide and be at peace," he wrote. "The war comes through the air. The bombs drop in the night. Quiet people go out in the morning and see air-fleets passing overhead—dripping death—dripping death!"[6]

The English would have slept a bit easier had they been aware of the problems the Germans were facing with their "wonder weapons." The Naval Airship Division lost its commanding officer and most of the crew of the airship L1 in a crash in the fall of 1913. Shortly after, a fire destroyed the L2 along with its designer and most of the twenty-eight crew members. Army officials remained enthusiastic, although some skeptics suggested that anti-aircraft fire might be something of a problem for a 450-foot long hydrogen-filled aerial behemoth cruising slowly overhead. The events of the days and weeks following the German invasion of Belgium and the beginning of war on the night of August 3/4, 1914 supported both views.

Initially, German strategists ignored the potential for long-range attacks on the enemy homeland. Instead they put the Zeppelins to work supporting Army operations at the front. On April 6, 1915, the crew of the LZ 21 (Z IV) dropped 500 pounds of bombs on the military fortress at Liège, Belgium. Damaged by anti-aircraft fire on its return flight, the airship crash-landed near Bonn. LZ 23 (Z VIII) was brought down by fire from French 75 mm field guns on August 23, while the LZ 22 (Z VII) fell victim to ground fire on the Eastern Front.

Three days later, on August 26, the LZ 17 dropped 1,800 pounds of high explosive bombs on the besieged city of Antwerp. Her skipper, Ernst Lehmann, commander of the ship in the pre-war era when she was the passenger-carrying *Sachsen*, rose to become the most successful of all Zeppelin commanders, only to die in 1937 as a result of injuries suffered in the crash of the *Hindenburg*.

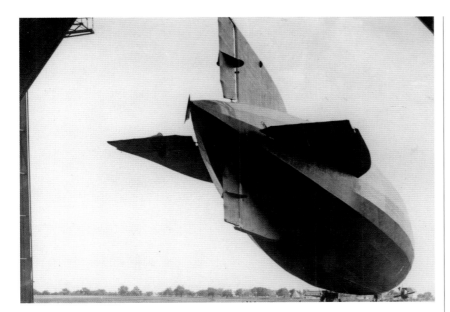

Fig. 58 Zeppelin LZ 100 (Navy L 53). (NASM 2A05522)

The Allies struck back on October 8, 1914, when Squadron Commander Spencer Grey and Flight Lieutenant R. L. G. Marix of the Royal Naval Air Service, flying Sopwith Tabloids armed with two 20 pound bombs apiece, attacked the railway station at Cologne, killing three civilians, and destroyed the LZ 25 (Z IX) in its hangar at Düsseldorf.[7]

But it would be the German Navy, its capital ships bottled up in port, that would launch the first genuine strategic bombing campaign in history. Captain Peter Strasser, commander of the German Naval Airship Division, was frustrated by the futile attempts to use the Zeppelins as tactical weapons. For all of its fear of the Zeppelin, England was defenseless against attack from the sky in 1914 and 1915. Airplanes could not yet climb as high as an airship, and in any case were not yet armed. Anti-aircraft guns scarcely existed.

In January 1915, the Kaiser, anxious to break the deadlock at the front, lifted his own order forbidding air attacks on Great Britain. The first small-scale raids that month underscored problems inherent in the enterprise—mechanical failures, navigational difficulties, the near-impossibility of hitting a specific target on the ground. Still, the bombs dropped on the coastal town of Yarmouth on January 13, 1915, killed four people and marked the beginning of the first strategic bombing campaign in history. For the next three years, German airships would attack Allied cities from Belgium and France to Russia, but Britain would remain the primary target (fig. 58).

The German Navy (63) and Army (40) operated a total of 103 rigid airships in

the period between 1908 and 1918. The largest of the wartime Zeppelins was almost 694 feet long and had a diameter of over 78 feet. With a crew of thirty, the behemoths had a range of almost 7,500 miles, and could operate at altitudes of over 20,000 feet at speeds of over 75 mph.[8]

Two companies manufactured rigid airships. Luftschiffbau Schütte-Lanz, a firm founded in Mannheim in 1909 by Johann Schütte (1873–1940), a professor of shipbuilding at a Danzig technical school, built over twenty airships, distinguished by their rigid frameworks of wooden girders. The rest were produced by the various organizations controlled by Count von Zeppelin and his subordinates. Alfred Colsman, whom the Count had lured away from the fledgling aluminum industry, concentrated on the manufacturing enterprise. Dr. Hugo Eckener took charge of training.

By mid-1917, the Zeppelin empire employed 17,075 workers. Corporate headquarters and the main construction facility were at Friedrichshafen, on Lake Constance (fig. 59). The Staaken Company was a subsidiary producing the large multi-engine bombers that would replace the Zeppelins in attacks on England in 1918. Ballon-Hüllen Gesellschaft, located at Berlin Tempelhof, manufactured the large gas cells that nestled in the airship's frame. Butchers all over Germany were required to ship tons of cleaned animal intestine to the firm, for use in the manufacture of the gas-tight gold-beater's skin that lined the huge linen hydrogen cells. The material held hydrogen well without generating as much static electricity as rubberized materials. Karl Maybach, son of automotive pioneer Wilhelm Maybach, ran Luftfahrzeug Motorenbau Gesellschaft, the associated firm that built airship engines. Ultimately, there was even a subsidiary corporation to build the sheds that housed these huge machines.

Between January 1915 and August 1918, German airships conducted 51 raids on Great Britain, dropping 196 tons of bombs that took 557 British lives and injured an additional 1,358. W. E. Shepherd, an American journalist in London, provided a vivid account of a metropolis under aerial attack. "Great booming sounds shake the city. They are Zeppelin bombs—falling—killing—burning … Suddenly you realize that the biggest city in the world has become the night battlefield on which seven million

Fig. 59 The Zeppelin factory, Friedrichshafen, Germany, 1918. (NASM, SI 7A44951)

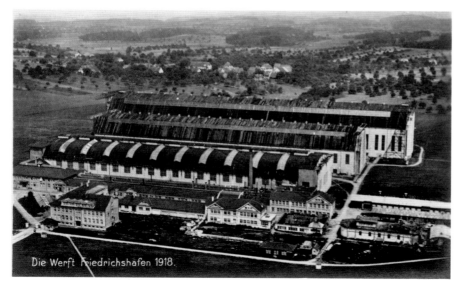

Die Werft Friedrichshafen 1918.

harmless men, women and children live."[9]

Other accounts suggest that civilians on the ground were often more fascinated than frightened by the aerial giants that came calling. Lady Ottoline Morrell described a Zeppelin in the night sky as, "a bright golden finger, quite small, among a fragile incandescence of clouds."[10] Mrs. Holcombe Ingleby wrote to inform her son that she had seen two Zeppelins: "The searchlights were on them and they looked as if they were among the stars … It was lovely and I ran upstairs from where I had a lovely view."[11] After watching a Zeppelin cruise overhead on its way to London one evening in 1916, George Bernard Shaw admitted to Beatrice and Sidney Webb that "the sound of the Zepp's engines was so fine, and its voyage through the stars so enchanting, that I positively caught myself hoping next night that there would be another raid."[12]

The Zeppelin crews were a tightly knit elite. Ernst Lehmann, a veteran Zeppelin commander, recalled that "there were no superfluous men aboard" a raiding airship, "and there was no such thing as relief after watches." The captain was "not only a superior, … [but] also comrade, friend, father, doctor and spiritual advisor all in one." He knew his men on a personal level—"that one had a wife and child at home, another had married young, and a third was the only son and sole support of aged parents."[13]

Rigger August Seim reported that the crews were well fed: "We got sausages, good butter, Thermos flasks containing an extra strong brew of coffee, plenty of bread, chocolate, and fifty grammes of rum or brandy per man."[14] The catch was that rations usually had to be consumed cold, to avoid the danger of an open fire, and that no alcohol could be consumed when the craft was flying at an altitude of less than 10,000 feet.

Working conditions were extreme. The engine cars, each containing two Maybach power plants, left scarcely enough room for the two mechanics stationed there to turn around. "The air in this nutshell was saturated with gasoline fumes and exhaust gases," Lehmann recalled. "To exist for hours in this roaring devil's cauldron, where glowing heat and biting cold alternated, required a stone constitution and iron nerves."[15] A crewman who slipped off one of the external ladders leading from the control or engine cars to the airship, or who made a misstep on a narrow catwalk, faced a 10,000 foot fall. Then there were the riggers who were sent scurrying up into the interior of the ship to repair damage to the envelope or gas cells, "with fingers that were often frozen stiffer than our bread and butter," as one of them recalled.[16]

But there were even more dangerous posts aboard an airship. Consider, for example, the occupant of the sub-cloud car. This was a small device, shaped something like a bomb, with an open cockpit and stabilizing fins and a rudder at the

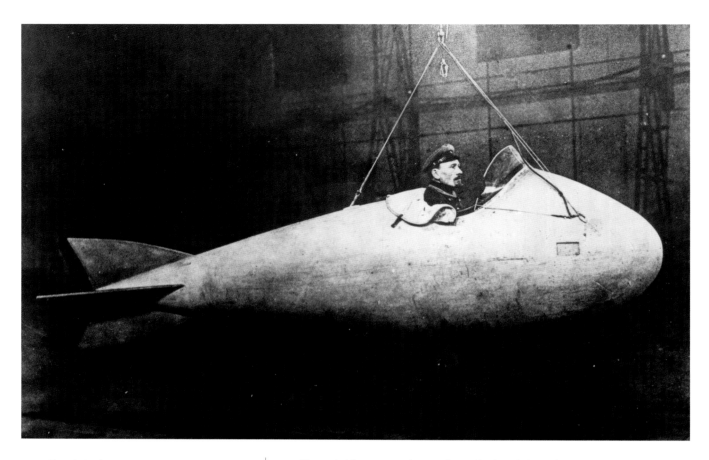

Fig. 60 The sub-cloud car. (NASM, SI 90-16223)

rear (fig. 60). The car was lowered out the bomb bay of an airship at the end of a 3,000 foot cable attached to a winch. The airship could cruise safely out of sight inside a cloud bank while the crewman aboard the sub-cloud car, dangling under the clouds hundreds of feet below, directed the bombing run via a telephone. Captain Ernst Lehmann himself tested the first sub-cloud car, which was used in combat for the first time during a March 17, 1916 raid on Calais.

But a duty station manning the machine gun nest mounted out in the open on top of the Zeppelin may have been even worse. A crewman had to spend considerable time preparing for a watch in that exposed position, where the temperatures often dropped to 30 or 35 degrees below zero. Dressing began by donning thick, woolen, long underwear, followed by standard blue flight coveralls, leather overalls, and a thick woolen coat. Next came the felt overshoes to cover a standard pair of boots, a pair of leather gloves, lined with sheep's wool, a bulky lined helmet with

goggles and a scarf. High-powered binoculars and a Dräger oxygen apparatus hanging around the neck completed the ensemble.

There was no safe berth on a Zeppelin, however. Ultimately, the bombing campaign against London and other Allied cities took a far heavier toll among the airship crews than among civilians on the ground. During the early months, the distance, time aloft, working conditions, and weather were the enemies of the airship crews. That began to change in June 1915, when Sublieutenant Reginald A. J. Warneford of the Royal Flying Corps, flying a Morane-Saulnier Type L monoplane, encountered LZ 37 crossing over Belgium at a relatively low altitude on its way to London. Climbing above the airship, he dropped a bomb on it, earning credit for the first destruction of a Zeppelin in air-to-air combat.

Ever more powerful rigid airships were designed and built in an attempt to increase speed and enable the aerial behemoths to climb above the danger. In the spring of 1915, the German government persuaded the Zeppelin Company to share experience and expertise with the rival Schütte-Lanz firm to produce a new generation of "super Zeppelins." The new L 30 class airships that emerged from the period of forced cooperation were six-engine, 181,200 cubic foot craft incorporating the best features offered by both manufacturers. In 1917, Navy officials instructed the man-

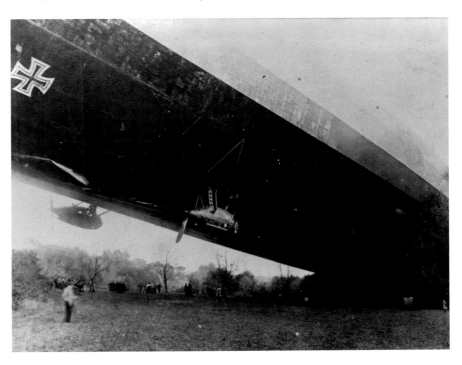

Fig. 61 LZ 96 (Navy L 49) in its final resting place, Neufchateau, France, October 1917. (NASM, A-48751)

ufacturers to develop an improved class of "height climbers," designed to operate at an altitude of over 18,000 feet, higher than the opposing fighters.

The new Zeppelins were technological marvels, but improved anti-aircraft guns and more advanced pursuit aircraft continued to bring them down in ever increasing numbers (fig. 61). The Naval Airship Division lost forty-five of its sixty-three Zeppelins (71%) in combat or to accidents. Twenty-three (57%) of the Army airships would never return. Forty percent of wartime Zeppelin crewmen lost their lives in the line of duty, including Korvettenkapitan Peter Strasser. The man who planned the campaign died in the flames of LZ 70, three miles high in the sky, on the very last Zeppelin raid against England.

BLIMP!

BRITISH OFFICIALS HAD a very different application in mind for lighter-than-air craft. On February 28, 1915, the First Sea Lord, Admiral of the Fleet Lord Fisher, ordered the construction of an experimental pressure airship for use in locating and destroying German U-boats preying on British shipping. When Jackie Fisher spoke, things happened. *Sea Scout* #1 (SS 1), which first flew on March 18, was simplicity itself, a single-engine, two-seat aircraft fuselage slung beneath a gas bag with fins at the rear.[17]

The origin of the term "blimp," universally applied to non-rigid or pressure airships like the SS 1, is one of the great etymological mysteries of aviation. The usual explanation is that the word derives from either a British or American designation of a Class B-Limp (or non-rigid) airship. Unfortunately, there is no record of the use of the term "limp" in any of the world's air services.[18]

The explanation offered by the *Oxford English Dictionary* seems far more likely. The *OED* reports that on December 5, 1915, RNAS Lt. A. D. Cunningham playfully flicked his finger on the taut envelope of the pressure airship SS 12, and then mimicked the resulting sound—Blimp! Gales of laughter could be heard issuing from

Fig. 62 Melvin T. Vaniman (center) and the unfortunate crew of the *Akron*, 1912. (NASM, 7A46946)

the mess as Cunningham's colleagues imitated the sound.[19]

Be that as it may, a host of British, French, Italian, and American blimps performed yeoman's service during World War I, escorting convoys into port and conducting anti-submarine patrols over critically important sea lanes. British officials claimed that their airships had spotted forty-nine German submarines during the course of the war, and sunk twenty-seven–a wildly optimistic claim. More important, it seems that no ship was torpedoed while with a convoy protected by the blimps of any Allied nation.

The U.S. Navy launched a pressure airship development program in 1916. One American firm, Goodyear, had entered the airship business in 1911, when the firm constructed the *Akron*, named after the town where the company was headquartered. The pressure airship featured a 345,940 cubic foot envelope measuring 260 feet in length and was commissioned by Melvin Vaniman, an Illinois farm boy who had traveled the world as a photographer (fig. 62). He was living in France in 1906 when he had a fateful encounter with Walter Wellman, an American newsman who had attempted to reach the North Pole by dog sled in 1894 and 1899.

By 1906, Wellman was about to launch another attempt, this time using an airship, the *America*, constructed by the Goddard family of French balloon builders (fig. 63). Wellman enlisted Vaniman, who had experimented with heavier-than-air flying machines, to serve as his mechanic. The pair succeeded in making the first short powered flights from Spitsbergen in 1907, and were prepared to press forward in 1908 with a new airship constructed by the Maillot firm. Faced with mechanical problems, they abandoned the venture when Robert Peary reached the Pole in 1909.[20]

Using an enlarged version of the *America*, Wellman and Vaniman attempted to fly the Atlantic Ocean in 1910. After covering 1,000 miles, and setting distance and time aloft records for airships, engine trouble forced them to land within a mile of a passing steamer. It was enough for Wellman, but Vaniman was unwilling to quit. His new airship, the *Akron*, sported a two-story gondola complete with a kitchen, dining area, salon and promenade. Unfortunately, Vaniman did not have much time to enjoy those amenities. He set out from Atlantic City on July 2, 1912. Fifteen

Fig. 63 Walter Wellman's *America*. (NASM, SI 77-10918)

Fig. 64 The Goodyear blimp *Pilgrim*. (NASM, SI 75-15330)

minutes later, flying at an altitude of less than 2,500 feet, and not yet having crossed the coastline, *Akron* exploded. Vaniman and four crewmen died when their plush gondola fell into a marsh.[21]

With war on the horizon, the U.S. Navy ordered sixteen of what were to be known as "B" class airships for training and anti-submarine patrol. Goodyear returned to the airship business when it received a contract for nine of those craft. The B. F. Goodrich Company and the Connecticut Aircraft Co. would produce the other seven. Goodyear and Goodrich both produced "C" and "D" class airships, offering increased power, speed and range. Some "C" ships were turned over to the Army. All subsequent contracts went to Goodyear.

A typical "B" class airship carried a crew of three housed in an airplane fuselage beneath a 163-foot envelope containing 84,000 cubic feet of lifting gas. Goodyear assembled airships at its Wingfoot Lake facility, near Akron. Powered by a single engine, the craft could cover 900 miles at a speed of 35 mph. During World War I, U.S. blimps operated from Naval air stations at Montauk Point and Rockaway Beach, New York; Chatham, Massachusetts; Cape May, New Jersey; Hampton Roads, Virginia; and Pensacola, Florida. A number of the 170 officers who earned their wings as blimp pilots between 1916 and 1918 flew French airships from European bases. Blimps operating in American waters logged 13,600 hours on patrol.

Continuing to meet the post-war airship needs of both services, Goodyear officials decided to expand operations in the hope of developing a civilian market. The company had high hopes of generating positive publicity with flights of the *Wingfoot Express*, the first company-owned and operated commercial airship. The craft set out on its sixth flight from an airship hangar at Chicago's White City Amusement Park late on the afternoon of July 21, 1919. Ten minutes later, the flaming wreckage came crashing down through the skylight of the Illinois Trust and Savings Bank building on the corner of Jackson and La Salle. Two of the five crewmen and nine bank employees lost their lives; another twenty-seven were injured. While the company made every effort to prove that the accident had not been a result of the fact that the airship was filled with 95,000 cubic feet of hydrogen, the tragedy was an important factor leading to the adoption of helium as a lifting gas for U.S. airships.[22]

French astronomer Pierre Janssen discovered helium, the second lightest element, as a thin, yellow spectral line while studying a solar eclipse in 1868. In 1903, an oil drilling operation in Dexter, Kansas, produced a strange gas geyser that would not burn. When University of Kansas scientists analyzed the gas, they found that almost 2 percent was helium. Far from being a rare gas, wells in the southwestern U.S. could produce the stuff in considerable quantities. While helium provided only 92.6 percent as much lift as hydrogen, and was far more expensive, it had the over-whelming advantage of being inert. Throughout the interwar years, the U.S. was the only nation with access to helium.

The Goodyear blimp C7 was the first U.S. Navy airship to be inflated with the gas. The Goodyear airship *Pilgrim*, which made its maiden flight from Akron on May 15, 1925, while initially inflated with hydrogen, was the first aircraft designed to be flown with helium, and was the predecessor for generations of Goodyear commercial blimps to follow (fig. 64). During the 1930s, the dozen or so Goodyear blimps carried the company name and image across the nation, inaugurating a tradition that continues to the present day.[23]

THE ITALIAN SPECIALTY

FROM THE OUTSET, the Italians preferred semi-rigid airship designs, in which a pressure envelope was coupled with a rigid keel running along the bottom of the bag to support the weight of control cabin and engines. Umberto Nobile, the leading Italian airship designer, held degrees in both electrical and industrial engineering. He was involved in the electrification of the Italian rail system until 1911, when he turned his attention to aeronautics. In July 1918, Nobile and his business associates—Giuseppe Valle, Benedetto Croce and Celestino Uselli—launched the Aeronautical Construction Factory. Their first product, the semi-rigid T-34, was sold first to the Italian army, then to the U.S. Army, where it was christened *Roma*. Thirty-four of her forty-five crewmen died when *Roma* nosed into high tension lines and burned near Langley Field, Hampton, Virginia, on February 21, 1922.[24]

Facing the threat that his company might be nationalized by the new government of Benito Mussolini, Nobile spent some time consulting with the Goodyear Company in Akron. He returned to Italy to face business rivals like General Gaetano Crocco and powerful political opponents, including the fascist General Italo Balbo, who would become Secretary of State for Air in 1926.

Nobile sold his latest airship, N-1, and his services as captain, to the polar explorer Roald Amundsen and American millionaire Lincoln Ellsworth, who were

Fig. 65 Umberto Nobile's SCA N-1, *Norge*. (NASM, SI-A-4423D)

determined to be the first to fly to the North Pole. On May 9, 1926, Commander Richard E. Byrd and his pilot, Floyd Bennett, claimed to have flown to the Pole and back. Just two days later, Nobile, Amundsen, Ellsworth and their crew guided the N-1, renamed the *Norge*, in honor of Amundsen's Norwegian homeland, away from Spitsbergen and headed north (fig. 65). They landed safely in Teller, Alaska, on May 13, having successfully overflown the North Pole.

In public, the fascists now celebrated Nobile as a national hero. Behind the scenes, they continued their efforts to undermine his company. Determined to return to the Pole with a purely Italian expedition, he recruited a crew and outfitted a new N-class semi-rigid airship christened the *Italia*. After two test flights hampered by bad weather, Nobile pointed the *Italia* north from Spitsbergen on May 23, 1928, with sixteen expedition members aboard. After dropping an Italian flag and a cross at the Pole, he began the return journey to Kings Bay. Strong headwinds, fog and the accumulation of ice on the envelope forced the *Italia* down onto the pack ice. Six crew members were carried away when the airship was blown back into the air, and were never seen again. One crewman in an engine car died in the crash. Nine men, including Nobile, were stranded on the ice.

Distress calls from Nobile's repaired radio were finally received two weeks later, and an enormous rescue effort involving eighteen ships and twenty-two

aircraft from six nations was soon underway. Locating the downed fliers proved to be very difficult. Tragically, Roald Amundsen and five companions died when their aircraft disappeared during the search. Five weeks after the crash, an airplane with room for only one passenger finally reached the survivors. Nobile was persuaded to fly out so that he could take command of the rescue of his comrades. Deteriorating weather prevented any return flights, however, and Nobile was castigated for "deserting" his crew. The remaining men would remain on the ice until finally rescued in July.

Disgraced, Nobile retired from the Italian air force and moved to the Soviet Union, where he helped to develop a Red Airship program producing at least nine semi-rigid craft by 1938. He returned to Italy to teach in 1936, then moved to the U.S., where he taught until 1943. After returning to Italy, following the fall of the fascist government, Nobile was celebrated as a hero and reinstated as a major general in the Italian air force. He remained a controversial figure, however, because of his years working for the Soviet Union. He returned to teaching, and died in Rome in 1978.[25]

A GOLDEN AGE?

FOR GERMANY, the coming of peace in 1918 brought little more than social, political and economic chaos. Late in October, rather than going to sea for a final climactic battle with the Allies, seamen of the Imperial high seas fleet launched a mutiny that spread to Wilhelmshaven and Kiel and ended with revolutionary sailors' soviets in effective command. While the naval airship ground and air crew remained loyal, they responded to orders to turn over all German aircraft to the Allies by destroying six airships housed in hangars at Nordholz and Wittmundhaven.

In the end, this act of rebellion made possible the survival of the Zeppelin Company. While Alfred Colsman planned to diversify the Zeppelin Company, developing new lines of metal products, Eckener was determined to return to civil airship production and operations. He ordered the construction of two smaller rigid airships, *Bodensee* (LZ 120) and *Nordstern* (LZ 121), and prepared to reinstitute and expand the pre-war DELAG passenger service (fig. 66). The victorious Allied powers had other ideas.

In 1920, the Allied commissioners ordered that all surviving Zeppelins be turned over as reparations. *Bodensee*, *Nordstern*, and LZ 106 all went to the Italians. LZ 113 went to the British, who studied the airship but did not fly it. The French took possession of LZ 114 (German naval designation L 72). Renamed the *Dixmude*, the

Fig. 66 Dr. Hugo Eckener (August 10, 1868–August 14, 1954). (NASM, 2AO5649)

airship made a series of record-setting flights over the Mediterranean and the Sahara under the command of Lieutenant de Vaisseau Jean du Plessis de Grénédan.

Having disposed of all surviving Zeppelin airships, the Allies now ordered the destruction of the company production facilities at Friedrichshafen. The U.S. Navy, however, had its heart set on acquiring one or more of the latest model Zeppelins that had been destroyed. On December 16, 1921, after prolonged negotiations, Allied leaders agreed that the U.S. could contract with the Zeppelin Company for a new airship similar to the destroyed LZ 70. As the negotiated price was higher than the amount of reparations owed, Eckener was even able to gain some income from the effort. Far more important, however, the project enabled him to circumvent the threatened ban on all new Zeppelin construction. At least one more giant rigid airship would take shape in the big hangars on the shores of Lake Constance.[26]

The new Zeppelin destined for the U.S. Navy would not, however, be the first U.S. rigid airship. Jerome Hunsaker, C. P. Burgess and Starr Truscott, the Navy's trio of airship engineering authorities, based their preliminary design for the first American rigid airship on the L 49 (LZ 96), which had attacked southern England on the night of October 19, 1917. Forced down by French fighter aircraft at Bourbonne-les-Bains, France, early the next morning, L 49 was captured by Allied troops before Kapitanleutnant Gayer and his crew had time to burn their craft. Allied engineers swarmed over the airship, capturing every detail in a set of measured drawings.

Work on the ZR-1 *Shenandoah* began at the Philadelphia Navy Yard in August 1919. By April 1922, assembly was underway in a large hangar at U.S. Naval Air Station Lakehurst, New Jersey. The airship was constructed of 400,000 pieces of duralumin, and measured 680 feet three inches long, ten meters longer than the German original. It was powered by six (later reduced to five) twelve-cylinder, 300 horsepower Packard engines.

The first rigid airship to be filled with helium rather than hydrogen, *Shenandoah* flew for the first time on September 4, 1923 (fig. 67). Over the next two years, this crown jewel of Naval Aviation would spend 740 hours in the air during the course of fifty-seven flights. In addition to its involvement in the development of mooring masts and other equipment and procedures, the airship was an important public relations tool, putting in appearances at state fairs and other public events across the nation. Early on the morning of September 3, 1925, *Shenandoah* was literally torn in half by a violent storm while on its way to a publicity appearance. It fell to earth in Noble County, Ohio. Commander Zachary Lansdowne died along with fourteen of his forty-three crew members.[27]

The loss of the *Shenandoah* was the latest in a growing string of airship disasters. *Dixmude*, originally built as LZ 114, suffered a catastrophic structural failure and was lost at sea with all fifty crew members on December 21, 1923. The British-built

Fig. 67 ZR-1 *Shenandoah*. (NASM, SI 74-3721)

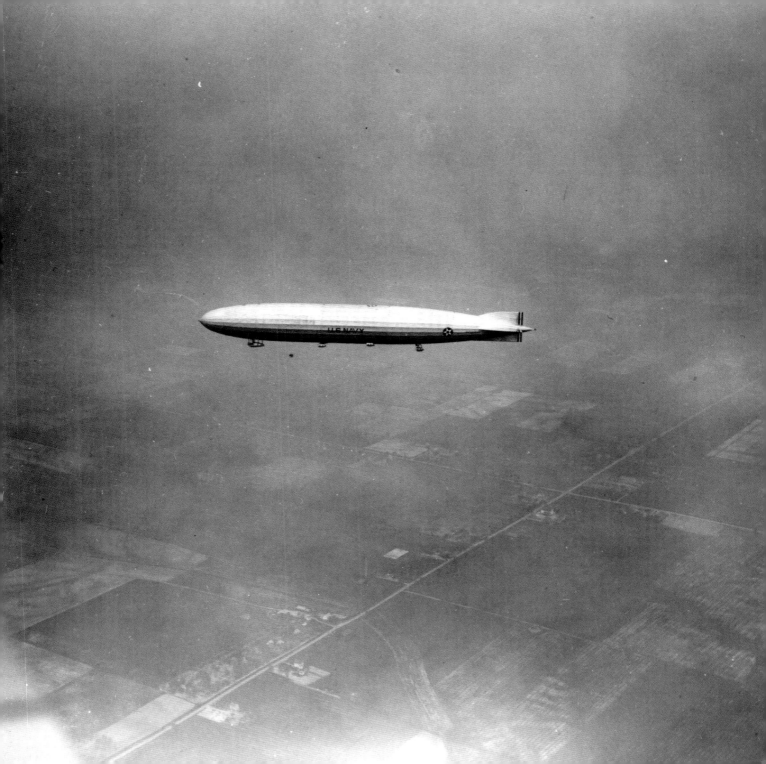

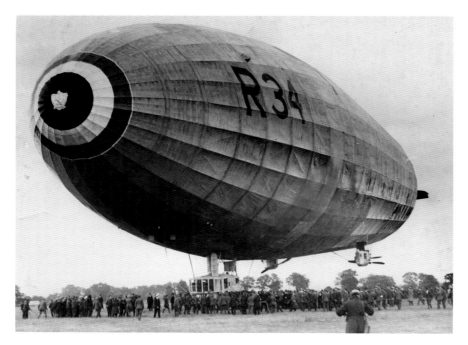

Fig. 68 His Majesty's Airship R34 lands at Pulham, Norfolk, on her return journey from America, July 1919. (NASM, SI 89-16898)

airship R38 was based on the wartime L 70 class. Destined for transfer to the U.S. Navy, where it would have been designated ZR-2, it broke up in the air during a test flight and fell into the Humber River on August 21, 1921. Forty-four of the forty-nine crew members died in the crash, including fifteen officers and men of the U.S. Navy who were training to fly the ship across the Atlantic. Her Majesty's Airship R80, designed by Vickers engineer Barnes N. Wallis on the basis of the Zeppelin L 70 class airships, suffered a near-catastrophic structural failure during her first flight on September 21, 1921.

The tragedies pointed to a basic design problem that would plague all airships. These long, thin structures had always been a compromise between minimum weight and sufficient strength. Early in World War I, when the Zeppelins proved vulnerable to anti-aircraft fire and fighters, German designers began to pare down both the structural weight and the strength of their airships so that they could climb to higher altitudes. As a result, the most advanced German airships, the aircraft that were turned over as reparations and which served as the models for post-war Allied designs, were structurally much weaker than earlier models. The inexperienced British, French and American crews would pay the price.

If there were disasters aplenty, the airship still offered the only practical means of moving freight and passengers through the air over intercontinental distances. The British, with Imperial and Commonwealth relationships stretching around the globe, were, after the Germans, the most committed builders of rigid airships. Following the first pressure airships of E. T. Willows (1905), Vickers Ltd. produced the first British rigid airship, the *Mayfly*, in 1909. Undeterred by the fact that *Mayfly* broke her back when being backed out of the hangar for her first flight, the British government and such private firms as Vickers, Shorts, Beardmore, and Armstrong-Whitworth built a total of eighteen rigid airships between 1910 and 1930.

For British airship proponents, the post-war era began on a high note. His Majesty's Airship R34 completed the first round trip aerial crossing of the Atlantic between July 2 and July 13, 1919 (fig. 68). In May 1919, the U.S. Navy flying boat NC-

4 completed the first flight across the ocean, with a re-fueling stop in the Azores. Less than a month later, John Alcock and Arthur Whitten Brown completed the first non-stop crossing in a modified twin-engine Vickers Vimy. Those flights had stretched the capacity of the airplane to its very limit, however.[28]

Commanded by Major G. H. Scott, the R34 made the double crossing with relative ease, carrying a crew of thirty, one stowaway and a cat named "Whoopsie." Those who flew in R34 affectionately referred to her as "Tiny." Measuring 643 feet in length and 79 feet in diameter, the airship was literally the size of a flying battleship.

In October 1924, long before the next airplane would fly the Atlantic, Hugo Eckener and his crew flew the LZ 126 from Germany to Lakehurst, New Jersey, to deliver the airship that the U.S. Navy would re-christen *Los Angeles* (ZR-3). By 1928, at a time when would-be transatlantic aviators were still dying in considerable numbers, the *Graf Zeppelin* (LZ 127) was carrying paying customers between Europe and the Americas in a luxurious fashion rivaling that of an ocean liner.

Convinced that the airship offered the ideal means to forge aerial links to the far corners of the Empire, the British government unveiled an Imperial Airship Scheme in 1923. The notion was to develop airships that could ferry troops and military equipment to trouble spots in record time, while also reducing travel time to Canada, India and Australia. In May 1924, Ramsay MacDonald's Labour Government introduced a new twist to the scheme. Instead of contracting with Vickers Ltd. to build and operate airships over intercontinental routes, the government created a unique public/private experiment. Vickers, representing private industry, would design and build one airship; the government-owned and operated Royal Airship Works at Cardington would produce another. The performance of the two airships could easily be compared, and would provide a demonstration of the comparative efficiency and quality of public and private enterprise.

The Imperial Airship program was enormously ambitious and fraught with technical challenges. The two airships would be larger than their German contemporary, *Graf Zeppelin*. The government airship, R101, first flown two years behind schedule on October 14, 1929, was 777 feet long with a maximum diameter of 131 feet 6 inches. Built primarily of steel (60% of the frame), the airship had a distinctive streamlined shape. Pride in this product of British technology led to extravagant claims as to the range and carrying capacity of the R101.

On October 4, 1930, after only a single seventeen-hour test flight in her final configuration, the R101 set out on a highly publicized aerial journey to India. The passenger list included Lord Thomson, head of the Air Ministry; Sir Sefton Brancker, director of civil aviation; R. B. B. Colmore, government director of airship development; and Vincent C. Richmond, chief designer. A few hours later, early on the morning of October 5, they and forty-four others died when the airship struck

a hillside near Beauvais, France, and burned. No definitive cause was ever established for the disaster, although bad weather was certainly a factor.

The Vickers airship, R100, first flown two days after R101, was a far better aircraft. The chief designer, Barnes N. Wallis, the most experienced airship designer outside Germany, headed a talented engineering team that included the novelist/engineer Nevil Shute Norway. The airship completed a fully successful round-trip flight to Canada in July and August, 1930, only to be grounded and broken up following the disaster of the R101. So ended the Imperial Airship Scheme, a victim of politics quite as much as technical shortcomings.

LOS ANGELES, AKRON, AND MACON

LIKE OTHER NATIONS, the U.S. was taking a closer look at the potential of rigid airships during the 1920s. Henry Ford was easing his way into aviation through the establishment of a modern airport in Dearborn, Michigan, and the development of a series of commercial aircraft culminating in the famous Ford 5-AT Trimotor. In 1920, Ralph Upson, winner of the 1913 James Gordon Bennett Trophy, and a leading Goodyear authority on airship design and construction, moved to Gross Ile, Michigan, to take up new duties as director of the Airship Development Corporation, established by Henry Ford's son Edsel, and William Mayo, a Ford engineer with an interest in a revolutionary new type of lighter-than-air craft.

The "Detroit group," as they became known, were planning a radical new design for a rigid airship that would not have an internal framework. Rather, the envelope itself, constructed of thin sheets of duralumin, would be rigid. With a contract from the U.S. Navy in hand, the Ford men forged ahead with work on the ZMC-2, first flown on August 19, 1929. Small, only 149 feet long, the "tin bubble," as it was known by both its proponents and detractors, sported eight small fins spaced equidistantly around the aft end of the teardrop-shaped craft. While ZMC-2 remained in service for over ten years, it remained little more than a curiosity, and Ford's interest faded away.[29]

The future of the rigid airship in America would rest on a partnership between two of the world's most experienced producers of lighter-than-air craft. From the beginning of the century to the end of the 1930s, Germany was the master of rigid

Fig. 69 A memorable moment in the career of the USS *Los Angeles* (ZR-3). Caught by a gust while moored at Lakehurst, New Jersey, on August 25, 1927, the tail was carried almost vertically over the mast. There were no serious injuries to the small number of crewmen aboard. (NASM, SI 76-2037)

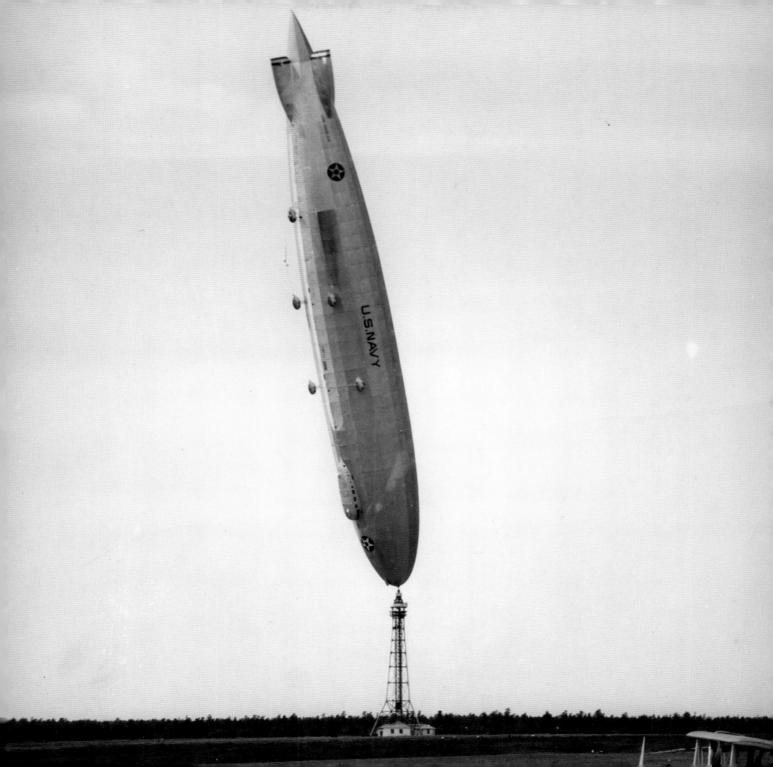

airship design and operations. The opportunity to build the LZ 126 (*Los Angeles* ZR-3) enabled Hugo Eckener, who succeeded Alfred Colsman as general manager in 1922 and was named managing director in 1928, to keep the Zeppelin firm in the airship business. First flown on August 27, 1924, LZ 126 was one of the most successful of all lighter-than-air craft, outliving all other rigid airships but one (fig. 69). The *Los Angeles* enabled a new generation of naval personnel to gain experience in handling and operating a big rigid and to explore the military role of such an aircraft. The airship would log some 4,180 hours during her fifteen-year career, and was finally broken up in October 1939.

Airship advocates extolled the virtues of the big rigids for fleet reconnaissance, but how could the largest, slowest, most vulnerable aircraft in the sky dodge in and out of the clouds while searching for the enemy? The answer might lie in a special "trapeze bar" fitted to the *Los Angeles*, which enabled an airplane to be launched and retrieved in flight. Naval planners began to consider the rigid airship as a "flying aircraft carrier," which could remain hidden from the enemy while the faster and more agile fighter airplanes could be launched, conduct scouting or attack missions, and come back aboard the airship while still in flight.[30]

Fig. 70 Paul W. Litchfield (July 26, 1875–March 18, 1959). (NASM, 7B04084)

Early aerial hook-on experiments conducted with *Los Angeles* worked well. A Navy five-year aircraft program authorized by Congress on June 24, 1926, included approval for the design and construction of two large rigid airships that would function as "flying aircraft carriers," launching and retrieving four to five fighter aircraft apiece, and storing them in a special hangar deck in the belly of the airship. Paul W. Litchfield, President of Goodyear Tire and Rubber, carefully positioned his firm, the most experienced American manufacturer of lighter-than-air craft, to capture the contracts to design and build the new airships for the Navy (fig. 70).

In October 1923, following the purchase of the LZ 126, Goodyear negotiated a partnership with Hugo Eckener and the Luftschiffbau Zeppelin company, creating a new firm, the Goodyear-Zeppelin Corporation, headquartered in Akron, Ohio. As part of the arrangement, Dr. Karl Arnstein, who had joined Luftschiffbau Zeppelin in 1915, emigrated to the U.S. in 1924, along with twelve veteran designers, to become vice-president of Goodyear-Zeppelin, and head the corporate design team (fig. 71). In October 1928, Goodyear-Zeppelin contracted with the U.S. Navy for the design and construction of two new airships: USS *Akron* (ZRS-4) and USS *Macon* (ZRS-5).

Between April and November 1929, a huge new airship dock took shape at the Akron airport. Measuring 1,175 feet long, with a maximum height of 211 feet, the facility would serve as the construction site for the two giant rigid airships taking shape on the drawing boards. Yet another piece fell into place in June 1929, when the Daniel and Florence Guggenheim Fund for the Promotion of Aeronautics appropriated $250,000 to establish an Airship Institute in Akron. Operating under the guidance of Theodore von Kármán, head of the Guggenheim Aeronautical Laboratory at the California Institute of Technology, the Institute was intended to serve as an intellectual center for scientific and technical studies relating to airships.

Construction of the USS *Akron* was underway by the end of October 1929. The airship was christened by First Lady Lou Henry Hoover on August 8, 1931, and left the dock for its first flight on September 27 (fig. 72). Measuring 785 feet long, with a diameter of almost 138 feet, *Akron*, with its sister ship, would be the fastest rigid airship ever built, capable of flying at speeds of over 80 miles per hour. In addition to the giant airship dock at Akron, the Navy constructed two additional

Fig. 71 Dr. Karl Arnstein (1887–1974). (NASM, SI-83-8083)

Fig. 72 USS *Akron* (ZRS-4).

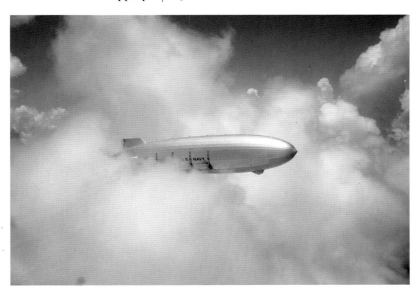

Fig. 73 An F9C-2 Sparrowhawk prepares to hook on to the "trapeze bar" of the USS *Macon* (ZRS-5). (NASM, SI 76-1191)

hangars, one at Naval Air Station Lakehurst, New Jersey, and the other at NAS Sunnyvale, California.

Early in 1932, *Akron* earned high marks for locating the position of opposing destroyers during a fleet exercise off the east coast. Over the next year the airship conducted "hook-on" experiments, launching and retrieving both Consolidated N2Y aircraft and the Curtiss XF9C-2. Selected as the standard naval aircraft to operate from the airships, two prototype and six production versions of the F9C-2 Sparrowhawk would serve with *Akron* and *Macon* (fig. 73). In addition to pioneering these and other operational procedures, *Akron* participated in additional fleet maneuvers and spent considerable time "showing the flag" while flying across the continent.

Jeanette Whitton Moffett, the wife of Admiral William A. Moffett, three-time Chief of the Bureau of Aeronautics, the architect of naval aviation and the Navy's most important supporter of the rigid airship, christened the USS *Macon* (ZRS-5) on March 11, 1933. Just thirteen days later, on April 4, her husband and seventy-three of the seventy-six crewmen on board the *Akron* died when the airship went down at sea during a storm off the coast of New Jersey.

Macon made her first flight on April 21, 1933, just two and a half weeks after her sister ship's demise. The airship received the first of its complement of Sparrowhawks in July, and suffered severe structural damage during a transcontinental flight to her permanent base at NAS Sunnyvale, soon to be renamed Moffett Field. *Macon* was destroyed, in turn, by severe turbulence off the California coast on February 12, 1935. Fortunately, only two of the eighty-three crewmen died in the accident. While nonrigid pressure airships would continue in service with the U.S. Navy until 1962, performing anti-submarine patrols and electronic surveillance, the age of the American rigid airship was at an end.[31]

TWILIGHT OF THE SKYSHIPS

THE SALE OF LZ 126 and the partnership with Goodyear breathed new life into the Zeppelin Company. Things looked even brighter after 1925, when the Treaty of Locarno lifted Allied restrictions on airship production. Hugo Eckener immediately launched a public subscription to fund a new commercial airship. Between depression-era public contributions and German government funding, work began on LZ 127, *Graf Zeppelin*, early in 1927. The finished product measured 775 feet in length, and had a diameter of 100 feet. It was unique among rigid airships. The five Maybach engines propelling the craft burned *blaugas*, a mixture of combustible gases only slightly heavier than air, and far lighter than gasoline or diesel fuel.

Over a nine-year career, this most successful of all commercial Zeppelins would spend 17,178 hours in the air during almost 600 flights. During August 1929, the *Graf Zeppelin* flew around the world: 21,200 miles in 21 days, 7 hours and 34 minutes, including a non-stop flight across Siberia. The airship flew the North Atlantic on several occasions, and offered regularly scheduled passenger services across the South Atlantic between 1932 and 1937. Along with *Los Angeles*, she must be regarded as the most successful rigid airship ever built (fig. 74).

LZ 128 was to have been a slightly larger version of the *Graf*, but the destruction of the R101 led Eckener and his colleagues to scrap their plans. Instead, they began work on an even larger airship that would be inflated with helium, rather than inflammable hydrogen, and powered by diesel engines, which burned fuel oil, far safer than either gasoline or *blaugas*. At the time, the U.S. had a monopoly on the world's supply of helium. As a result, while *Shenandoah*, *Akron* and *Macon* had crashed, they had not burned.[32]

Fearing that the U.S. would reject a request for the sale of helium, however, Eckener did not raise the issue. The new airship, *Hindenburg* (LZ 129), would fly with hydrogen. Ludwig Dürr, who had joined the Zeppelin team in 1899, headed an engineering team that included Arthur Foerster, chief structural engineer, who designed a "fatter" airship than its predecessors. As a result, LZ 129 featured a more favorable ratio of lift to structural weight, and a greater resistance to torsion. Knut Eckener, son of the head of the company, was in charge of construction.

The success of the *Graf Zeppelin* had reignited a new wave of "airship fever" in Germany. Nazi interest in the symbolic value of *Hindenburg*, as the LZ 129 was named, is apparent in the fact that initial government financial support, half a million dollars, came from Minister of Propaganda Joseph Goebbels. Six months later, in March 1935, Air Minister Hermann Goering invested $2 million, and created an operating company, Deutsche Zeppelin-Reederei GmbH (German Zeppelin

Airline Company), with Lufthansa, the government-owned airline, as principal shareholder. From now on, Luftschiffbau Zeppelin would design and build airships, but the Nazi-controlled Deutsche Zeppelin-Reederei would operate them (fig. 75). Hugo Eckener, no friend of the regime, was forced to accept the presence of huge swastikas on the tail fins of his creation.

First flown on March 4, 1936, *Hindenburg* was the most luxurious aerial vehicle of the era. It was designed to convey a crew of forty and seventy-two paying passengers across the Atlantic in style and at a speed matching that of any other mode of transoceanic transport (fig. 76). Three fully stocked bars were manned by a

Fig. 74 *Hindenburg* and *Graf Zeppelin* peddle motor oil.

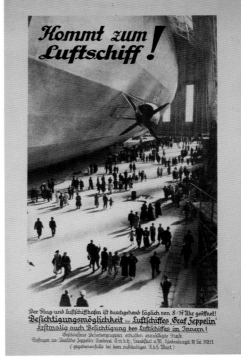

Fig. 75 "Come by Airship!" An advertisement for *Graf Zeppelin* by the Deutsche Zeppelin-Reederi GmbH. (NASM)

Fig. 76 A passenger cabin aboard the *Hindenburg*. (NASM, SI 77-8277)

Fig. 77 The bar and smoking lounge aboard *Hindenburg.* (NASM, SI 79-10063)

Fig. 78 A seating area aboard *Hindenburg.* (NASM, SI 79-10060)

steward twenty-four hours a day. There was a library, a smoking room designed to prevent the escape of sparks (fig. 77), and a sick bay managed by a physician.

One of the most famous pianos of the twentieth century, a baby grand constructed of aluminum, dominated one corner of the lounge. A typical luncheon menu included "Bavarian-style" fattened duck with Champagne cabbage, while dinner offered both a fish and meat course. On an Atlantic crossing, the airship carried 250 bottles of wine. Since a wine glass would spill when the Hindenburg nosed 10 degrees up or down, the elevator men had standing orders not to allow the inclination to exceed 5 degrees.[33]

Passengers uniformly pronounced the airship to be the quietest, smoothest, safest means of crossing the Atlantic (fig. 78). "We slipped through the air with velvety smoothness and almost no vibration," one passenger remarked. "The ship did not sway or buck, the motors hummed but faintly. It was only when you thrust your hand out of the open window into the eighty-miles-an-hour wind that you had any idea of our speed."[34] Deutsche Zeppelin-Reederei publicists were only too pleased to confirm those words of praise. "No passenger on any Zeppelin has ever suffered from air sickness," they explained.[35] None, that is, until the afternoon of May 6, 1937.

LZ 129 offered regular services across both the North and South Atlantic during the 1936 season. Tragedy struck at the end of the first Transatlantic crossing of 1937. In one of the century's great aerial catastrophes, *Hindenburg* caught fire and burned while approaching the mooring mast at U.S. Naval Air Station Lakehurst, New Jersey, on the evening of May 6, 1937, just one year and two days after her first flight (fig. 79). Of the ninety-seven people on board, thirty-five, including thirteen paying passengers, lost their lives. Captain Ernst Lehmann, who had survived the

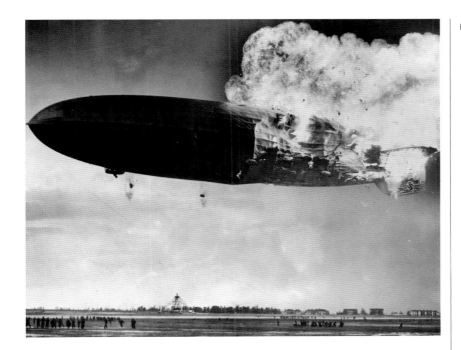

Fig. 79 *Hindenburg*, May 6, 1937. (NASM, SI 73-8701)

Zeppelin campaign of World War I, would succumb to his injuries. Captain Max Pruss, who was in command of the flight, was badly burned but survived. The disaster also took the life of one member of the ground crew.[36]

Why did the *Hindenburg* burn? There is little evidence to support the rumors of sabotage. Hugo Eckener, who was not on the flight, believed that the airship had been overstressed during landing maneuvers. Others claim that the fabric of the outer envelope was especially combustible and might have contributed to the accident. Given the fact that the craft carried 7,000,000 cubic feet of hydrogen, no detailed explanation seems necessary. A slightly torn gas cell coupled with some form of simple static discharge would have been sufficient.

The Zeppelin Company built one more rigid airship—*Graf Zeppelin II* (LZ 130)—in 1938. It probed British radar defenses during the early months of World War II, and was broken up in May 1940.

The story of the rigid airship illustrates the role of transitional technologies that flourish until more appropriate means of performing a task reach fruition. It was no accident that the era of the airship was closing just as large flying boats proved capable of linking the continents.[37]

BLIMPS IN WAR AND PEACE

WITH THE LOSS OF *Shenandoah*, *Akron,* and *Macon*, U.S. Navy interest in lighter-than-air flight languished. When the *Hindenburg* arrived at the U.S. Naval Air Station Lakehurst, New Jersey, on the evening of May 6, 1937, the Navy maintained only four blimps at the facility, including the experimental metal-clad ZMC-2, almost a decade old. With war clouds gathering on the European horizon, however, military planners were unwilling to completely abandon their considerable experience with lighter-than-air craft. In August 1937 the Navy contracted with Goodyear for two new blimps, L-1 and K-2. For a time, at least, Dr. Karl Arnstein, chief designer Hermann Richard Liebert, and their team would remain in the airship business.[38]

The first of the new craft, L-1, was a copy of a Goodyear advertising blimp that would be used for training. The K-2, 246 feet long with a capacity of 404,000 cubic feet, was the largest blimp in the air and the first in a new line of long-distance patrol airships. In June 1940, as part of the Roosevelt administration's push to re-arm America in the air, the Navy was authorized to acquire forty-eight additional blimps. Plans were soon underway for new airship bases to be constructed at South Weymouth, Massachusetts; Elizabeth City, North Carolina; Brunswick, Georgia; Richmond, Florida; Homma, Louisiana; and Hitchcock, Texas.

In spite of the best intentions, however, the U.S. Navy had only ten airships in service when the Japanese attacked Pearl Harbor on December 7, 1941. Until she was officially drafted into the Navy on March 10, 1942, the *Resolute,* Goodyear's Los Angeles-based commercial blimp, patrolled the coastline as a sort of aerial privateer, the crew armed only with the pilot's hunting rifle.[39]

When the U.S. entered the war, Commander Charles Emery Rosendahl was serving as a special assistant for lighter-than-air matters to the U.S. Navy Bureau of Aeronautics (BuAer). The most experienced of all American airship men, he was a 1914 graduate of the Naval Academy who served on destroyers, cruisers and battleships during World War I. Qualifying as a naval aviator in 1924, he was immediately assigned to the *Shenandoah*. When that airship broke up during a line squall over Noble County, Ohio, on September 3, 1925, Rosendahl was able to free balloon the nose section to a safe landing, saving the lives of the six other crewmen and earning the Distinguished Flying Cross in the process. He served as skipper of both the *Los Angeles* and *Akron,* was aboard the *Graf Zeppelin* during her epic flight around the world, and was serving as commander of NAS Lakehurst at the time of the *Hindenburg* disaster.

As BuAer's LTA expert, Rosendahl played a key role in selecting the sites for airship bases along the Atlantic and Gulf coasts. When the U.S. was plunged into

war, he immediately ordered that two blimps be deflated, packed and shipped by rail from Lakehurst to the west coast. Following the loss of the *Macon*, the Navy had turned Moffett Field over to the Army. With the need for a blimp base in the San Francisco area, the Navy asked for the return of the historic field with its giant airship dock. Santa Ana, California and Tillamook, Oregon would also serve as important blimp centers, with auxiliary bases established at Del Mar, Eureka, Lompoc, and Watsonville, California; Astoria and North Bend, Oregon; and Shelton and Quillayut, Washington.

Between September 1941 and April 1944, Goodyear built 154 airships for the Navy. In addition, five pre-war commercial airships were pressed into military service as L-4 to L-8. The vast majority of wartime blimps, 133 of them, were K-ships. Officially, the Navy identified them as ZPN-Ks—Z identifying an LTA craft, P for patrol, N for non-rigid and K to indicate the model. In the phonetic alphabet used for radio identification, K stood for "King." To the men who operated them, they would always be King ships.

These aerial workhorses came in three basic sizes. The early K-ships were almost 250 feet long and 58 feet in diameter. The three models that went into service during World War II boasted gas capacities of 416, 425, and 456,000 cubic feet. Most K-ships were powered by a pair of 550 hp Pratt & Whitney engines that would move a blimp through the air at a maximum speed of just over 70 mph.

Each airship envelope arrived from the factory packed into a box measuring only twelve feet long, six feet tall and six feet wide. The empty weight of the envelope alone was five tons. Like most blimps, the King ships operated with a very low pressure of roughly one ounce per square inch, less than one per cent of atmospheric pressure at sea level. As a result, a small puncture, such as a bullet hole, would result in a very slow leak. In order to maintain pressure, and shape, each envelope was furnished with two internal ballonets, which were inflated by air from the propeller slipstream entering two scoops on the engine nacelle. The pilot controlled the amount of air in the ballonets from the cockpit.

A typical control car was just over forty feet long, nine feet wide and fourteen feet tall. To conduct long-range patrols, each blimp would normally fly with ten officers and men, broken into watches. Machine gun posts fore and aft, a cockpit area, a console for the flight engineer, navigation and communication stations, a small galley, two canvas bunks, chairs for the off-duty crew, a gasoline fueled auxiliary power unit to provide electricity, and a special unit to blow air into the ballonets when the normal system for doing so failed were all shoehorned into the relatively small control car.

Life aboard a K-ship was a no-frills experience. In addition to the overcrowding, the craft had no soundproofing. With the thirteen-foot diameter propellers spinning away just inches from the aluminum walls, they were incredibly noisy. Then there was

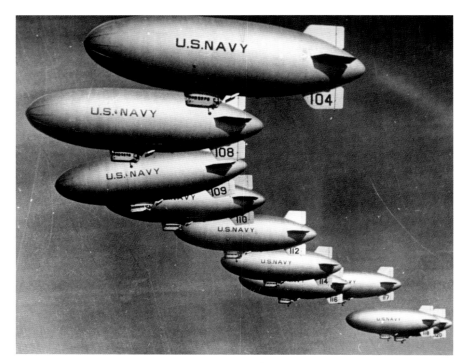

the never-to-be-forgotten aroma of gasoline, rubber, aircraft dope and sweaty bodies. Nor was there any privacy on board a wartime blimp. The urinal consisted of a rubber hose with a funnel on the end hanging on a bulkhead. The toilet was a small metal can with a minimal seat sitting in the open at the rear of the car. The user placed a waxed paper bag in the "can" and disposed of the waste out the nearest window. The waxed paper bags served double duty. The blimps rolled and tossed like ships at sea.

The cabin featured a forward area for the pilot, on the left, who operated the elevator with a large wheel on his right side, and the co-pilot, who controlled the rudder with a steering wheel. The control inputs were transmitted to the elevators and rudders through cables and a chain and sprocket system. One veteran airship man describes the response to control inputs as "sluggish."[40]

Three radio receivers and two transmitters allowed for communications by both voice and continuous wave Morse code transmissions. When "secure communications" were required, the blimp crews resorted to the use of carrier pigeons, trained to return to the home base.

In addition to the K-ships, the Navy would procure twenty-two L-ships, seven G models and four M-class blimps during World War II. The L- and G-ships were training craft (fig. 80). The M-type blimps were 35 feet longer than the K-ships, with a capacity of 647,500 cubic feet of helium. An order for twenty-two of the larger craft was reduced to four when it became apparent that the U-boat threat was on the wane.

For the airships, active service in World War II began on January 11, 1942, when Kapitänleutnant Reinhard Hardegen, commanding U-123, one of five submarines dispatched by Admiral Karl Dönitz to sink ships along the Atlantic coast of the U.S., sank the British steamer *Cyclops* off the Massachusetts coast. The U-boat crews would remember the weeks and months to come as the "Happy Time," a period during which they wreaked havoc with individual ships moving up and down the American coast and convoys carrying vital supplies to England, and, eventually, the Soviet Union.

As the Battle of the Atlantic took shape, the blimps emerged as an important anti-submarine weapon. In addition to operating from bases on the U.S. mainland, Navy

airships flew from air stations in Trinidad, Puerto Rico, Bermuda, Jamaica, Panama, British Guiana, Dutch Guiana, Brazil, and Colombia. On the other side of the Atlantic, the blimps patrolled the Western Mediterranean from a new base at Port Lyautey (Kenitra), French Morocco.

Between January 2, 1942 and May 15, 1945, airships of the Atlantic Fleet flew over 37,554 sorties, remaining in the air for 378,237 hours. The Pacific blimps made over 20,150 flights, raising the wartime total to over half a million miles flown by the blimps. During the course of World War II, the blimps escorted some thousands of vessels. It is said that no ships were lost in convoys when airships were present.

K-ships were fitted with radar to locate submarines on the surface, and a Magnetic Anomaly Detector (MAD), capable of identifying a metallic object, such as a submarine, for a distance of up to 400 feet through air or water. Searching for a sub from scratch with a MAD was like looking for a needle in a haystack. The usual procedure was to proceed to the location of a radar signal or the report of a surface ship. If the blimp's MAD equipment returned a positive reading, the ship would cruise overhead to ascertain if the target was moving. The blimps could also drop sonobuoys, small hydrophone- and radio-equipped devices that could detect and transmit the sound of a submarine's propellers.

Once the crew had identified a target, they could attack with four 325-pound Mark 17 depth bombs, two carried in an internal bomb bay and two on an external rack. A 50-caliber aircraft machine gun was mounted in a gunner's station above the cockpit. A 30-caliber machine gun was mounted on a rear window. By 1944, the K-ships were also equipped with Mark 24 acoustic torpedoes and Hedgehog depth charges.

Actual anti-submarine attacks were quite rare. Only nineteen such attacks were recorded in 1943. A post-war comparison of U.S. Navy attack reports with German U-boat records failed to produce any cases in which a German submarine was sunk by a blimp acting alone. U-boats certainly were sunk by blimps operating in concert with surface ships, however. Two K-ships played a critical role as members of a surface and air team that sank the last U-boat of World War II in American waters on May 5, 1945.

In addition to their anti-submarine role, the blimps were critically important to search and rescue efforts at sea. The airships spotted downed aircraft, ships in danger and survivors in the water.

Success came at a price. One of the best-known mysteries of the war in the air began to unfold just before noon on August 16, 1942, when L-8 touched down in Daly City, California—without its two-man crew. Lt. Ernest D. Cody and Ensign Charles Adams had taken off from San Francisco's Treasure Island at 06:00 that

morning. At 07:50, they reported that they were investigating an oil slick off the Farallon Islands. The airship was sighted several times that morning, but all attempts to contact the crew failed. The possibility that the pair had been snatched by otherwise undetected Japanese submariners was too far-fetched to be considered, and the calm weather that morning made it unlikely that both men could have been thrown from the car. Had one crewman slipped and fallen out the door, followed by the second man trying to catch him? We will never know what took the lives of these first two casualties of the wartime airship program.

Throughout the war, most of the action, and the fatalities, occurred in the Atlantic. One blimp, K-74, was shot down by a U-boat on July 18, 1943, with the loss of one crewman who died in the water. Only one of the nine crewmen aboard K-64 survived when that airship collided with K-7 on the foggy morning of October 16, 1943. Three officers and five enlisted men were lost later that month when K-94 caught fire in the air. All told, thirty-five men died on operational missions flown by blimps of the Atlantic fleet. Perhaps five others died in ground accidents.[41]

At the close of World War II, fifteen operational blimp squadrons were patrolling some 3 million miles of ocean off both coasts. The airships continued to play an important role in anti-submarine patrols during the post-war era. Goodyear produced the ZSG4 and ZSG2G as early replacements for the aging King ships. The ultimate replacement was the ZPG-2N, the Nan-ship. Introduced in the early 1950s, the N-ships were 343 feet long, 80 feet in diameter, with a gas capacity of 1,011,000 cubic feet. They featured a control car 80 feet long, complete with an on-board engine compartment and a compact Combat Information Center (CIC).[42]

The onset of the Cold War created one final role for U.S. Navy airships. The fear of a Soviet surprise attack led to the creation of a series of early warning lines stretching across North America. These were integrated networks of radar stations and communications facilities. Large blimps, equipped with advanced radar systems and capable of remaining in the air for long periods of time, were used to close gaps in the network.

In 1954, Goodyear delivered four new ZPG-2 blimps, three of which were designed for the Airborne Warning Mission and designated ZPG-2W. The new airships featured one radar antenna mounted on the belly of the control car, and a height-finding radar installed on top of the envelope. With a crew of twenty-one, the ZPG-2W ships could remain in the air for more than 200 hours, a fact demonstrated when one of the craft made a double Transatlantic crossing, covering 8,216 miles in 264 hours.

The final Navy blimp, the ZPG-3W, first flew in July 1958. Basically an enlarged ZPG-2W, the airship's envelope was 343 feet long and 75 feet in diameter with a gas capacity of 1,500,000 cubic feet. A forty-foot surveillance antenna, the largest ever flown in an aircraft, was suspended inside the gas envelope, with the height-finding

radar mounted on top of the craft. A seventy-five-foot ladder in a gas-tight vertical fabric tunnel led from the control car to the sealed radar platform inside the envelope. Longer than a football field, each of the ships had cost $8,722,000.

On July 6, 1960, eighteen of the twenty-one crewmen dispatched from Lakehurst to search for a lost yacht lost their lives when their ZPG-3W slammed into the Atlantic. Admiral Rosendahl, now retired, blamed the disaster on the fact that single-cell pressure airships had simply grown too large, and argued for a return to a form of rigid airship.

The disaster did nothing to improve the reputation of the blimp in naval service. In the spring of 1961, NAS Lakehurst was placed on the list of military bases to be closed as a cost-saving measure. Pentagon planners argued that helicopters and improved fixed wing aircraft could perform radar picket, search and rescue and other duties more effectively and efficiently than the blimps. The long history of lighter-than-air operations in the U.S. Navy officially came to an end on November 30, 1961.[43]

It was not, of course, the end of the blimp. Goodyear restarted its corporate airship operation at the end of the war with seven L models and six K-ships purchased from the Navy. A new era in the saga of the Goodyear blimp dawned in 1959, when the first of the new GZ-19 airships, *Mayflower*, took to the air. The new craft featured major improvements to the control car and a 132,000 cubic foot envelope. *Mayflower* was upgraded to GZ-19A in 1966, and fitted with a 147,300 cubic foot envelope that enabled it to operate with the first of the "Skytacular" signs, featuring four-color messages in running lights on the side of the airship.

Columbia debuted the GZ-20 class airships, with their 202,700 cubic foot envelopes, bigger signs and improved engines, in 1969. At 247,800 cubic feet, *The Spirit of Akron* (GZ-22), introduced in 1982, was Goodyear's largest blimp. Outfitted with fly-by-wire electronic controls, propellers that could be swiveled for improved maneuvering and other features designed to intrigue potential military customers, it was also the company's most technologically advanced product. When the airship was lost in a 1999 accident, Goodyear continued to use older model airships.

In 2007, only three Goodyear manufactured airships were still in operation: *The Spirit of Goodyear,* based in Ohio; *The Spirit of Innovation*, operating out of Florida; and the California-based *Spirit of America.* Four other Goodyear-owned airships, manufactured by the American Blimp Company and operated for Goodyear by the Lightship Group, are based in Brazil and Europe. American Blimp, based in Hillsboro, Oregon, produced such well-known advertising airships as Metlife's *Snoopy One* and *Snoopy Two.* Airship Management Services, Inc., also operates large blimps for corporate clients. While the giants that roamed the skies during the first four decades of the twentieth century are no more, the sight of a large pressure airship in flight continues to delight people around the globe.

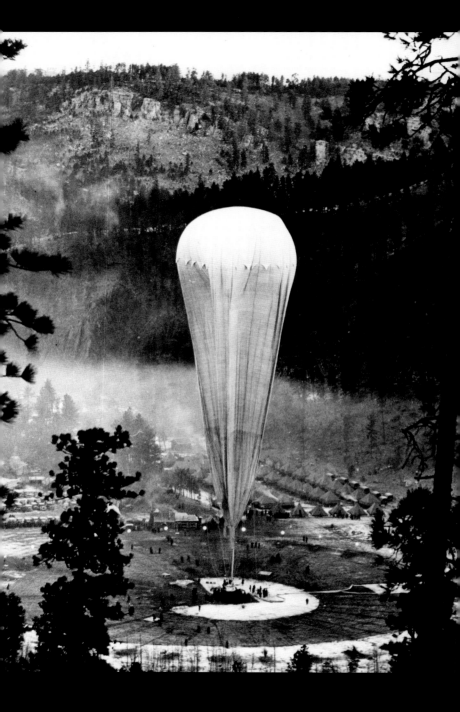

SCIENCE IN THE SKY

SCIENTIFIC BALLOONING FROM THE BEGINNING TO TODAY

"AD ASTRA PER ARDUA"

U NTIL THE ADVENT OF THE SPACE AGE, the balloon continued to offer one great advantage over the airplane—the ability to climb to the very roof of the sky, where there was too little air to provide lift for wings or to support air-breathing engines. As a result, the oldest flying machine remained an essential tool enabling scientists to study conditions in the upper atmosphere and near-earth space, and to develop and test equipment and techniques that would protect the first generation of space travelers.

John Jeffries, a Loyalist American physician, launched the era of balloon science when he ascended from London on November 30, 1784, on a flight piloted by Jean-Pierre-François Blanchard. Dr. Jeffries commissioned Jones & Sons, Ltd., London instrument makers, to provide a large barometer and thermometer to be carried aloft. Henry Cavendish, the chemist who had first isolated hydrogen, gave Jeffries several vials to fill with samples of air gathered high above the earth. In addition, he carried a compass, an electrometer and a hygrometer with which to study conditions aloft. Jeffries confirmed that the temperature decreased with altitude, and kept a careful record of the declining barometric pressure and of variations in humidity.

French aeronaut Étienne Robertson purchased *L'Entreprenant*, the world's first military balloon, when the Corps d'Aérostiers was disbanded in 1799. His claim to have reached 23,526 feet during an ascent from Hamburg with a companion, M. Lhoëst, on July 18, 1803 was surely an exaggeration. A balloon with the capacity of *L'Entreprenant* could not reach such an altitude and retain sufficient gas or ballast for a safe return to earth. Robertson's report that Lhoëst's head swelled to such an extent that he was unable to wear his hat also fueled suspicions.

Joseph-Louis Gay-Lussac and Jean-Baptiste Biot flew another decommissioned military balloon from Paris on August 24, 1804 to an altitude of 13,000 feet and conducted electro-magnetic experiments that contradicted results reported by Robertson. Reascending alone, Gay-Lussac reached 21,400 feet. Charles Green claimed to have set a new record of 27,146 feet on September 10, 1838. The reality may have been something closer to 25,000 feet. Jean-Augustine Barrel and a physician, Jacques Bixio, must have come close to Green's record during an ascent from the Paris Observatory on July 25, 1850. Whatever their actual altitudes, pioneering balloonists were clearly approaching a point where human beings could no longer survive without supplemental oxygen.

James Whitbread Lee Glaisher marshaled professional scientific support for a program of high-altitude research. A pioneering student of the atmosphere and head of the department of magnetics and meteorology at the Greenwich

Observatory since 1838, Glaisher was intrigued by a series of altitude flights undertaken by Charles Green and John Welsh of the Kew Observatory with the support of the British Association for the Advancement of Science between August and November 1852.

Determined that the balloon should be a tool of science, "rather than an object of exhibitions, or a vehicle for carrying into the higher regions of the air … mere seekers after adventure," the scientist convinced the members of the British Association to fund a series of fully instrumented research flights. Henry Coxwell, an experienced aerial showman, built a suitable balloon with a capacity of 90,000 cubic feet of lifting gas. Glaisher took command of the scientific arrangements, positioning an assortment of thirteen instruments on a special table in the basket.

After preliminary flights on July 17 and August 18, 1862, Coxwell and Glaisher rose into the air from Wolverhampton at 1:00 p.m. on September 5. Climbing through a layer of cloud, they broke into bright sunlight, with a deep blue sky above, and the endless, rolling, cloud tops beneath them. Two hours later they were 26,000 feet in the air. "Up to this time," Glaisher reported, "I had taken observations with comfort and had experienced no difficulty in breathing, while Mr. Coxwell, in consequence of the exertions he had to make had breathed with difficulty for some time." Small wonder. Henry Coxwell, age forty-three, and James Glaisher, ten years older, were now approaching 30,000 feet without supplemental oxygen!

Glaisher was soon unable to move his arms or legs. "I fell backwards, my back resting against the side of the car and my head on its edge." Unable to speak, and rapidly losing consciousness, he saw Coxwell struggling to reach the valve line tangled in the ropes above the load ring. His next memory was of his companion shaking him awake. Unable to use his hands because of the combination of bitter cold and lack of oxygen, Coxwell had clambered up onto the load ring and yanked the valve line with his teeth. The pair returned safely to earth an hour and a half after take-off.[1]

Glaisher would make a great many more balloon flights before his death in 1903, and participate in the founding of what would become the Royal Aeronautical Society (1866). Glaisher and Coxwell had traveled only six miles, straight up, but they faced perils that rivaled those encountered by other scientific adventurers of the era who traversed thousands of miles in search of the North Pole or the source of the Nile. Those who doubt that have only to consider the fate of the next group of aeronauts to venture into the substratosphere.

That flight began on April 15, 1875, when Gaston Tissandier, Joseph Crocé-Spinelli and Théodore Sivel ascended from the La Villette gas works, near Paris. Tissandier, a native Parisian, was a chemist serving as the head of the Union Nationale laboratory, a professor at the Association Polytechnique, and the founding editor of the scientific journal *La Nature*. An interest in meteorology led to his first

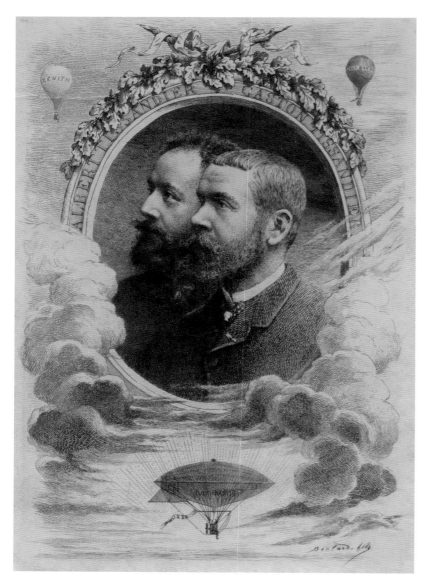

balloon flight in 1868. Two years later, in September 1870, he piloted a balloon out of besieged Paris, and continued serving as an observation balloonist with the French army in the field, emerging from the conflict as a national hero.

In 1873, the French Society for Aerial Navigation began sponsoring a series of high-altitude flights with the balloon *Zénith*, designed to gather information on the upper atmosphere, and perhaps snatch the world's altitude record back from the English. Gaston Tissandier and his brother Albert began working with Paul Bert, a professor of physiology at the Sorbonne whose studies of the effect of pressure on the human body laid the foundation of modern aerospace medicine (fig. 81). The balloonists "ascended" to 20,000 feet in Bert's pressure chamber, experiencing "the disagreeable effects of decompression and the favorable influence of superoxygenated air." On the basis of that experience, the aeronauts would ascend with large, striped bags of oxygen-rich air, from which they could take occasional breaths through long tubes.[2]

The Tissandier brothers made one ascent with fellow researchers Crocé-Spinelli and Sivel on March 23–24, 1875. Three weeks later, on April 15, Gaston took Crocé-Spinelli and Sivel aloft once more. At 23,000 feet, Tissandier reported that his hands were cold. Crocé-Spinelli was struggling for breath, and Sivel had just cut loose more ballast to send them even higher. At 25,000 feet, Tissandier noted that "[The] condition of stupefaction is extraordinary." He awoke half an hour later to find his companions unconscious and the balloon rapidly descending. He dropped ballast to slow their descent, then fell unconscious again. When the aeronaut regained his senses, he was unable to revive Sivel and Crocé-Spinelli, both of whom were bleeding from the mouth.

Tissandier brought the *Zénith* safely to earth, but both of his companions were dead. Paul Bert presented the eulogy at the funeral, celebrating the two men as

martyrs in the cause of science. Clearly, high-altitude ballooning was not for the faint of heart. It required more than idle curiosity to justify the risks. When the next scientist braved the upper air two decades later, it was with a very specific research agenda in mind.

THE MYSTERIOUS RAYS

B Y 1900, PHYSICISTS FACED a series of new puzzles, the answers to which would lead to an entirely new understanding of the universe. This era of revolutionary change began in 1895, when Wilhelm Conrad Röntgen and his French colleagues, Henri Becquerel, and Marie and Pierre Curie, announced the discovery of radiation, a mysterious energy produced by natural materials such as uranium. Experimentation showed that exposure to the newly discovered "X-rays" dramatically increased the electrical conductivity of gases. This phenomenon resulted from "ionization," the action of "ions," or electrical carriers, created by the interaction of radiation with the atoms of gases.[3]

The surprise came when it was discovered that gases, including the air, were always slightly ionized. Was this the result of natural sources of terrestrial radioactivity, or was the atmosphere being bombarded by radiation from above? As physicists gradually became aware of the widespread occurrence of low-grade radiation in the rocks and soil, the early conclusion was to reject the notion of an extraterrestrial source for ionization. Measurements with simple gold-leaf electrometers, however, left room for doubt.[4]

In 1909 Albert Gockel of Fribourg University, Switzerland, suggested sending an electrometer aloft on a balloon to determine if the level of radiation dropped as the craft ascended. Karl Bergwitz, a German physicist, made the first such flight in October of that year. Gockel followed suit in December. In both cases, inadequate instruments yielded inconclusive results.

Undeterred, Gockel flew with improved electrometers in 1910 and 1911, reporting a slight but surprising increase in radiation at higher altitudes. Victor Hess, a twenty-eight-year-old physicist at the Institute of Radium Research in Vienna took up the quest in the summer of 1911. Using an improved electrometer, he made nine flights to altitudes of up to 16,400 feet in 1911 and 1912. Discovering that the radiation at that altitude was six times higher than that on the ground, Hess announced that "cosmic gamma radiation" of extraterrestrial origin was raining down on the earth.

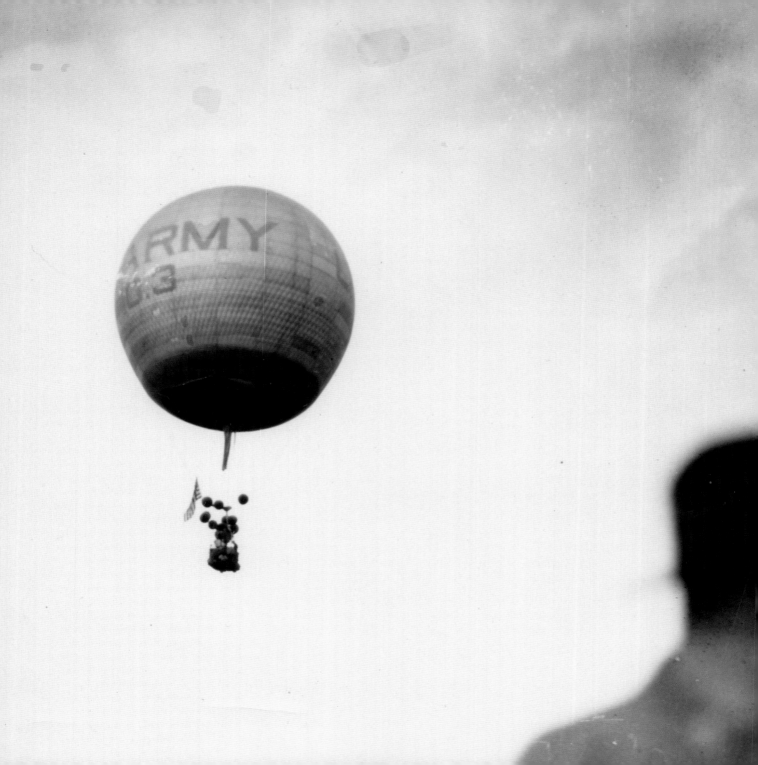

DEATH IN THE SKY

B Y THE EARLY 1920s it was clear that there were more practical reasons to probe the mysteries of the upper atmosphere. Wireless transmissions depended on conditions in the ionosphere, 300 kilometers up. The development of the turbo-supercharger made it possible to operate aircraft engines in the thin, frigid air of the substratosphere for the first time. U.S. Air Service test pilots breathed oxygen through pipe stems and operated without benefit of pressure garments or electrically heated flying clothing as they coaxed their open-cockpit biplanes to ever higher altitudes. They returned to earth semi-conscious, with tales of the incredibly difficult physical conditions encountered nearly eight miles above the surface of the earth. A great many questions would have to be answered, a great many problems solved, before military or commercial flying operations could be conducted in the inhospitable region of the substratosphere (fig. 82).

The use of balloons to answer those questions was a dangerous business, as evidenced by the experience of U.S. Army Air Corps balloonist Captain Hawthorne C. Gray, who launched from Scott Field, Illinois on November 4, 1927 on his third attempt to explore conditions and test equipment that would enable air crew to survive and function at altitudes of over 40,000 feet (fig. 83). The balloon and basket, with the lifeless body still inside, was found the next afternoon in a tree near Sparta, Tennessee. The pilot had apparently become confused and parachuted a full bottle of oxygen to earth in an effort to climb even higher. He died of hypoxia. "His courage," suggested the citation of his posthumous Distinguished Flying Cross "was greater than his supply of oxygen."[5]

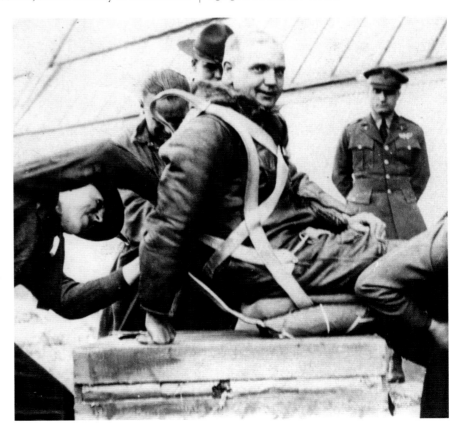

BALLOON SONDES

FOLLOWING GRAY'S DEATH, there were only two obvious routes open to scientists interested in studying conditions in the upper atmosphere. Balloon sondes carried automatic recording instruments into the upper atmosphere without endangering a human aeronaut. The French researcher Gustave Hermite flew the first meteorological "registering balloons" in 1892. They were relatively large craft that descended very slowly through the normal loss of gas, commonly remaining aloft for long periods of time and covering distances of up to 700 miles. The German meteorologist Richard Assmann introduced an improved design in 1901, a closed rubber balloon designed to burst at altitude, parachuting the instruments to earth much closer to the take-off point.

Lawrence Rotch, director of the Blue Hill Meteorological Observatory in Massachusetts, introduced the Assmann balloons to America during the 1904 Louisiana Purchase Exposition in St. Louis. Between 1904 and 1908 the Blue Hill staff supervised the launch and retrieval of some eighty instrumented balloons. A typical flight lasted two to three hours, during which time the balloon would reach an altitude of eight to ten miles. Fifty-three of the fifty-six balloons launched in 1908 were recovered with good instrument records.

Charles Greeley Abbot, director of the Smithsonian Astrophysical Observatory, used small aerostats to carry specially designed pyrheliometers into the upper atmosphere. Abbot was attempting to study the nature of solar energy and its impact on the earth. Because of the extent to which portions of the spectrum were absorbed during passage through the earth's atmosphere, it was important to obtain readings from as high an altitude as possible. The first of the instruments was launched from a Weather Bureau station at Omaha, Nebraska, in July 1914. Abbot claimed that the scientific package, which was retrieved in Iowa, attained an altitude of 15 miles. Later Smithsonian balloons climbed 20 miles into the sky.

Abbot also confirmed the existence of an atmospheric region first discovered by the French meteorologist Léon Teisserenc de Bort in 1899 on the basis of his own experiments with sounding balloons. As expected, average temperatures fell as a balloon climbed toward an altitude of seven to ten miles. At that point, temperatures unexpectedly stabilized, and even rose a degree or two. Abbot referred to this mysterious region of static temperature as the isothermal layer. In fact, the instrumented balloons had entered the stratosphere, an atmospheric region occurring between seven and thirty miles up.

Physicist Robert Millikan first employed balloon sondes to investigate "cosmic rays," a term he coined in 1925. He had served as vice chair of the National Research

Council, an organization created by the National Academy of Sciences during World War I as a means of marshaling the full power of American science in support of the national defense. In that capacity, Millikan supervised work on an unmanned balloon weapon. Building on that wartime experience, he obtained a grant from the Carnegie Institution in 1921 to support the design and construction of automatic electroscopes for balloon sondes.

Millikan sent four instrumented balloons aloft from the U.S. Air Service facility at Kelly Field, Texas, in 1922. Russell Otis, one of his graduate students, equipped an airplane with a Millikan electrometer and conducted additional tests in 1922–23. Together, the pair also operated an electrometer at the top of Pike's Peak in the fall of 1923. When all of these experiments produced readings below those predicted by pre-war European researchers, Millikan announced that an extraterrestrial origin for penetrating radiation was unlikely. Coming from a distinguished scientist, the 1923 recipient of the Nobel Prize for physics, the announcement carried enormous weight.[6]

Subsequent tests led Millikan to doubt his original conclusions, however. Moreover, European experiments in which electrometers were flown on airplanes confirmed the pre-war findings. Ultimately, even Millikan was forced to admit that his data was flawed. There was no longer any doubt that the mysterious rays were indeed coming from the Cosmos.

SCRAMBLING FOR ALTITUDE

ONE RESULT OF THE COSMIC RAY CONFUSION was to underscore the uncertainty of data produced by automatic instruments. There was a clear value in sending a human observer to extreme altitudes to obtain reliable readings.

In 1929 the Belgian Fonds National de la Recherche Scientifique (FNRS) approved a 400,000 franc grant to Auguste Piccard, a Swiss physicist teaching at the University of Brussels, who proposed to build a sealed, pressurized balloon gondola that would enable him to conduct cosmic ray measurements at record altitudes. The world's first pressurized balloon gondola was a globe of pure aluminum measuring just under four feet in diameter. A pressure regulator of the type used aboard German U-boats maintained air in the cabin, which was circulated through alkaline filters to purge it of carbon dioxide. Piccard had half the gondola painted white and half black. Small external fans would allow the researchers inside to turn one side or the other toward the Sun to regulate the interior temperature.

In order to carry two men and their instruments into the stratosphere, Piccard designed the largest balloon envelope built to that time; so large that it could have lifted the weight of a locomotive off the ground! What seemed to be only a bubble of hydrogen at launch expanded to completely fill the 500,000 cubic foot balloon at altitude. To conserve weight and maximize altitude, the scientist did away with the normal load ring, suspending the gondola from a fabric girdle around the lower section of the balloon.

Piccard flew the *FNRS* for the first time with assistant Paul Kipfer on May 27, 1931. Launching from Augsburg, Bavaria, where the balloon had been constructed, the pair rose to a record altitude of 51,784 feet. Things did not go well. The crew worked feverishly to seal a leak in the skin; the rope system enabling them to open the gas valve to descend broke; and temperatures climbed to over 98 degrees in the tiny cabin when the fans designed to turn the gondola failed. As the gas cooled after nightfall, *FNRS* descended naturally, depositing the two scientists safely on a glacier in the Bavarian Alps. Damaged in landing, the gondola would never fly again.

Piccard had been able to take only one inconclusive reading with his electroscope. With his reputation as a high-altitude explorer established, however, he had little trouble in persuading the FNRS to fund a second balloon, which he flew to a new record altitude of almost 52,500 feet with Max Cosyns on August 18, 1932 (fig. 84). Using improved instruments, including a Geiger counter, this journey into the stratosphere provided a greater scientific return than the first flight.[7]

Only a few days before the much-publicized second *FNRS* launch, German physicist Erich Regener sent a balloon sonde equipped with improved automatic instruments up to an altitude of more than sixteen miles, six miles higher than Piccard had achieved. But the public paid little attention to Regener's instrumented flight, whereas Piccard returned from the stratosphere as a scientific celebrity of the first order. For the newspaper-reading public of the 1920s and 1930s, the mysterious stratosphere was not just a layer of the atmosphere. It was a new and dangerous frontier in the sky, full of mysteries waiting to be unlocked by the intrepid scientist/explorers.

Soviet dictator Joseph Stalin, who used flight spectaculars as a means of building national pride and impressing the rest of the world with Russian technological prowess, recognized the value of setting a new world altitude mark. Officials of the Aviation Branch of Stalin's Ministry of War and the Scientific Investigation Institute for the Rubber Industry (NIIRP) constructed the stratostat *USSR*, a balloon even larger than Piccard's. Standing 118 feet tall when fully inflated, the craft featured a gondola made of riveted aluminum sheets. On September 30, 1933, Georgi Prokofiev, Ernst Bernbaum and Konstantine Gudunov achieved their goal, rising to 58,700 feet.

Less than two months later, on November 20, 1933, Lt. Commander Thomas G. W. "Tex" Settle (USN) and Major Chester Fordney (USMC) launched the balloon

Fig. 84 Auguste Piccard and Max Cosyns in the gondola of the *FNRS*. (NASM, SI 88-13375)

Fig. 85 Major Chester Fordney (left) and Lt. Com. Thomas G. W. "Tex" Settle following the *Century of Progress* flight, November 20, 1933. (NASM, SI 71-3015)

Fig. 86 *Century of Progress.* (NASM, SI 75-15326)

Century of Progress, named for the World's Fair under way in Chicago, from the airport at Akron, Ohio and flew to an altitude of 61,221 feet (fig. 85).[8] Auguste Piccard's twin brother Jean, who had immigrated to America in 1926, headed the scientific team planning that flight. The *Century of Progress* was outfitted with two electroscopes, a cosmic ray telescope, and fruit flies that would serve as guinea pigs for studies of genetic mutations. On October 23, 1934, Jeanette Piccard, flying with her husband, Jean, ascended to an altitude of 57,579 feet in the *Century of Progress,* becoming the first woman to enter the stratosphere (fig. 86).

Unwilling to allow the record to slip through their fingers, the Soviets prepared to raise the mark with a new balloon, *Osaviakhim I.* Selection of the three crew members was based on a national search, the "winners" of which were treated to a rigorous training program. On January 30, 1934, the balloon rose to a new record altitude of 72,178 feet over Moscow. Low on both ballast and gas, everything went wrong on the way down. The crew died when the gondola broke loose from the balloon and smashed to earth. Stalin, Molotov and Marshal Voroshilov, the head of the Soviet military, presided as the ashes of the heroes were buried in the Kremlin wall.

Captain Albert W. Stevens of the U.S. Army Air Corps recognized that a concerted effort to win the race to the stratosphere offered an opportunity to pursue some important technological and scientific goals while at the same time achieving inter-

national prestige for his service. A graduate of the University of Maine with a B.S. and M.S. in electrical engineering, Stevens set up power plants for mining companies before enlisting in the Air Service in 1917. Trained as an aerial photographer and bombardier, he was twice decorated for valor during photo missions over the Western Front.

Stevens returned to the U.S. as a Captain and spent most of the next fifteen years assigned to the Air Corps Engineering Division at McCook and Wright Fields, Dayton, Ohio (fig. 87). He developed the equipment and techniques required to take high-quality oblique aerial photographs; and participated in the creation of the first photomosaic map of the U.S. for the Air Corps and the Geological Survey. In 1924, he teamed with Army test pilot John Macready in an eight-week, 10,000 miles campaign that produced aerial photographs of cities and towns from Dayton to San Diego, California. On June 12, 1922, Stevens accompanied the crew of a Martin bomber as they climbed to 24,306 feet, where he bailed out, reaching the ground safely more than ten minutes later and thirty miles from the point at which he had begun his record-setting jump.[9]

In 1932, Stevens launched an effort to convince his superiors of the advantages of establishing an Air Corps high-altitude balloon program. The Belgian/Swiss and Soviet flights were to initiate a race for the prestige of setting the world altitude record. Perhaps more important, Stevens pointed out that U.S. Navy plans for the Settle-Fordney flight were already under way. Air Corps leaders approved a year-long study effort, and the use of military personnel, facilities and equipment, but refused to fund the development or manufacture of new equipment.

Stevens immediately turned to his friend Gilbert Grosvenor, head of the National Geographic Society. The *National Geographic Magazine* was an American success

Fig. 87 Captain Albert W. Stevens (March 13, 1886–March 26, 1949) (left) and Captain St. Clair Street prepare for a high-altitude photographic flight, October 10, 1928. (NASM, SI 92-5823)

story, with an astounding one million monthly readers by 1934. The leaders of the National Geographic Society took careful note of growing public interest in what was rapidly becoming a race to the stratosphere by rival nations. The organization had built its reputation on support for adventurous expeditions with "scientific" trappings, from Robert Peary's 1909 trek to the North Pole to Hiram Bingham's discovery of the "lost" Inca city of Machu Picchu in 1911. The editors of the Society's famous magazine were always interested in a story that would enable their readers to share the thrill of discovery and a sense that their dues made them a part of the thrilling search for new knowledge.

Albert Stevens and his project seemed made to order for the *National Geographic*. Even more intriguing, an adventurous ascent to record altitudes could now be linked to a newsworthy scientific controversy. Robert Millikan, a deeply religious man, was arguing that cosmic rays were photons, uncharged particles produced by a constant creative force that would prevent the ultimate winding down of the universe. Arthur Holly Compton, another Nobel laureate on the faculty of the University of Chicago, argued, on the other hand, that cosmic radiation was produced by charged particles resulting from the disintegration of matter, not its creation. As the newspapers were quick to point out, what appeared to be an esoteric disagreement involved questions related to the creation and ultimate fate of the universe.[10]

Albert Stevens was a known commodity to Grosvenor and his colleagues. The airman had contributed articles to the Society's famous magazine, and participated in several expeditions sponsored by the organization. In December 1933, the Society agreed to donate $25,000 to support the enterprise. Donations from other individuals and organizations, including Eastman Kodak, Sherman Fairchild, Fairchild Aerial Camera Corporation, and Cornelius Whitney, President of Pan American Airways, brought the total up to $45,000.

Stevens also worked hard to ensure that the project would return maximum scientific benefit. This was not only an honest goal of the flight, but also a key element in the public relations effort that would call favorable attention to the Air Corps, the National Geographic Society and other participants. His first step was to enlist the support and services of Robert Millikan, now head of the California Institute of Technology. A Scientific Advisory Board established with the assistance of Millikan and the National Geographic Society helped to create a well-rounded research program. The primary scientific work of the flight would include measurement of temperature, pressure and humidity; photographs of the solar spectrum; electroscopic studies of the atmospheric electrical gradient, which would provide information on cosmic rays; measurements of solar radiation; atmospheric sampling; radio propagation studies; the exposure of plant spores to the upper atmosphere; and information on wind patterns.[11]

By late February 1934, Stevens was still $5,000 short of his $50,000 budget. Dow Chemical, which manufactured the *Explorer* gondola of Dowmetal, a lightweight magnesium alloy, and Goodyear-Zeppelin, the firm that produced the envelope, came to the rescue by supplying their contributions at below cost.

The envelope, with a capacity of 3,000,000 cubic feet, was five times larger than any balloon the company had ever produced. Designed by a team of engineers headed by the famous Zeppelin designer Karl Arnstein, the balloon was constructed of two acres of rubberized cotton fabric produced in three weights to be used in different sections of the envelope. At launch, it would contain a small bubble of hydrogen filling only 7 percent of its total capacity. On its climb into the stratosphere, the *Explorer* balloon would gradually swell into a complete sphere.

Brig. General Oscar Westover, assistant chief of the Army Air Corps, assigned Major William E. Kepner as the pilot and commander of the flight, and Captain Orvil Anderson as the alternate pilot and operations manager in charge of launch preparations (fig. 88). Unlike Stevens, both men had extensive lighter-than-air experience and were graduates of the Navy rigid airship pilot training program.

Following a survey of some forty potential launch sites, Stevens and his colleagues selected "a wonderful natural bowl" eleven miles southwest of Rapid City, South Dakota. Located in the gold mining area of the Black Hills, this natural depression was originally known as the Bonanza Bar. It consisted of a level area the size of three or four football fields surrounded on three sides by vertical walls. The topography of the area, coupled with the presence of an inversion layer of cold air over the bowl, would allow the crew to inflate and launch the huge balloon in calm, relatively wind-free conditions. The proximity to a U.S. Army post clinched the decision.

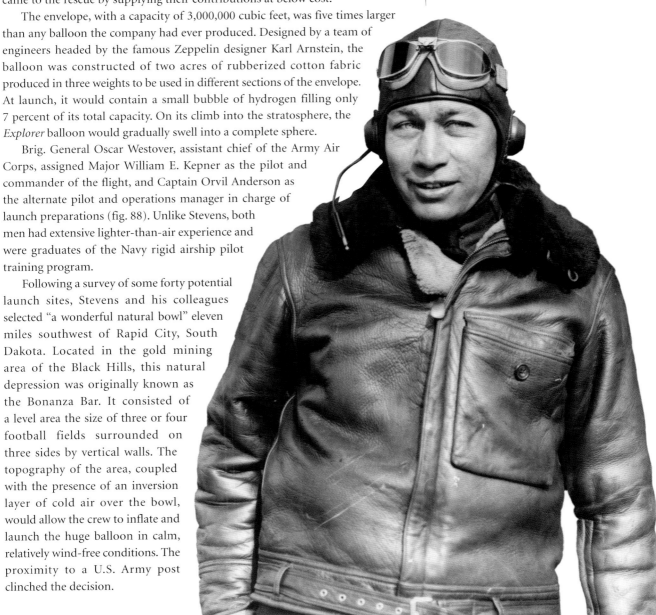

Fig. 88 Orvil A. Anderson (1902–1966). (NASM, SI 82-6100)

Hydrogen from the first of 1,500 cylinders trucked into the site began to hiss into the envelope laid out on the floor of what was now known as the Stratobowl, at 7:50 a.m. on July 27, 1934. Stevens and Anderson climbed into the gondola before 5 a.m. the next morning. Kepner would remain outside, standing on top of the gondola to supervise the launch. By noon they had reached an altitude of 40,680 feet. An hour later they were approaching 60,500 feet when they noticed that several large rips were developing in the lower portion of the envelope. Beginning their descent short of a record altitude, they were passing through 16,000 feet when the gas bag began to disintegrate (fig. 89).

With the balloon literally falling out of the sky, Kepner opened the hatch and climbed onto the top of the gondola to assist the others in exiting. Anderson's parachute opened when he was only halfway out of the hatch. He jumped holding the silk canopy in his arms. The pressure of the wind trapped Stevens halfway out of the hatch for a few seconds, until Kepner helped him push free. All three men landed safely near Holdredge, North Dakota, 225 miles from the Stratobowl. The gondola was completely destroyed, although the spectroscope survived, along with data that had been recorded photographically.

An accident review panel determined that improper folding had damaged the envelope, allowing hydrogen to mix with the air, resulting in an explosion. The National Geographic Society, which had gotten a much more exciting story than if the flight had been a complete success, agreed to fund another attempt. The *Explorer II* balloon boasted a capacity of 3,700,000 cubic feet, 700,000 cubic feet larger than its predecessor. It would be filled with slightly heavier, but much safer, helium gas.

Kepner was scheduled to attend the Air Corps Tactical School at Maxwell Field, Montgomery, Alabama. Stevens, assigned duty as the pilot in command, and Anderson would make the second attempt on their own. Capt. Randolph P. Williams would serve as operations officer. The first attempt to inflate the new balloon on the floor of the Stratobowl on July 12, 1935, failed when a faulty ripping panel opened prematurely. Repairs and the installation of an improved design prevented another attempt until November 11 (fig. 90).

Fig. 89 *Explorer I* breaking up in the air, July 27, 1934. (NASM, SI 75-15238)

Fig. 90 *Explorer II* ready to launch, November 11, 1935. (NASM, Lee Wells Collection, SI A-43421)

Fig. 91 *Explorer II* gondola. (NASM, SI A-4423-F)

By 11:40 a.m., just over four and one-half hours after take-off, Kepner and Anderson calculated that they had reached 72,395 feet. The rest of the flight was uneventful (fig. 91). The pair landed safely near White Lake, South Dakota at 3:14 p.m., having established a world altitude record.

The Soviets were unwilling to abandon the field. On June 23, 1935, the balloon *USSR-1 bis* carried a three-man crew to an altitude of 50,000 feet, at which point the craft began to drop out of the sky, probably because of damage to the envelope. Two of the crew parachuted to safety, reducing the weight of the craft and allowing the third man to survive a hard landing. On July 18, 1938, two Soviet pilots and two physicians ascended in *Substratostat.* For reasons that are not clear, all four men were found dead when the balloon made a gentle landing. With their own failures, and the near disaster of *Explorer I* in mind, the Soviets developed a new balloon, *Komsomol VR-60*, which would parachute back to earth in the event of problems at altitude. While the details are sketchy, the balloon is known to have reached 52,500 feet on October 12, 1939.

The Poles made a belated entry into the field. Based on a study of U.S. and Soviet experience, the Polish Civil Defense League funded the construction of a rubberized silk envelope with a capacity of 4,400,000 cubic feet of hydrogen, and weighing 40 percent less than the smaller *Explorer II* balloon. Damaged during inflation in October 1938, the envelope was repaired and was being prepared for a second attempt when Germany invaded Poland on September 1, 1939.[12]

The *Explorer* program was far more than a stunt. On the twentieth anniversary of the flight, Dr. Hugh L. Dryden, Director of the National Advisory Committee for Aeronautics, noted that, in addition to their very real scientific contributions, the flights were a "convincing demonstration that man could protect himself from the environment of the stratosphere." General Henry H. Arnold, commander of the U.S. Army Air Forces during World War II, remarked that the Stratobowl flights made significant contributions to the Allied victory, including the development of improved magnesium alloys, pressurization gear and flight clothing. "Many other items of equipment and methods were improved," he continued, "which later played important parts in giving American airmen superiority in the skies of Berlin and Tokyo."[13]

BALLOONING INTO THE SPACE AGE

IT WAS APPARENT THAT TRADITIONAL materials limited the altitude that balloons could reach. The rubberized cotton envelope of the *Explorer II* balloon weighed some seven tons. Early in 1935, T. H. Johnson, a colleague of Jean Piccard's at the Bartol Research Foundation of the Franklin Institute, suggested that they cooperate in developing lightweight cellophane envelopes to replace traditional rubber aerostats used in meteorological and scientific studies. The work continued with a grant from the National Advisory Committee for Aeronautics after Piccard joined the aeronautical engineering faculty at the University of Minnesota in 1936. While he continued his experiments with new materials, Piccard was unable to overcome the tendency of cellophane to crack at low temperatures. During the only flight test of his multi-balloon *Pleiades* concept on July 18, 1937, he employed a cluster of ninety-two latex balloons to carry an instrument package aloft.

Simultaneously, researchers in the U.S. and Europe were developing miniaturized scientific instruments and telemetering systems. Arthur Compton, who was uncomfortable with scientific experiments on manned balloons, encouraged his colleagues at the University of Chicago to join the effort to produce trustworthy balloon-borne radiosondes for cosmic ray research. The National Bureau of Standards and the National Academy of Sciences sponsored the continued development of telemetry systems, and research programs that employed them.

A host of new technologies came of age during World War II, including the turbojet engine, the long-range rocket and nuclear weapons. By the end of the conflict, a few far-sighted individuals realized that humanity stood on the edge of the space age. The requirements of national defense quickly replaced scientific curiosity or the desire for international prestige as the post-war impetus to explore what would soon become a new operational military environment. Ironically, buoyant flight, the oldest flight technology, proved indispensable in the drive to cross into the new frontier beyond the atmosphere.

The Air Force Air Material Command funded a Balloon Group Research Division at New York University, while the University of Minnesota team built around Jean Piccard set to work on several high-altitude balloon efforts for the Navy. Piccard, who continued to dream of a personal return to the stratosphere, was still searching for a tough, lightweight plastic film that would be suitable for a clustered balloon, *Pleiades II*. His collaboration with Otto C. Winzen began in the fall of 1945.

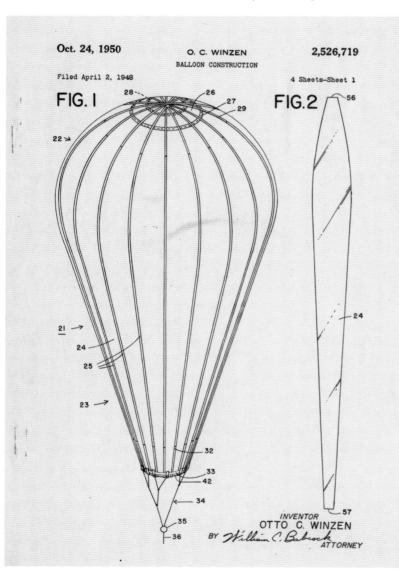

Oct. 24, 1950

O. C. WINZEN
BALLOON CONSTRUCTION

2,526,719

Filed April 2, 1948

4 Sheets-Sheet 1

FIG. I

FIG. 2

INVENTOR
OTTO C. WINZEN
BY William C. Babcock
ATTORNEY

Winzen emigrated to the U.S. from Germany in 1937, and spent the war years in internment camps. Enrolled in the aeronautical engineering program at the University of Detroit, he approached the University of Minnesota faculty for advice on an altimeter that he was developing. Fascinated by the challenge of high-altitude ballooning, Winzen almost immediately abandoned his project and adopted Piccard's.

Together the two men approached the Navy, where they found a few far-sighted officers who recognized the practical importance of investigating the physical environment of near-earth space, through which guided missiles would pass and in which flight crews would soon be operating. The aging scientist and the young engineer soon found a corporate home at the General Mills Corporation. A producer of breakfast cereals prior to World War II, General Mills officials had developed a significant research capacity on the basis of wartime contracts, and were anxious to identify new projects in order to diversify. Winzen, a first-rate engineer and a visionary with an ability to maneuver through the government bureaucracy, became head of the newly established General Mills Aeronautical Research Laboratories, with Piccard as a consultant.

In the fall of 1947, the Office of Naval Research (ONR) contracted with General Mills for equipment and services required to carry a variety of experiments aloft aboard unmanned balloons with envelopes manufactured of polyethylene film. Winzen had spearheaded the production of this lightweight, petroleum-derived transparent film, which was resistant to both temperature fluctuations and ultra-violet radiation. He would continue to develop the material over the next few years, producing ever thinner, and lighter, plastic envelopes (fig. 92). Balloons were soon climbing to the roof of the sky made of plastic film only one thousandth of an inch (one mil) thick.

On September 25, 1947, the first of the new Project Skyhook balloons, a plastic envelope with a capacity of almost 198,000 cubic feet, carried a

payload of scientific instruments to an altitude of 31,000 feet (fig. 93). Within a year, the project was sending balloons to altitudes in excess of 100,000 feet for relatively long duration stays at a cost of as low as $2,000 per flight. During the decade between 1947 and 1957, literally hundreds of cosmic ray instruments and plates were carried aloft beneath billowing yards of polyethylene.

The program was soon carrying spectrographs and other geophysical instruments into the upper atmosphere. On August 15, 1957, a Skyhook balloon carried the first *Stratoscope* aloft. Developed by Princeton astronomer Martin Schwarzschild, the system consisted of a 12-inch telescope that researchers could point from the ground. The project produced the clearest images of sunspots and other solar phenomena available up to that time.

Stratoscope II, a 36-inch telescope designed to make infrared measurements of Mars, was flown on January 13, 1963. A second *Stratoscope II* balloon package studied the planet Venus and six red giant stars. The National Center for Atmospheric Research *Coronascope II*, another solar instrument, went aloft on May 3, 1964, aboard a 32 million-cubic-foot balloon. An X-ray telescope prepared by MIT staff members and flown aboard a 34 million-cubic-foot aerostat on October 16, 1970 remained above 148,000 feet for more than ten hours. Neutron spectroscopy, micrometeorite counts, and X-ray, gamma ray, infrared, and ultraviolet experimental packages have also been flown aboard balloons. Geophysicists and earth scientists were also quick to take advantage of the new balloons for earth resources and aerial photographic work and to conduct auroral and zodiacal light studies. Biologists and aerospace medical specialists sent plants and animals into the upper atmosphere aboard balloons.

Dr. James Van Allen of the University of Iowa's department of physics achieved yet another technical breakthrough with the Rockoon, developed under a grant from the Office of Naval Research in 1952. By launching a sounding rocket from a balloon at

Fig. 93 A Skyhook balloon. (NASM, SI 97-15944)

an altitude of 70,000 feet, Van Allen and his colleagues were able to attain altitudes of up to 300,000 feet. These early experiments suggested the possible existence of trapped radiation in near-earth space—one of the great scientific discoveries of the space age. The first U.S. satellites confirmed the existence of the Van Allen belts.

New companies were popping up in the field. Otto Winzen left General Mills in 1949 to found his own firm. With the help of his wife, Vera, who played a key role as vice-president and chief of production at Winzen Research, Inc., the company quickly became a leader in the field. Charles B. Moore, Jr., a member of the original NYU balloon group, replaced Winzen as head of the General Mills aeronautical laboratories. The third Minneapolis-based balloon firm, G. T. Schjeldahl was founded in Northfield, Minnesota. Paul Edward Yost, J. R. Smith, Joseph Kaliszewski, and Dwayne Thon, all General Mills veterans, founded Raven Industries in 1956.

BALLOON BOMBS

SCIENCE KEPT THE BALLOON MANUFACTURERS BUSY, but it did not make them rich. During their early years, both Winzen and Raven were forced to turn their facilities to the production of every sort of polyethylene product from boat covers to food packaging. For these struggling young companies, secret contracts with the intelligence community often meant the difference between financial success and failure. Carefully hidden from view, each of the major balloon companies maintained "back room" operations dedicated to intelligence contracts.

The notion of using unmanned balloons to bomb the enemy was by no means new. In 1848 the citizens of Venice tossed out the Austrians, who had occupied the city since 1814, and declared a Venetian Republic. Austria stuck back, laying siege to Venice. Recognizing the difficulty of placing artillery in the terrain around the city, Lieutenant Franz von Uchatius suggested bombarding Venice with unmanned hot air balloons. The ship *Volcano* launched balloons on August 22, 1848. Equipped with timers to release thirty pounds of explosives when the balloon was over the city, the results were mixed. Venice suffered minor damage, and a shift of the wind carried some of the balloons back over the Austrian lines.

The Austrian idea came of age during World War I. In the summer of 1917, Robert Millikan, a rising star of American physics and vice-chair of the National Research Council, left his teaching position at the University of Chicago and enlisted as a Major in the U.S. Army Signal Corps. As the commanding officer of a new Science and Research Division, he supervised a wide variety of projects, including

the development of an unmanned, automatically ballasted balloon designed to cover long distances and "to carry over enemy country propaganda, incendiary matter, or bombs."[14]

While the Great War ended before Millikan's team could launch their first balloon, British authorities launched a similar project in 1939. Labeled Project Outward, the program launched unmanned balloons from points in England when favorable winds would carry them into enemy territory. Some of the balloons carried incendiary bombs; others trailed metal cables designed to brush power lines and create short circuits that would disrupt the electrical power transmission networks. Between March 20, 1942 and September 4, 1944, 99,142 Outward balloons were directed against Axis targets in Europe: 55,483 incendiaries, and 45,599 featuring trailing cables. The damage done by a single balloon to the Böhlen power station near Leipzig on July 12, 1942 was four times the entire cost of the program.[15]

The wartime Japanese FUGO balloon program was far better known and more ambitious, but less effective, than Outward. Japanese balloon experiments began with the SEGO project of the late 1920s, in which thirteen-foot envelopes carried propaganda materials and bombs across the Amur River into Soviet territory. In the fall of 1942 both the Army and the Navy launched competing projects to develop long-range balloons as a means of attacking the west coast of the U.S. While any resulting damage would be welcome, the Japanese assumed that the transpacific balloons were primarily intended to start forest fires.

By the fall of 1943, the Army and Navy programs were combined into a single effort known as FUGO. The project name was an amalgam of FU, the thirty-second character in the Japanese hiragana syllabary, and GO, referring to a series of numbers, thus, Project 32. During the winter of 1943–44, the team launched some 200 balloons to test the feasibility of the project. Almost ten feet in diameter, the balloons were constructed of rice paper, coated with a solution of polyvinyl and alcohol, and fitted with tracking devices. Aluminum valves released hydrogen when the internal pressure rose too high, while an automatic ballasting system helped keep the balloons in the air. Project managers determined that a balloon rising into the jet stream winds, blowing from west to east at speeds of up to 185 mph during the peak months from November to March, could easily reach the U.S. in three days.

From the fall of 1944 into the spring of 1945, thousands of Japanese citizens turned out a total of 10,000 FUGO envelopes. A typical type-A FUGO balloon was 32.9 feet in diameter, and composed of 600 sheets of special paper, laminated in four layers and fastened with vegetable glue.

Ballast bags, four incendiaries and one high explosive antipersonnel bomb were attached to an aluminum load ring suspended beneath the hydrogen-filled envelope (fig. 94). A wooden box mounted on top of the ring contained four aneroid

Fig. 94 FUGO Japanese balloon bomb.
(NASM, 2003-6574)

barometers to measure the balloon's altitude, and a battery to power the release of ballast and weapons at the appropriate time. The automatic control system kept the balloon flying at an altitude of between 30,000 and 38,000 feet.

The first FUGO attacks were launched on November 3, 1944. Ten days later, Coast Guardsmen witnessed one of the balloons falling into the sea five miles west of Hawaii. On December 6, four workers near Thermopolis, Wyoming, witnessed what proved to be the explosion of a FUGO antipersonnel bomb. Over the next few months, reports of similar incidents multiplied. A study of the re-covered fragments, and an analysis of the geographic origin of the sand ballast, indicated that the balloons were launched from sites in southern Japan. Counter-measures included special alerts for anti-aircraft artillery units and interceptor squad-rons across the West Coast. In an effort to prevent the Japanese from gauging the success of the effort, American newspapers were prohibited from men-tioning any incidents in their area.

In all, between 6,000 and 9,300 balloons were launched during the course of the program. One researcher has tallied some 355 FUGO incidents in the U.S. While that would indicate that less that 6 percent of the balloons successfully crossed the Pacific, it is safe to assume that additional craft fell into remote areas and were unreported. The only deaths known to have resulted from the FUGO campaign occurred near Bly, Oregon, on May 5, 1945. Elsye Mitchell, the pregnant wife of a local minister, and five picnicking Sunday school students, died when a downed FUGO balloon they were investigating exploded. Any assessment of the impact of the Japanese balloon bomb program has to conclude that the results of the effort failed to justify the cost.

BALLOONING INTO THE COLD WAR

THE FUGO BALLOON PROJECT underscored the relative simplicity of the technology enabling an unmanned balloon to cover intercontinental distances. That knowledge, coupled with the post-war emergence of polyethylene balloons to carry scientific payloads aloft, suggested new possibilities to those planning covert operations.

The links between the intelligence community and the plastic balloon industry were forged during the years immediately following World War II. The NYU group was an early recipient of intelligence funding in support of its work on a constant-altitude aerostat. Officials of Radio Free Europe were quick to recognize the potential of the balloon as a delivery system for propaganda pamphlets. Project Mogul, launched in 1947, employed Skyhook balloons to carry sensitive instruments designed to detect nuclear explosions. According to U.S. Air Force officials, the loss of Mogul balloon #4 near Roswell, New Mexico, in July 1947 sparked the best known of all post-war UFO incidents.[16]

RAND Corporation analysts first suggested using balloons to conduct aerial photography of the Soviet Union in 1946. While watching the launch of a Skyhook balloon several years later, it occurred to General George W. Goddard, a pioneer of aerial photography, that such a balloon could fly great distances, "and take some mighty pretty pictures on the way."[17]

Project Gopher, established on October 9, 1950, was the first U.S. attempt to develop a reconnaissance balloon program. Under contract to the Office of Naval Research (ONR), General Mills engineers experimented with improved plastics and designs for balloons that would carry K-17 aerial cameras to high altitudes. Using barometric systems and simple on-board trackers, the balloons were capable of remaining in the air for extended periods. Launched from bases in Western Europe and Turkey, they would be carried by the prevailing winds across the Soviet Union, snapping photos as they went. When the balloons left the Soviet coast, a signal would sever the balloon from the gondola, which would drift down on a parachute. A C-119 Flying Boxcar, homing in on a beacon carried by the camera package, would snatch the parachute and its intelligence treasure out of the air.

Early the following year, the USAF Cambridge Laboratory launched a balloon-based study of the jet stream winds blowing at altitudes between 50 and 100,000 feet. The program was code-named Moby Dick, in honor of the centennial of Herman

Melville's masterpiece. The new program would provide a scientific "cover" for Gopher, or any follow-on balloon-based reconnaissance effort.

Tests of the balloon and camera equipment were under way by the spring of 1952, following considerable difficulties with the contractor. Project development continued into 1954 under the code name Grandson. Ancillary studies considered the use of Skyhook type balloons to deliver a variety of terror weapons, from incendiary bombs to chemical and biological agents.

In an effort to confuse Soviet intelligence analysts, Moby Dick (the code name for the meteorological cover story balloons) and Genetrix (the code name for the reconnaissance balloon campaign) balloons were launched during the same period. Between January 10 and February 4, 1956, 448 Genetrix balloons were sent on their way into Soviet airspace. If the USAF officials responsible for the campaign expected Soviet authorities to ignore the steady stream of spy balloons traversing the skies of the Motherland, they were sorely disappointed.

Of the 123 balloons that were tracked, roughly 60 fell victim to Soviet air defense measures or mechanical failure. Sixty-six balloons made it to the recovery area, but only forty-four of the equipment packages could be retrieved. Forty of those units (11.2 percent of the total balloons launched) contained useable film covering some 8 percent of the total land area of the USSR and China. While the Soviets fumed, attacked the perfidious American sky pirates, and sponsored propaganda displays of the downed balloons, equipment and photos, the project yielded a significant return at the bargain basement price of only $48.49 per mile of terrain photographed.[18]

RISING TO THE CHALLENGE

JUST AS THE NEW BALLOON TECHNOLOGY provided an inexpensive means of lofting scientific and intelligence-gathering equipment to extreme altitudes, it also allowed human beings to climb to the very edge of space. Some of these early flights had purely scientific objectives. On May 31, 1954, Charles Dollfus, the great French aeronaut, ascended to 7,000 meters (22,960 feet) to assist his astronomer son Audoin in searching for the presence of water vapor in the Martian atmosphere. Five years later, on April 22, 1959, Audoin reached 42,000 feet beneath a large string of weather bureau balloons in order to study Venus. Malcolm Ross and R. Cooper conducted solar coronal studies from the open basket of a balloon at 38,000 feet on August 7, 1959. Important telescopic and spectrographic observations were also conducted during the *Stratolab V* flight.

For the most part, however, the piloted high-altitude ascents of the post-war era were aimed at aerospace medical research and the development of life-support systems, pressure garments, high-altitude parachutes, instruments, and other items of equipment that would be required for operations under the harsh conditions of space. As with the plastic balloon itself, the renaissance of piloted high-altitude ballooning began with a U.S. Navy contract to General Mills.

C. B. Moore brought his interest in constant-altitude balloons and a taste for adventure when he migrated from New York to Minneapolis. Moore made his first flight aboard a General Mills balloon rigged to carry a human being on November 3, 1949. His superiors in the Mechanical Division, however, failed to see any benefit for the company, and insisted that flights with a human pilot be conducted after hours to avoid insurance or liability problems. After a year of effort, Mechanical Division officials brought Moore's manned balloon work to the attention of a federal agency, which offered funding to develop these balloons as training devices for blimp pilots and for use in various intelligence operations.[19]

M. Lee Lewis, a naval officer assigned to Moore's General Mills balloon team before becoming the ONR balloon project officer in 1951, and Malcolm Ross, who followed him in both posts, focused attention on the high-altitude potential of Moore's work. Lewis and Ross argued for sending human beings to the edge of space aboard the plastic giants.

Rear Admiral Calvin Bolster, chief of naval research, rejected a preliminary plan for manned balloon flights as being "too experimental." Undeterred, Ross and Capt. W. C. Fortune, the head of the ONR Air Branch, presented the program to Admiral Frederick Furth, the new head of the ONR in 1954. He approved. "With this nod," Ross later recalled, "the program that became Stratolab was created."[20]

Ross's first step was to order that a gondola shell intended for use in a cancelled Piccard project called *Helios*, be transferred from Lakehurst, New Jersey, to Otto Winzen's shop in Minneapolis for refurbishing. The crew also began to test large plastic balloons to destruction in a hangar at South Weymouth, Massachusetts. Pressure suits, instruments, and other items of equipment were also evaluated. The group enlisted the cooperation of interested parties in both the Navy and Air Force. A panel composed of experts from the University of Minnesota, General Mills and the Navy offered technical advice on matters ranging from systems development to balloon design.

By the summer of 1956 a program of manned training flights was under way, including an open basket ascent by Ross and Lewis to 40,000 feet on August 10, 1956. The flight marked the first return of a U.S. manned balloon to the stratosphere since 1935. During a second open basket ascent on September 24, 1956, Harold Froelich and Keith Long reached an altitude of 42,000 feet.

The Stratolab gondola was, as *U.S. News and World Report* noted, "a manned space laboratory."[21] The old *Helios* shell had been refurbished and completely tested. The Stratobowl in the Black Hills would serve as the launch site. The *Stratolab I* flight on November 8, 1956, saw Ross and Lewis reach an altitude of 76,000 feet aboard a 2,000,000 cubic-foot balloon before a valve failure caused a rapid descent that proved very difficult to slow. The two naval officers emerged safely from the gondola with a record altitude in hand and much new scientific and technical information. A total of five high-altitude Stratolab flights followed between 1956 and August 1961. In addition, the program included five additional purely scientific flights to lower altitudes of up to 40,000 feet.

The high-altitude balloon flights begun in 1956 soon took on a special significance. The orbiting of *Sputnik 1* in October 1957 established space as a Cold War arena in which the United States and the Soviet Union would compete for military position, international prestige, and scientific honors. Manned space flight clearly lay in the immediate future, and the high-altitude balloon flights offered an opportunity to test men and equipment under nearly equivalent conditions. As Otto Winzen noted in 1958: "It is now generally recognized in scientific circles that the manned balloon capsule is the prototype for the manned space cabin." He was in a position to know. Between June 1957 and October 1958, Winzen Research constructed five manned capsules and balloons employed in an epic series of flights.[22]

The Stratolab ascents were the work of the Office of Naval Research team. The USAF Manhigh program was operated by the staff of the Aero Medical Laboratory at Holloman Air Force Base, New Mexico. Under the leadership of Dr. John Paul Stapp, this laboratory had conducted a series of highly publicized experiments to measure the human reaction to extreme conditions faced during high-altitude, high-speed flight. Stapp himself had become one of the most famous aerospace figures of the 1950s as a result of his rides on rocket-powered sleds in order to study the effect of windblast and G-forces encountered during high-speed ejection.

Fig. 95 David Simons. (NASM, USAF 159052AC)

The Holloman team began with a series of balloon flights using animals as test subjects. Stapp insisted on continuing the program with manned ascents. "Animals did nothing up there but breathe, eat and defecate," he explained to his team. "They didn't talk on the radio or shift around in a 180-pound mass or fidget in a pressure suit or try to grab scientific observations out of those saucer-shaped portholes, or do any of the things you will have to do when you go up."[23]

Major David G. Simons, the Manhigh project officer, hoped to make the first flight himself (fig. 95). Instead, Stapp ordered Simons, a physician and flight surgeon, to monitor the flight from the ground. Capt. Joseph W. Kittinger, Jr., the project test pilot, rode the balloon to an altitude of 96,000 feet on June 2, 1957 (fig. 96). On August 19, Simons reached 101,516 feet on the *Manhigh II* ascent. Lt. Clifton McClure, a twenty-eight-year-old volunteer, reached 99,700 feet on *Manhigh III*.

The Manhigh flights led to the Excelsior program. Between November 16, 1959 and the summer of 1960, Joe Kittinger made three ascents in an open gondola to test the equipment and procedures for parachute jumps from extreme altitudes. He set an unofficial world altitude record, and an official record for the world's highest parachute jump, when he bailed out of the *Excelsior III* gondola at 102,800 feet on August 16, 1960. A short-lived USAF Stargazer program, designed to support astronomical research, ended after a single launch on December 13, 1962.

With astronauts and cosmonauts orbiting the earth during the early 1960s, the second era of manned high-altitude ascents drew to a close. Manhigh, Stratolab, and Excelsior prepared the way for human beings to enter space. But the price was high. Captain Joe Kittinger almost died when the shroud lines of his stabilizing parachute wrapped around his neck during the *Excelsior I* jump in November 1959. Clifton McClure was, in the words of a *Washington Star* news headline, "Nearly Baked in AF Balloon Error," during the flight of *Manhigh III* on October 8, 1958. McClure, who was neither a pilot nor a balloonist, had endured temperatures of between 150 and 160 degrees above 80,000 feet for several hours. He was so severely dehydrated that he had to be hospitalized. Air Force spokesman Dr. Knox Millsaps commented, "Something went wrong with our calculating about insulation and temperatures."[24]

M. Lee Lewis, a Stratolab pioneer, died in a 1959 ground accident involving a gondola suspension system. V. C. Prather drowned when his pressure suit filled with water after a landing at sea following the flight of *Stratolab V* on May 4, 1961. Prather and Malcolm Ross had launched from the carrier USS *Antietam* aboard a 10-million-cubic-foot aerostat, the largest balloon ever to carry men aloft, and set a world altitude record of 113,740 feet. Human beings had climbed to the edge of space using a technology born two centuries before.[25]

Fig. 96 Joseph W. Kittinger. (NASM, SI 87-6749)

The post-war era of high-altitude ballooning produced a civilian casualty, as well. On May 1, 1966, Nick Piantanida, a thirty-four-year-old New Jersey truck driver, athlete, and skydiver, ascended from Joe Foss Airport in Sioux Falls, South Dakota aboard the *Strato-Jump III* gondola. His goal was to set a new world altitude record for balloons, and to establish a new mark for the highest parachute jump, beating the previous unofficial record of 102,800 feet set by Air Force Captain Joseph Kittinger in 1960. Since the Air Force had not submitted Kittinger's jump as an official record, however, the world mark for the highest skydive was held by a Soviet airman, Major Yevgeny Andreyev, for a jump from 83,500 feet in November 1962.

This would be Piantanida's third attempt. The first try, in October 1965, ended when a six-knot wind sheared the top off his giant, helium-filled polyethylene balloon at just 22,700 feet. The balloonist parachuted back to a safe landing in the St. Paul, Minnesota, city dump. Raven Industries built the gondola and the balloons for the next two attempts. Paul Edward Yost, one of the founders of the company and the acknowledged father of the modern hot air balloon, managed flight operations.

Piantanida reached a world record altitude of 123,500 feet in *Strato-Jump II*, in February 1966. When he was unable to disconnect his onboard oxygen supply in order to make the jump, however, ground controllers had no choice but to cut the gondola loose from the balloon, allowing Piantanida to return safely to earth still seated in the gondola, dangling beneath a large parachute. Because of the mishap, the flight did not qualify for the world altitude record.

Strato-Jump III was at 57,600 feet when ground controllers heard a sudden hissing sound and Piantanida started to say, "Emergency." Yost immediately ordered the gondola cut loose once again. It took twenty-six minutes to parachute back to earth, landing in a field near Worthington, Minnesota, a little more than sixty miles from the take-off point. When the chase crew arrived they found the pilot alive but unconscious. While the cause of the accident has never been completely resolved, Piantanida apparently depressurized his helmet accidentally and fell unconscious from hypoxia. He died on August 29, 1966, without regaining consciousness.[26]

FLOATING INTO THE FUTURE

MORE THAN TWO CENTURIES after its invention, the balloon remains a critically important scientific tool. Beginning in 1958, a team of Air Force researchers developed the first modern "super pressure balloons." These balloons are sealed, so that the internal pressure rises as the balloon climbs to its "pressure altitude," where the weight of the helium is the same as the weight of the

ambient air that it displaces. Since these craft will remain at their pressure altitude for extended periods, they are also known as constant altitude balloons. In order to withstand the very high internal pressures, they are usually constructed of Mylar, a tougher film than polyethylene.

Capable of remaining aloft for weeks or months at a time, constant altitude balloons can be tracked and interrogated by earth satellites, providing a simultaneous picture of atmospheric conditions all over the globe. The result was the GHOST (Global Horizontal Sounding Technique) balloon system, introduced in the early 1960s.

Today, the Columbia Scientific Balloon Facility is the focal point of balloon-based research in the U.S. Established in Boulder, Colorado, in 1961 under the auspices of the National Science Foundation (NSF), the facility was moved to the wide open spaces of Palestine, Texas two years later and designated the National Scientific Balloon Facility in 1973.

Operation of the facility was transferred from the NSF to the National Aeronautics and Space Administration in 1982. In October 1987, NASA contracted with New Mexico State University to operate the site, which was renamed the Columbia Scientific Balloon Facility (CSBF) in 2006, in honor of the crew of the Space Shuttle *Columbia*. The NASA balloon program is managed by staff members of the Wallops Island Flight Facility, Virginia.

Conventional scientific balloons are manufactured of polyethylene film about half as thick as the grocery store variety. The film is cut into spindle-shaped segments called gores, some 180 of which make up one of the larger NASA balloons. When initially inflated, one of these balloons stands half again as tall as the Washington Monument. Called "zero pressure" balloons, they are open at the bottom so that the internal and external pressure remains the same. A typical flight will reach an altitude in excess of 137,000 feet and remain aloft for up to two weeks.

During its first quarter century, the CSBF launched more than 1,700 balloons for researchers in thirty-five universities, twenty-three government agencies and thirty-three foreign countries. Payloads grew from a maximum of 400 pounds in the mid-1960s to 8,000 pounds, as much as three compact cars, by the early twenty-first century. Balloons have increased in size from an average of 2.8 million cubic feet in 1964 to balloons of well over 30 million cubic feet today. With missions lasting months at a time, modern Ultra Long Duration Balloons (ULDB) continue the long tradition of extending our knowledge of the earth and its place in the cosmos.

RENAISSANCE

THE POST-WAR HISTORY OF SPORT BALLOONING; THE GREAT TRANSOCEANIC AND AROUND-THE-WORLD BALLOON VOYAGES; A LOOK AT THE FUTURE OF THE OLDEST WAY TO FLY

HOT AIR MAKES A COMEBACK

IN THE EARLY YEARS OF THE TWENTIETH CENTURY, sport ballooning attracted only the very rich, along with a few military officers and professional airmen who dominated the sport during the heyday of the James Gordon Bennett competitions of the 1920s and 1930s. Before and during World War II, the U.S. Navy used free balloons to provide basic training for blimp pilots, but by the end of 1945 the notion of floating across the landscape in a free balloon belonged to a bygone era.

Don Piccard was determined to change that. Born in 1926, the son of Jean-Félix and Jeanette Piccard, he first ventured aloft in a balloon as a seven-year-old "crew member" while his mother earned her ballooning license under the tutelage of Gordon Bennett winner Ed Hill. After wartime service in the U.S. Navy as a balloon and airship rigger, Piccard set out to reinvigorate sport ballooning. In 1947 he obtained the envelope of a Japanese FUGO balloon bomb and persuaded the *Minneapolis Times* to sponsor a flight and purchase the necessary hydrogen. Local military reserve organizations provided some scrap aluminum, which Piccard, with the assistance of workers at the University of Minnesota Medical Laboratory, fashioned into a basket. The resulting two-hour flight marked the first post-war civilian balloon ascension in the country.

In September 1948, while living in Swarthmore, Pennsylvania, Piccard acquired a 35,000 cubic-foot war-surplus Navy balloon, which he inflated with coal gas. The following year, Piccard, Peter Wood, Tony Fairbanks, and others established the Balloon Club of America. The difficulty of acquiring a balloon, coupled with the $1,000 cost of the helium for a single inflation, however, limited the appeal of the sport. By the end of the 1950s, there were perhaps ten flyable free balloons in civilian hands in the U.S.[1]

The answer lay in a radically new version of the hot air balloon. Since the late nineteenth century, balloonists in Europe and America had experimented with kerosene and fuel oil as a means of producing hot air. Auguste Piccard and Max Cosyns developed a propane-fired burner shortly before World War II, but the envelope caught fire during inflation. By 1948 James Contos was experimenting with a mixed kerosene-propane hot air system.[2] None of those early experiments worked especially well or attracted much interest.

Paul Edward Yost solved the problems and opened a new era in the history of lighter-than-air flight. Born on an Iowa farm in 1919, Yost attended the Boeing School of Aeronautics, spent the war years with the U.S. Army Air Forces, and afterward flew airplanes in Alaska. In 1949 he leased his single-engine Stinson and his services as a senior engineer and tracking pilot to the High Altitude Research

Division of General Mills, where he became involved in both scientific and covert balloon projects.

"We were doing low altitude as well as high altitude helium balloon testing," Yost later explained. "We trained a lot of men to fly … under a classified program to put men behind the Iron Curtain." Gas balloons took many hours to inflate with helium, which cost a dollar per pound lifted and could be used for only one flight. Moreover, the weight lifted included the ballast required to operate a gas balloon. It occurred to Yost that hot air balloons could be used over and over, and inflated very quickly with a cheap fuel. For training flights, he suggested, "you had just as well use hot air."[3]

Yost began experimenting with small hot air balloons in 1954, using plumber's fire pots as a heat source. Within a few days he was sending tethered thirty-footers aloft from his backyard. In October, 1955, he made a tethered flight aboard a thirty-nine-foot plastic balloon with a gasoline burner pressurized with a tire pump. Film of that experiment earned Yost a $47,000 development grant from the Office of Naval Research. The goal was to build a reusable balloon that would carry a pilot to an altitude of 10,000 feet and remain in the air for three hours. With the grant in hand, Yost and three other General Mills employees established Raven Industries.

They spent about four and a half years studying temperatures, experimenting with materials, analyzing different fuels, and developing new burner systems. The pay-off came on October 20, 1960, when Yost made his first free flight in a hot air balloon from an abandoned airfield at Bruning, Nebraska. This first Raven balloon featured a nylon envelope, propane burners, and two instruments—a sensitive altimeter and a rate of climb indicator. Three weeks later, Yost went aloft for a second time aboard a slightly modified version from the famed Stratobowl near Rapid City, South Dakota.[4]

Yost's hot air balloon failed to interest the Office of Naval Research. The firm continued to provide conventional balloons and services for a variety of clandestine projects, including the distribution of propaganda leaflets behind the Iron Curtain, and applied their expertise to the production of inflatable structures, tethered aerostats, and parachutes. They sold their first civilian hot air balloon in November 1961. The following year Don Piccard came aboard to manage an embryonic sport balloon program.

Piccard came to public attention on September 18, 1957, when he flew a cluster of plastic balloons that he called *Pleiades*, a project conceived by his father. *Life* magazine coverage of the flight led to a contact with Gilmore Schjeldahl, who was manufacturing plastic bags out of Mylar, rather than polyethylene. Having sold Schjeldahl on "what quarter mil Mylar could do in a high altitude flight," Piccard moved to Minnesota in 1958 to head a research and development effort for the company. For the next four years he worked on a number of projects, from inflatable

structures to Mylar superpressure balloons, while continuing to publicize sport ballooning. On August 17, 1959, he flew a gas balloon from Lafayette, Indiana, commemorating the flight of the *Jupiter* a century before, when John Wise flew the first stamped letters that had passed through a post office. On July 19, 1961, Piccard launched from the Fairbault, Minnesota airport and rose to an altitude of 34,642 feet, a world record altitude for gas balloons of the class he was flying.[5]

Arriving at Raven five months later, Piccard set to work fine-tuning the *Vulcoon,* the company's initial commercial balloon. His aim was to create a new adventure sport, complete with new ways for hot air balloons to compete. The James Gordon Bennett distance competition made no sense for hot air balloons, with their limited flight duration. Planners of the annual St. Paul Winter Carnival agreed to sponsor the first ever hot air balloon race sanctioned by the National Aeronautic Association. Amateur balloon builder Tracy Barnes won the event, which "changed ballooning," Piccard believed, "from a carnival stunt and a wacko deal to a competitive sport."[6]

Charles Dollfus, director of the French Musée de l'air, one of the world's most experienced aeronauts, and an old friend of the Piccard family, was fascinated by the new generation of hot air balloons, and suggested a flight that would provide the nascent sport with an important publicity boost. With his assistance, Ed Yost and Piccard piloted one of their company products across the English Channel on April 13, 1963, traveling roughly 50 miles from Rye, England to Saint-Georges, France, in three hours, making international headlines in the process.

Not all of the publicity was positive. On January 18, 1964, nine aeronauts in eight balloons launched from Catalina Island on a race to the California coast. Don Piccard dropped out soon after take-off when his balloon was damaged in a collision with a tree. Ed Yost, the only person to reach the mainland, won the event. Six other contestants, including actor Cliff Robertson and Hollywood stunt pilot Frank Tallman, were rescued from the water. Barbara Keith, a red-headed Connecticut grandmother of ten, drowned: "Who wants to knit an afghan when she can sit in that little canvas chair suspended beneath a 40-foot bag and be part of the wind," she had responded to a reporter's question. The new hot air balloon technology had claimed its first victim.

The Balloon Federation of America, founded on March 16, 1961, as a confederation of three gas balloon clubs, provided some structure for the new sport. Piccard left Raven in the fall of 1964 to found his own balloon company in Costa Mesa, California. A decade later he was turning out two balloons a week. His biggest model, with a 77,000-cubic-foot envelope, sold for $6,375. While there were still only 300 balloons in the nation, Piccard pointed to two customers who were making $100,000 a year as full-time balloonists. "They hire themselves out to county fairs, shopping center openings and the like," he explained. "You can make a lot of money just giving people rides all the time."[7]

A major turning point came in 1972, when the nine members of the Albuquerque (New Mexico) Aerostat Ascension Association purchased their first balloon. Four months later, Dan McKee, station manager of KOB-TV, asked station employee and "Quad-A" member Sid Cutter to stage a large-scale gathering of hot air balloons to celebrate a station anniversary. Twenty thousand people turned out to watch thirteen balloons compete. Don Piccard won the "First Albuquerque Roadrunner and Coyote Balloon Race," landing closer to a target than any other entrant. The event was such a success that the locals submitted a bid to host the First World Hot air Balloon Championships the following year. They won the bid, and established a tradition that continues today. The 2006 Albuquerque Balloon Fiesta drew over 800,000 visitors who thrilled to the sight of more than 700 balloons from 41 states and 19 foreign nations.

Sport ballooning grew by leaps and bounds over the next three decades (fig. 97). New manufacturers entered the field, as clubs popped up across the nation and the number of pilots increased. By the early twenty-first century the FAA reported 7,791 licensed balloon pilots in the United States, operating a total of perhaps 3,700 balloons. In an age when human beings have walked on the moon, sent robot explorers rolling over the surface of other worlds, and dispatched automated spacecraft beyond the edge of the solar system, we can still enjoy the sensation of drifting low and slow across the landscape, sharing the experience of the first men and women who took to the sky.[8]

CROSSING THE OCEAN...

THE GREATEST OF THE NINETEENTH-CENTURY AERONAUTS—Charles Green, John Wise, T. S. C. Lowe, W. H. Donaldson among them—dreamed of ballooning across the Atlantic. Each, in turn, admitted defeat. By the 1950s, while airliners whisked hundreds of people across the Atlantic every day, the challenge of floating across the ocean began to intrigue a new generation of balloon adventurers.

What proved to be a forty-year-long "Golden Age" of long-distance sport ballooning began on December 12, 1958, when the *Small World* lifted off from Tenerife, in the Canary Islands, bound for the Americas. The British crew—Andrew Eiloart and his son Timothy, and Colin Mudie and his wife, Rosemary—rode in a boat-shaped gondola designed by Mudie, who had once crossed the Atlantic in an 18-foot sailboat. They would fly low, using sea water as ballast. The design, and Mudie's experience, proved crucial when the balloon was

forced down in the ocean during a storm three days after take-off. Twenty-one days and 1,200 miles later, they were discovered by a fisherman and towed to a safe landing on a beach in the Bahamas.[9]

Chicagoan William Brenton, who had paddled a canoe across the Atlantic, made three unsuccessful attempts to make the trip by balloon, finally admitting defeat in June 1969. Rod Anderson, his actress wife Pamela Brown, and Malcolm Brighton, the crew of the balloon *Free Life*, were less fortunate. The trio lifted off from East Hampton, Long Island at 1:40 p.m. on September 20, 1970, bound for Europe. When a crescent-shaped rip appeared in the envelope soon after take-off, Brighton, the only experienced pilot on board, opted to continue the flight. The trio traveled 900 miles northeast before encountering a rain squall and radioing that they were descending through 600 feet. An extended search turned up nothing more than an empty Styrofoam ice chest with the price tag, $1.96, still attached.[10]

The next challenger, forty-eight-year-old Thomas Leigh Gatch, Jr., was the son of a vice admiral, a member of the West Point class of 1946, and had won a Bronze Star in Korea. A life-long bachelor and a teetotaler, he was a published novelist who took special delight in singing the role of Professor Henry Higgins in a local production of *My Fair Lady*. Pondering why such a man would want to fly the Atlantic in a balloon, his niece noted, "I think it's possible he thought there was no reason he shouldn't try it."[11]

Gatch launched the *Light Heart*, from Harrisburg, Pennsylvania, on the bitterly cold evening of February 18, 1974. A hot air pilot, he planned to become accustomed to the operation of his new craft before he reached the ocean. He flew in a pressurized fiberglass gondola that he had outfitted in his garage, dangling beneath ten large, helium-filled superpressure scientific balloons. Unlike his predecessors, who had opted for a low level crossing, Gatch planned to climb up to 38,000 feet and ride the jet stream to Europe. He disappeared without a trace.[12]

Robert Berger, a member of Tom Gatch's launch crew, nursed his own dream of an Atlantic crossing. He was saddened but not deterred by the loss of his friend. "If you're going to undertake the longest ego trip in the world," he informed a reporter, "you've got to be first." On August 6, 1974, seven months after Tom Gatch disappeared, Berger lifted off from Lakehurst Naval Air Station dangling beneath a plastic balloon standing twelve stories tall. He fell over a mile to his death an hour later when his balloon burst over Barnegat Bay, New Jersey.[13]

Malcolm S. Forbes was the next to try. Forbes presided over a publishing empire and was famed for his lavish lifestyle, which included a private jet ("The Capitalist Tool"), *Highlander* yachts, a French château, a Moroccan palace and collections of everything from fine art to Fabergé Easter eggs, toy soldiers and Harley Davidson motorcycles. Out for a drive in 1972, Forbes noticed a sign offering balloon rides and persuaded his chauffeur to come along with him. Just a year later, in the fall of

Fig. 97 Photo: courtesy Marilee Nason and the Anderson-Abruzzo Albuquerque International Balloon Museum.

1973, Forbes and his son Bobby flew a hot air balloon from Coos Bay, Oregon, to a watery landing just off Gwynn Island, Virginia. By January 1975, Forbes was ready to cross the Atlantic aboard the *Windborne*, a craft consisting of thirteen hydrogen-filled balloons rising 600 feet above a sealed gondola.

Forbes's plans were literally dashed just before dawn on January 7, 1975, when a wind gust caught the towering chain of balloons and lifted the gondola off the launch platform while it was still tied down. The launch director cut the balloons loose. The millionaire aeronaut and his companion, Dr. Thomas F. Heinsheimer, were badly shaken but uninjured. Forbes, who had spent $750,000 on the project, announced that he would try again within a month, then cancelled the project. "When I tried to put the money in the budget for this year," he explained, "a couple of sons … said that I'd had my crack at it, and, as my oldest son said, 'If you try again, you'll be a crackpot.'"[14]

Bob Sparks was less wealthy but more experienced in the air, with over 500 flights to his credit by the spring of 1975. Two years before, he had attempted to fly the Atlantic in the *Yankee Zephyr*, featuring an outer envelope containing 73,000 cubic feet of helium, surrounding an inner hot air balloon. The pilot would use the propane burners to maintain altitude when the gas cooled at night. This approach, which avoided the yo-yo rise and fall of a balloon as helium was heated by the sun during the day and cooled at night, would prove to be a key to very long-distance ballooning. It was an idea born over 150 years before when Pilâtre de Rozier lost his life in a mixed hot air and hydrogen balloon. In his honor, balloons of this type are still known as Rozieres.

After preliminary shakedown flights, Sparks lifted off from Bar Harbor, Maine, at dawn on August 9, 1973. Late that night, fifty miles off the coast of Newfoundland, he encountered a violent thunderstorm. As lightning flashed around the balloon, Sparks bounced up and down, at one point dropping over 10,000 feet in two minutes. Ditching in the Atlantic, he bobbed about in his seaworthy gondola for five hours until rescued by a Canadian icebreaker.[15]

Two years later, Sparks was back for another try with the balloon *Odyssey*. "We've worked from the premise that Bob won't make it and that survival is the first essential," his flight director, Harden Crawford, explained, pointing to a gondola that doubled as a catamaran. Launching from the Seabrook Country Club on Cape Cod just before dawn on August 21, 1975, Sparks heard a voice coming up from below: "Hi Bob, it's me!" His crew chief, G. Hadden Wood, had stowed away by simply hanging on to a trailing rope as the balloon took off. "I wanted to kill him," Sparks told a reporter. "But once you're in a situation like that, the only thing I could do was pull him aboard." Early that morning the pair discovered a leak high in the envelope. As their helium gradually escaped, the pair dropped closer to the ocean, finally touching down in the water at 6:50 that evening. Pilot and passenger were rescued by a Coast Guard helicopter.[16]

Karl Thomas, a German-born airport operator from Flint, Michigan, took off from Lakehurst Naval Air Station in a red, white and blue balloon standing 100 feet tall on June 25, 1976. Six days later, a Soviet freighter rescued the balloonist, who had spent three days in his lifeboat.[17]

By 1976, Ed Yost, the most experienced and knowledgeable aeronaut of his generation, succumbed to the call of the Atlantic. He lifted off from Baldwin Head, Maine at 6:10 a.m. on October 5, 1976, aboard a silver and black helium balloon, the *Silver Fox*. One hundred and seven hours and 2,500 miles later, Yost was forced down in the Atlantic west of the Azores and only 750 miles from the European mainland. Rescued by a German freighter, the balloonist could take comfort in the fact that he had broken two world records, surpassing the old mark of 87 hours in the air, and the previous distance record of 1,893 miles.[18]

The fact that Ed Yost, a consummate balloonist, fell short of the goal caught the attention of Max Leroy Anderson. A forty-two-year-old Albuquerque businessman who had learned to fly at fourteen. Anderson valued the sense of freedom and independence that he found in the sky, a place where survival demanded a cool head, good judgment, and solid skills. He and his friend and fellow millionaire, land developer Ben Abruzzo, pioneered hot air ballooning in Albuquerque, a city that would become a world center of the sport. Intense competitors, they had emerged victorious in a string of balloon events.[19]

Early in 1977, Anderson and Abruzzo decided that the Atlantic was a worthy challenge. The pair hired Ed Yost to provide a suitable balloon and gondola for $50,000, with an additional $3,000 for gas balloon training. W. C. Wiley, Anderson's corporate pilot, would manage the project and head the ground crew. Meteorologist Robert Rice would handle the all-important weather forecasting duties. Physicist Richard Schwoebel, who had long experience with high-altitude scientific balloon programs, would advise on scientific and technical questions. Jim Mitchell, an ex-newspaperman and a friend of both Anderson and Abruzzo, signed on to handle the press.

In calling their black and silver balloon *Double Eagle*, they were offering homage to Charles Lindbergh, the original lone eagle. The pair lifted off from Marshfield, Massachusetts, on September 9, 1977, and landed in the sea three miles off the coast of Iceland 65 hours and thirty minutes later. Rescued by a helicopter, the pair were suffering from exposure. Far from a pure defeat, however, Anderson and Abruzzo regarded the voyage of the *Double Eagle* as a learning experience. They were planning the second attempt before they returned home from the first.

A line of competitors were hoping to beat them to it. On October 10, 1977, Dewey Reinhard and Steve Stevenson, a pair of Colorado Springs, Colorado,

Fig. 98 Maxie Leroy Anderson (September 10, 1934–June 27, 1983), Ben Abruzzo (June 9, 1930–February 11, 1985), and Larry Newman relax at the conclusion of the *Double Eagle II* flight. (NASM, SI 96-15173)

businessmen, left Bar Harbor, Maine, aboard the balloon *Eagle*. Their flight ended in a water landing just 27 miles east of Halifax, Nova Scotia, where they were rescued by a Canadian Coast Guard cutter.[20]

By the summer of 1978, Anderson and Abruzzo's preparations for a second try were well under way. Larry Newman, a twenty-something unemployed airline pilot who was regarded as one of the best hang-glider pilots in the nation, would accompany them aboard *Double Eagle II*. Newman, who had introduced Anderson to the sport, would pay one-third of the costs and help to recondition and outfit the gondola (fig. 98).

Ed Yost was building a balloon in which Joe Kittinger, a veteran of the USAF Manhigh and Excelsior balloon programs, hoped to cross the Atlantic. Kittinger, who would not be ready as soon as the *Double Eagle II* crew, challenged the New Mexicans to race across the Atlantic—if they were willing to wait. "We would not," Abruzzo replied, "wait for one minute." While ignoring Kittinger's challenge, Anderson and Abruzzo challenged Don Cameron to just such a race—as long as he waited until *Double Eagle II* was ready to fly in the fall.[21]

Cameron was unwilling to wait. A thirty-seven-year-old aeronautical engineer based in Bristol, England, he was one of the world's leading manufacturers of balloons. He launched *Zanussi*, a Roziere design, from a sports stadium in St. John's, Newfoundland on July 26, 1978, accompanied by Major Christopher Davey, an officer in the Royal Tank Regiment. Just as it seemed that Cameron would capture the prize, a rip developed in the envelope, dropping the balloonists into the water only 110 miles from the French coast.

Anderson, Abruzzo, and Newman arrived in Presque Isle, Maine on August 7, 1978, accompanied by advisors, friends, well-wishers and a crew of technicians and reporters from ABC, which had purchased the media rights to the flight. Four days later, at 8:42 p.m. on August 11, 1978, *Double Eagle II* lifted off into a darkening sky, with a string of red New Mexican chilies dangling from the bow. At 10:02 p.m., August 16, 1978—117 hours and 59 minutes after take-off—Maxie Anderson, Ben Abruzzo and Larry Newman crossed the Irish coast, finally achieving the old dream of ballooning across the Atlantic. They landed near Miserey, France, east of Paris, twenty hours later, having spent 137 hours, 5 minutes and 30 seconds in the air (fig. 99). They had not only flown the Atlantic, but had set new records for both duration and distance (2,700 miles).

Fig. 99 *Double Eagle II* approaches a landing, August 17, 1978. (NASM, SI 7A43915)

GIRDLING THE GLOBE

T HE FLIGHT OF *DOUBLE EAGLE II* generated a wave of excitement on both sides of the Atlantic. French bartenders offered "balloon" cocktails to celebrate the event. In the U.S. the conquerors of the Atlantic were media celebrities, their exploits documented on television and in newspapers, magazines, and a book. They received the Congressional Gold Medal, the highest civilian award bestowed by the Congress. The triumph of *Double Eagle II*, however, seemed only to have whetted the appetites of the Albuquerque trio, and others like them, for ever more challenging long distance flights:

May 29, 1978: Anderson and Abruzzo win the first James Gordon Bennett balloon race held in forty-one years. Flying *Double Eagle III*, they take off from a Long Beach, California, parking lot and travel 560 miles to a safe landing 57 hours and seven minutes later.

October 1979: Vera Winzen Simons and four companions attempt the first flight across North America in the balloon *Da Vinci*. Launching from Tillamook, on the Oregon coast, they are forced down by a storm in Ohio, having covered more than 1,800 miles.

May 1980: Maxie Anderson and his son Kris fly the balloon *Kitty Hawk* 3,000 miles from San Francisco, California, to a safe landing near Matane, Quebec (fig. 100). While a bit short of the Atlantic coast, the flight is generally credited as the first balloon crossing of North America.

November 10, 1981: Ben Abruzzo and Larry Newman, accompanied by fellow Albuquerque resident Ron Clark and Rocky Aoki, the owner of the Benihana restaurant chain, lift off from Nagashima, Japan, aboard the twenty-six-story *Double Eagle V* (fig. 101). They land in California's Mendocino Forest 84 hours and 31 minutes later, having traveled 5,768 miles to complete the first balloon crossing of the Pacific Ocean.

September 15–18, 1984: Joseph Kittinger, who had long before written himself into the record books as a high-altitude balloonist and parachutist, became the first person to fly the Atlantic in a balloon solo. He launched the *Rosie O'Grady Balloon of Peace* from Maine and flew 3,700 miles to a landing near Savona, Italy.

When reporters interviewed the *Double Eagle II* balloonists the day after they landed in France, Ben Abruzzo announced that he had a new goal: "That's to build a bigger balloon and … go around the world in thirty days, fly all the way around the world, entirely circumnavigate the globe."[22]

Maxie Anderson and his friend Don Ida made the first serious attempts to achieve that goal. Unfortunately, the two died in a balloon crash near Bad Brückenau, Germany, on June 27, 1983. Ben Abruzzo and his wife, Pat, were killed in a light plane

Fig. 100 *Kitty Hawk* in flight, May 1980. (NASM, SI 7A48634)

crash near Albuquerque on February 11, 1985. But the dream of circumnavigating the world in a balloon did not die with them. Beginning in 1981, and continuing for the next eighteen years, dozens of balloonists announced that they would try to circle the globe. Eighteen times, balloons actually lifted off in an attempt to achieve the ultimate flight:

November 1–3, 1981: Maxie Anderson and Don Ida fly the balloon *Jules Verne* 2,676 miles from Luxor, Egypt, to Hansa, India, in the first announced attempt to circumnavigate the globe.

December 20, 1981: Anderson and Ida fly only twenty miles over India in their second attempt.

July 7, 1982: Anderson and Ida fly the *Jules Verne* 1,162 miles from Rapid City, South Dakota, to Midland, Ontario, in 16 hours.

January 12, 1993: Following an unsuccessful attempt to launch from Akron, Ohio, in February 1992, Larry Newman, accompanied by Don Moses and cosmonaut Major General Vladimir Dzhanibekov, lifts off from an airport near Reno, Nevada. They travel only five miles when the huge "anchor balloon" dangling beneath the craft strikes the ground and rips, bringing the flight to an end. Standing 300 feet tall, taller than the Statue of Liberty, the craft resembles a giant hourglass, with a standard helium balloon above and a decidedly non-standard "anchor balloon," filled with compressed air, dangling below. The plan was to ballast the balloon by pumping air in and out of the lower balloon. At $5 million, it was the most expensive balloon ever constructed. Newman honored two of his nine sponsors by naming the balloon itself, *Virgin Earthwinds*, in recognition of the various enterprises headed by entrepreneur Richard Branson, and the gondola, *Earthwinds Hilton*, in honor of hotel mogul and sport aviation enthusiast Barron Hilton.[23]

January 12, 1994: A year later, Larry Newman sets out from Reno once again aboard the *Earthwinds Hilton*. This time his crew includes Dzhanibekov, David Melton, and Ben Abruzzo's son Richard. The total cost of the project has skyrocketed to $7 million. The balloon climbs to 34,000 feet and travels 200 miles before problems with the valve mechanism of the anchor balloon force a landing near Tranquility, California.

December 31, 1994: On his last try, flying with Dave Melton and George Saad, Larry Newman covers

Fig. 101 The crew of *Double Eagle V*: (rear) Ben Abruzzo, (left) Rocky Aoki, (seated left) Larry Newman, Ron Clark. (NASM, 7A43922)

seventy miles aboard *Earthwinds Hilton* when the anchor balloon bursts, ending the flight.

January 10, 1996: Steve Fossett, a fifty-year-old commodities broker from Beaver Creek, Colorado, launches his Roziere balloon, *Solo Challenger*, from the Stratobowl, near Rapid City, South Dakota. Fossett had earlier set a speed record for solo sailing the Pacific, raced automobiles at Le Mans, swum the English Channel and competed in the Iditarod dog sled race. Recognizing new challenges in the sky, he became the first person to solo the Pacific in a balloon in March 1995, flying 5,400 miles from Seoul, South Korea to Canada in four days. He has covered 2,500 miles on his first around-the-world attempt and is 100 miles over the Atlantic when bad weather and equipment problems halt his progress. Fortunately, Fossett is able to find an air current that carries him back to a landing on a frozen lake near Hampton, New Brunswick, Canada.[24]

January 7, 1997: Richard Branson, a forty-six-year-old British business phenomenon and sportsman, and founder of Virgin Records and Virgin Atlantic Airways, launches the 195-foot-high *Virgin Global Challenger* from Marrakech, Morocco, with Alex Ritchie and veteran Swedish balloonist Per Lindstrand. Sixteen hours after take-off, having lost so much helium that they could not possibly complete the trip, the trio land in Algeria. "As I was sitting in the capsule while our balloon was plunging uncontrolled toward the earth," Branson comments to a reporter, "the thought crossed my mind that maybe a round-the-world flight really is impossible." Safely back on the ground, he is more optimistic, noting that, "I'd put money on someone doing it 24 months from today," and predicting a time when improved technology would enable adventure tourists to circle the globe in a balloon.[25]

January 12, 1997: Bertrand Piccard, a thirty-seven-year-old Swiss psychiatrist and the grandson of Auguste Piccard, the inventor of the pressurized balloon gondola, lifts off from Switzerland's Château-d'Oex with Wim Verstraeten aboard the balloon *Breitling Olympic Orbiter*. Sponsored by a firm of Swiss watchmakers, the Roziere balloon featuring kerosene fired burners was built by Don Cameron, the English balloon builder who would produce many of the craft attempting the round-the-world flight. Leaking kerosene fumes force the crew to ditch in the Mediterranean twenty miles south of Montpellier, France.

January 13, 1997: Steve Fossett takes off from St. Louis, Missouri, aboard a Cameron balloon, *Solo Spirit*. He flies 9,672 miles in 144 hours 15 minutes to a landing in a wind storm near Sultanpur, India. In setting a new world record, the balloonist had flown at altitudes of up to 24,000 feet, constantly breathing oxygen and suffering sub-freezing temperatures in his unpressurized gondola. "We can only surmise that Steve is enduring awful conditions," a Cameron employee remarks. "But he's a man of steel and wouldn't complain about anything."[26]

December 31, 1997–January 5, 1998: In the closing hours of 1997, Steve Fossett rises out of Busch stadium, St. Louis, aboard the *Solo Spirit* on his third try to circumnavigate the globe. The stakes are considerably higher now. In November 1997, the Anheuser-Busch Company announced that a Budweiser Trophy and $500,000 would go to the first balloonist to fly around the world. Another $500,000 would go to a charity selected by the victor. Traveling in the jet stream, the intrepid aeronaut reaches speeds of over 160 miles per hour as he sweeps across the Atlantic and over Europe. Unfavorable winds and a malfunctioning burner control force Fossett to land in a Russian wheat field, 7,300 miles from St. Louis.[27]

December 31, 1997: Kevin Uliassi, a thirty-four-year-old architect and engineer, lifts off in the balloon *J. Renee*, named for his wife, from a quarry near Rockford, Illinois. The rupture of a helium cell soon after launch forces an emergency landing in Indiana after traveling only 300 miles.[28]

January 9, 1998: Less than a week after Steve Fossett set down in Russia, Dick Rutan, who, with Jeana Yeager, made the first non-stop, unrefueled airplane flight around the world in the *Voyager* in 1986, launches aboard the balloon *Global Hilton* from Vaughn, New Mexico, near Albuquerque. Two hours later, after a flight of only 100 miles, a rip in the inner helium-filled portion of the envelope forces Rutan and Dave Melton to bail out. Rutan lands on a cactus, while Melton is blown into a wire fence. Their 170-foot tall balloon lands eight hours later in a tree near Lindsay, Texas.

January 29–February 7, 1998: Accompanied by Andy Elson and Wim Verstraeten, Bertrand Piccard lifts off from Château-d'Oex aboard *Breitling Orbiter II*. All of the conditions for success seem to be in place. China's refusal to allow the trio permission to overfly the People's Republic, however, forces a landing near Sitkinwa Minhla, Myanmar (Burma), having broken the world's endurance record by remaining in the air for six days, two hours and 44 minutes. Their distance, 5,266 miles, is far short of Steve Fossett's record, however.

August 7–16, 1998: Steve Fossett makes his fourth attempt to circle the world along a southern route, reducing the problem of crossing international borders. Launching *Solo Spirit 3* from a sports stadium at Mendoza, Argentina, Fossett has set new distance and endurance records (14,236 miles in 205 hours, 59 minutes) when he encounters a thunderstorm 500 miles off the Australian coast and plunges over 20,000 feet down into the shark-infested waters of the Coral Sea. He is rescued eight hours later.

December 18–25, 1998: Three of the world's most experienced long-distance balloonists—Per Lindstrand, Richard Branson, and Steve Fossett—launch from Marrakech, Morocco, aboard a Lindstrand balloon, *ICO Global*, and fly 12,404 miles in 178 hours to a landing in the Pacific, just ten miles from Kahuku Point, Oahu,

Hawaii. They have flown over halfway around the world, across all of Asia, only to be forced down by a stationary weather front blocking the winds that would have carried them on to the west coast of the U.S.

February 17–March 7, 1999: A pair of British balloonists, Andy Elson, a forty-five-year-old aeronautical engineer, and forty-eight-year-old Colin Prescot, fly the balloon *Cable & Wireless* 8,953 miles in 425 hours, 42 minutes, from Almeira, Spain, to a point almost 168 miles southeast of Tokyo, Japan, where difficult weather conditions force a landing.

March 3–21, 1999: Bertrand Piccard and Brian Jones, an RAF veteran and engineer who helped to develop the flight systems for *Breitling Orbiter 3*, finally complete a non-stop balloon flight around the world, traveling 25,361 miles from Château-d'Oex to a landing near Dakhla, Egypt, in 477 hours and 47 minutes (fig. 102).

A Roziere balloon designed and built by Cameron Balloons, of Bristol, England, *Breitling Orbiter 3* stands 180 feet tall when fully inflated. The envelope is constructed of a nylon welded to a helium-tight membrane covered with an outer protective skin coated with aluminum on both sides to provide improved thermal control. The shape and special features of the envelope are designed to ensure maximum temperature stability in order to conserve helium and reduce propane consumption.

Piccard and Jones spend almost three weeks in a Kevlar and carbon epoxy capsule roughly the size of a minivan (fig. 103). The daily routine calls for each man to spend eight hours alone at the controls; eight hours working with his crewmate; and eight hours in the single bunk. Cabin heating grows less efficient as the outside

temperature falls to minus 50 degrees Celsius. Piccard has to chip ice crystals created by the moisture in their breath from delicate electrical circuitry. Drinking water stored inside the gondola freezes. Jones suffers with a cold, while Piccard resorts to self-hypnosis to fight depression and fall asleep. "When Neil Armstrong stepped on the moon, he was happy to be so far away," Bertrand Piccard comments after the flight. "When we stepped onto the desert, we were happy to put our footprints back on earth."

In spite of the hardships, the two balloonists were able to find a deeper meaning in their great adventure. "For me, the flight was a unique opportunity to establish a friendlier relationship with our planet," Bertrand Piccard explains. "Human beings always want to control nature, but flying around the world by balloon ... we must harmonize with nature, following the rhythm of the wind."[29]

Breitling Orbiter 3 was first around the globe, but there were those who sought an even more elusive goal—a solo non-stop circumnavigation:

February 22–March 3, 2000: Kevin Uliassi flies *J. Renee* 12,710 miles from Rockford, Illinois to Nyaungu, Myanmar (Burma). Problems with weather, equipment and diplomatic permissions for potential overflights convince Uliassi to end the flight.

August 4–17, 2001: Steve Fossett launches *Solo Spirit 3* from Northam, Australia, on his fifth attempt to solo the globe. He flies 11,968 miles to Bagé, Brazil, where he is forced down by bad weather.

June 19–July 3, 2003. The sixth time is the charm for Steve Fossett, who flies *Bud Light Spirit of Freedom* roughly 20,521 miles from Northam, Western Australia, to a landing at Blue Hills, Queensland, Australia, completing the first solo balloon flight around the world (fig. 104). Living in an unpressurized gondola the size of a closet for over two weeks is not easy. Fossett

Fig. 104 Steve Fossett and Richard Branson. (Photo by Eric Long, NASM)

cruises at more than 20,000 feet and breathes oxygen from liquid oxygen containers. The gondola has a bench and a sleeping bag. The pilot averages four hours of sleep a day, usually in the form of cat naps lasting forty-five minutes or less. He eats military rations, "meals ready to eat" (MREs), each of which comes with a chemical heat pack, one of which he uses to thaw a frozen propane line.

Steve Fossett went in search of further challenges, completing the first two solo airplane flights around the world, the second of which was meant to establish a solo distance flight record that would stand for the foreseeable future. He disappeared while flying a light plane in the Nevada desert in 2007. The voyage of the *Spirit of Freedom* was a fitting end to an extraordinary era of long-distance balloon flights that had begun forty-five years before with an unsuccessful Atlantic attempt by the crew of the aptly named *Small World*. It had been a period filled with disappointment and tragedy, as well as triumph.[30]

FLOATING INTO THE FUTURE—AIRSHIPS

WHERE THE FUTURE OF THE RIGID AIRSHIP IS CONCERNED, hope springs eternal. While the fiery demise of the *Hindenburg* may seem to have been the funeral pyre of the Zeppelin, enthusiasts continue to dream of an airship renaissance. The airship, with its relatively low speed, vulnerability to weather, and special ground handling requirements was never more than a stopgap measure able to meet the military and commercial need for long-range air operations until the advent of suitable fixed wing aircraft. Still, airship proponents continue to search for a niche application to justify the return of the big rigids.

While the Goodyear-Zeppelin Corporation was not officially dissolved until February 14, 1941, the partnership effectively ended with the *Hindenburg* disaster. Goodyear Tire and Rubber organized a wholly owned subsidiary, the Goodyear Aircraft Corporation, on December 5, 1939. The new company was not prepared to give up on the rigid airship. In December 1941, Goodyear publicists explained how several airships with a capacity of 9,500,000 cubic feet of helium, and deploying hook-on versions of the Navy's latest scout-dive bomber, could guard the U.S. coast from enemy attack.

The plan was updated in the spring of 1945, suggesting that a commercial airship one-third again larger than the *Hindenburg* could transport 180,000 pounds of cargo non-stop over a distance of 7,000 miles, and offer passengers all of the

amenities of an ocean liner "except for the swimming pool." With a price tag of $8 million, the aerial behemoth would occupy an economic niche midway between that of the steamship and the airplane.[31]

President Truman's Air Coordinating Committee reported enthusiastically on the plan. Goodyear hired Hugo Eckener, the world's authority on commercial airship design and operation, to consult on the project. Charles E. Rosendahl offered his enthusiastic support. Promoted to rear admiral after service as the captain of the heavy cruiser USS *Minneapolis* during the battle of Tassafaronga, off Guadalcanal, in May 1943, Rosendahl spent the rest of the war as Chief of the Naval Airship Training and Experimental Command, effectively outranking the officers commanding blimp operations. Retiring in November 1946, he became the leading spokesman for the return of the rigid airship, suggesting to Congress that a fleet of such craft operated by existing steamship lines "can give us an unapproachable margin of supremacy in the field of transoceanic air commerce." Moreover, he argued that the new airships could still serve the U.S. Navy as "flying aircraft carriers." Surviving Goodyear drawings from this period show small monoplane fighters nestled in a hangar deck.[32]

In the spring of 1948, the U.S. House of Representatives authorized the U.S. Maritime Commission to procure airships of the sort described by Goodyear. Rosendahl and Paul W. Litchfield, Chairman of Goodyear, and a long-time proponent of the airship, testified on behalf of the bill. Theodore von Kármán, the world's leading aerodynamicist, concurred the large airships would be "more economical than planes" for freight operations. In spite of such support, the project died in the Senate.[33]

There was always the hope that the airship would prove just the thing to solve a specific problem. The Soviets announced that they were interested in developing large airships for Arctic operations. Dirigibles were touted as the perfect vehicles to transport oil, carry high-value cargo such as fruits and vegetables, or haul cut timber out of remote locations.

Perhaps radical technical developments could increase the capabilities of the airship. British, German, and Italian planners explored the notion of an unmanned, jet-propelled airship capable of delivering nuclear weapons. Goodyear engineers, desperate to revive the dwindling market for military blimps, touted the potential virtues of a nuclear-powered pressure airship measuring 520 feet in length with a gas capacity of 4 million cubic feet powered by a nuclear power plant. An eighty-six foot long, two-story control car would house a crew of twenty-four. Radiation levels, the engineers promised, would "be of such a low order that no elaborate ground handling equipment or special crew environment need be provided." Fortunately, common sense prevailed.

Fig. 105 Photo: courtesy Marilee Nason and the Anderson-Abruzzo Albuquerque International Balloon Museum.

William Miller and his colleagues at New Jersey's Aeron Corporation drew initial inspiration for their triple-hulled craft from the *Aereon* experiments of Solomon Andrews, the Civil War–era mayor of Perth Amboy, New Jersey. The group proposed a hybrid vehicle featuring a thick, helium-filled deltoid hull that would also develop aerodynamic lift. The project, which resulted in a flying prototype but failed to attract government funding, was immortalized in John McPhee's classic book, *The Deltoid Pumpkin Seed*.[34]

Frank Piasecki, a Pennsylvania-based helicopter pioneer, began assembling his "Helistat" at the U.S. Navy facility at Lakehurst, New Jersey, in 1979. The craft featured a 343-foot long Dacron gas bag lifting a large bridge-like frame with an H-34 helicopter at each of the four corners. Funded by the U.S. Forest Service, the Helistat was intended to provide a fuel-efficient means of transporting large bundles of timber out of inaccessible areas. By 1983, however, the project was the target of both General Accounting Office officials, who identified it as a "boondoggle," and Navy, NASA and Federal Aviation Administration staffers who questioned both Piasecki's design and workmanship.

The program was plagued by technical glitches, a slipping schedule and costs that climbed from an initial estimate of $6.7 million at the outset to $31.2 million. The Helistat effort came to a tragic end on the evening of July 1, 1986, when the craft crashed during a test flight, taking the life of one crew member and injuring four others.[35]

Two years later, in 1988, Luftschiffbau Zeppelin, which had remained in business producing silos, radar antennae and other non-flying products, launched a study to gauge the feasibility of a new-generation commercial airship. A positive report led to the creation of a spin-off company, Zeppelin Luftschifftechnik GmbH, in 1993, and the production of a prototype Zeppelin NT (New Technology), which first flew at Friedrichshafen in September 1997.

The Zeppelin NT is large, measuring 246 feet long with a capacity of over 290,460 cubic feet of helium, and uses vectored thrust engines to compensate for the fact that the gas volume is insufficient to fully support the weight of the airship and payload. The Zeppelin NT is a semi-rigid craft, with a triangular keel structure that carries the weight of the control car and engines. The envelope, constructed of modern high-strength materials, features a ballonet to maintain internal pressure and shape.

Since 1997, the company has produced three more Zeppelin NT aircraft, with a fourth under construction and scheduled for completion in 2008. By the end of 2003, Deutsche Zeppelin-Reederei (the Zeppelin Transport Company) had flown some 30,000 passengers on pleasure flights. The Nippon Airship Corporation purchased one of the craft in the spring of 2004. A Zeppelin provided airborne security at the Athens Olympic Games, while another craft has conducted aerial geophysical surveys for the De Beers Company in South Africa.

While the Zeppelin name is once more in the air, no new rigid airships have been produced since 1938. All plans for such craft, including that of the German Cargolifter, have failed to produce a flying machine. Interest continues, however, and the Defense Advanced Research Projects Agency (DARPA), the research and development organization of the U.S. Department of Defense, has issued several contracts to study the potential for large airships that would fill a variety of roles.

In the spring of 2005, DARPA, the Navy and the Army funded studies for Hybrid Ultra-Large Aircraft (HULA), lighter-than-aircraft that would also depend on the aerodynamic lift produced by air flowing around the hull to carry heavy cargo over great distances. The Army *Walrus* airship, for example, would have transported 500 tons of men and equipment over a distance of 12,000 miles. Congressional skepticism led to the cancellation of the program in March 2006.

DARPA immediately found a new niche for the old technology, funding studies leading to the development of a remotely controlled pressure airship so large that it would dwarf the Statue of Liberty. The craft, identified as the ISIS (Integrated Sensor Is Structure), would carry an array of sensors up to 70,000 feet where it could loiter

for days or weeks, providing real time reconnaissance information, from detailed battlefield images to the ability to track a single individual traveling about a city.

There are even those who envision a series of airships that would rise into earth orbit—and beyond. The JP Aerospace Corporation proposes flying into space using a "three stage" LTA system. The first stage would consist of an atmospheric airship that would carry a crew of three and their payload to an altitude of 140,000 feet, where they would dock with a permanently positioned buoyant station. This crewed facility would provide living quarters and workspace in which to construct the third "stage," an inflatable structure over a mile long that would climb to 200,000 feet on the basis of a tiny amount of gas in the envelope. At that point an electrical propulsion system would slowly accelerate the craft to orbital velocity over a period of weeks. Funding research leading to a prototype of the first stage craft was provided by DARPA with the intention that the resulting high-altitude airship could serve as a reconnaissance vehicle.[36]

FLOATING INTO THE FUTURE—BALLOONS

DURING THE TWENTIETH CENTURY, high-speed aircraft and earth-orbiting satellites replaced the balloon as the primary means of conducting aerial reconnaissance. Ironically, twenty-first-century technology breathed new life into the world's oldest military aircraft. Beginning in the 1960s, the Westinghouse Electric Corporation began to develop radar and communications systems that could be mounted on World War II–vintage British barrage balloons. When the veteran balloons proved far too unstable for modern electronic systems, DARPA, NASA and the USAF funded the development of tethered aerostats specially designed to carry communications gear and long-distance surveillance equipment to high altitudes.

In 1971, Westinghouse officials established TCOM as a subsidiary to develop a communications and television relay system carried aloft by tethered aerostats. Westinghouse won an Air Force contract to operate a tethered airborne radar surveillance system in the Florida Keys to detect and track airborne intruders. A decade later, TCOM marketed a Low Altitude Surveillance System (LASS), a tethered balloon that carried scanning radar to an altitude of 10,000 feet, where it could provide a relatively low cost airborne early warning capability for developing nations, as well as improved border surveillance for the U.S.

Aerostats produced by the now independent TCOM, L.P., Lockheed Martin and other manufacturers continue to guard Americans at home and abroad. The USAF operates a series of 420,000 cubic feet balloons along the southern border of the U.S. American forces stationed in Iraq and elsewhere send smaller tethered aerostats up to one thousand feet in the air, where they provide radar coverage to a range of twenty miles and serve as communication relays.[37]

Nor are balloons limited to operations within the atmosphere. The oldest flight technology entered earth orbit on August 12, 1960. *Echo I*, constructed by the G. T. Schjeldahl Company, was an aluminum-coated Mylar balloon measuring 100 feet in diameter, inflated in space by residual air, benzoic acid, and anthraquinone. The craft served as a reflector for bouncing radio signals from coast to coast.

Soviet scientists and engineers wrote a new chapter in the history of ballooning in June 1985, when the *Vega 1* and *Vega 2* spacecraft entered the atmosphere of Venus. Both probes released superpressure balloons on their way down to the surface. Filled with helium, each of the two "aerobots" measured about eleven and one-half feet in diameter, and carried some fifteen pounds of instrumentation and communications gear. Both of the balloons flew at an altitude of over thirty miles above the surface of the planet and continued to transmit valuable information until their batteries ran down. Researchers from Old Dominion University and NASA's Jet Propulsion Laboratory propose a future Venus Mobile Explorer featuring metal balloons capable of withstanding the extremes of the Venusian atmosphere for extended periods.[38]

Following the lead of such visionaries as science-fiction master Arthur C. Clarke, NASA mission planners are considering the potential of buoyant flight technology to explore Mars, Jupiter, and Saturn. Recent studies suggest that the high atmospheric density, low temperature, and relatively light winds that prevail on Titan point to a hot air balloon as the "most economic, elegant, and reliable way" to explore Saturn's largest moon. Once inflated and launched into Titan's dense, cold atmosphere, the interplanetary aerostat would need only a fraction of the heat energy required by a terrestrial balloon, and could be kept aloft for months by a radioactive heat source. Flying at a cruise altitude of 10 kilometers, the craft would circumnavigate Titan in less than an earth year, carrying 45 kilograms of cameras, spectrometers, organic analyzers and subsurface radars.[39]

Balloons continue to carry scientific instruments to the roof of the sky. Technologically advanced descendants of the smoke-filled bag that Joseph and Étienne Montgolfier sent up from the town square of Annonay in the spring of 1783 have already flown in the atmosphere of another world. If current plans bear fruit, lighter-than-aircraft will play a key role in the exploration of the solar system. For the world's oldest flight technology, it seems that there is still no place to go but up.

APPENDIX 1
A CHRONOLOGY OF LIGHTER-THAN-AIR FLIGHT

PREPARED BY PETE D'ANNA

212 BC
Archimedes discovers the buoyancy principle while performing water immersion tests to determine the specific gravity of gold.

AD 1250
English monk Roger Bacon visualizes the creation of airborne vehicles based on the displacement/buoyancy principle.

1650
Otto von Guericke, the mayor of Magdeburg, Germany, invents a vacuum pump to pull the air out of a closed vessel.

1660
The English philosopher Robert Boyle first describes the relationship between pressure, volume, and temperature in gases.

1670
Francesco Lana de Terzi suggests that the evacuation of thin walled copper spheres would make them buoyant.

August 8, 1709
Bartolomeu Lourenço de Gusmão flies a small hot air balloon in the presence of the King of Portugal.

1765
Scottish chemist Joseph Black identifies the first elemental gas, known today as nitrogen.

1766
Henry Cavendish discovers inflammable air, which Antoine Lavoisier renames hydrogen in 1783.

1772
Tiberius Cavallo fills animal membranes with hydrogen, but the volume is too small to provide sufficient lift.

June 4, 1783
Joseph and Étienne Montgolfier provide the first public demonstration of their hot air balloon in the town square of Annonay, France.

August 27, 1783
Jacques Alexandre-César Charles and the Robert brothers demonstrate the first unmanned hydrogen balloon from the Champ-de-Mars in Paris.

September 19, 1783
The Montgolfier brothers send a sheep, a rooster, and a duck aloft from the courtyard of the palace of Versailles as the royal family look on.

October 15[?], 1783
Étienne Montgolfier becomes the first human being to make a tethered flight, rising from an area near the Réveillon workshop in the Faubourg Saint-Antoine, Paris. Jean-François Pilâtre de Rozier follows soon thereafter.

November 21, 1783
Pilâtre de Rozier and François Laurent, marquis d'Arlandes, become the first human beings to make a free flight, making a 25-minute flight from the Château de La Muette, Paris, in a Montgolfier balloon.

December 1, 1783
Jacques Charles and Marie-Noël Robert make the first manned free flight in a hydrogen-filled balloon, flying 27 miles from the Tuileries Palace, Paris, to a safe landing near Nesles, France.

January 19, 1784
Joseph Montgolfier ventures aloft from Lyons with a number of passengers aboard the large hot air balloon *Le Flesselle*.

February 25, 1784
Italian aeronaut Paolo Andreani, accompanied by the brothers Augustine and Charles Gerli, makes the first balloon flight outside of France at Milan, Italy.

June 4, 1784
Madame Elisabeth Thible becomes the first woman to make a balloon flight,.

June 24, 1784
Peter Carnes, a Bladensburg, Maryland, lawyer, sends Edward Warren, a thirteen-

year-old spectator, on a tethered hot air balloon flight near Baltimore, making Warren the first American to ascend in a balloon in America.

August 25 and September 1, 1784
James Tytler makes the first free balloon flights in Great Britain at Edinburgh, Scotland.

September 15, 1784
Vincenzo Lunardi makes the first hydrogen balloon ascent in England before a crowd of 150,000 spectators.

January 7, 1785
Jean-Pierre Blanchard and Dr. John Jeffries complete one of the first great aerial voyages, flying the English Channel from Dover to Calais.

June 15, 1785
The balloon claims its first victims when Pilâtre de Rozier and Jules Romain crash to their deaths in an attempt to cross the English Channel from France to England in a hybrid hydrogen and hot air balloon.

January 9, 1793
Jean-Pierre Blanchard makes the first manned free balloon flight in America, traveling 15 miles from Philadelphia to Woodbury, New Jersey.

April 2, 1794
French officials create the world's first military aviation unit, the Corps d'Aérostiers. Within two months, the unit would be conducting battlefield observations at Maubeuge, Charleroi, and Fleurus.

1798
Jeanne-Geneviève Labrosse Garnerin becomes the first woman to make a parachute jump, and, a year later, the first woman to make a solo free balloon flight.

July 7, 1819
Madame Blanchard, widow of Jean-Pierre Blanchard and a leading aeronaut in her own right, becomes the first woman to die in a balloon accident.

November 7–8, 1836
Englishman Charles Green and two passengers fly the 70,000 cubic foot coal gas–inflated balloon *Royal Vauxhall* from London to the Royal Duchy of Nassau in Germany for a record distance of 340 miles in 18 hours.

September 24, 1852
Henri Giffard flies his steam-powered dirigible 17 miles from Paris to Trappe.

July 1, 1859
John Wise and three companions lift off from St. Louis aboard the balloon *Atlantic*. The trio land in a forest near Henderson, New York, having set a new distance record of 809 miles in 20 hours 40 minutes.

1861–1863
Thaddeus S. C. Lowe organizes and leads an observation balloon unit to serve with the Union armies. Balloonist John La Mountain operates independently with the federal forces based at Fort Monroe, Virginia. The Confederates make several attempts to develop observation balloons, but without much long-term success.

September 5, 1862
Meteorologist Professor James Glaisher and balloonist Henry Coxwell fly the 90,000 cubic foot balloon *Mammoth* to almost 30,000 feet.

October 4, 1863
Gaspard-Félix Tournachon, a photographer better known as Nadar, makes the first flight with the balloon *Le Géant*, measuring 197 feet tall with an envelope containing 212,000 cubic feet of lifting gas.

1870
When Prussian troops besiege Paris, balloons are used to evacuate important public officials and documents from the city.

April 15, 1875
Gaston Tissandier ascends to an altitude of more than 25,000 feet aboard the

balloon *Zénith*, accompanied by Joseph Crocé-Spinelli and Théodore Sivel. Tissandier survives but his companions succumb to the effects of high altitude.

October 8, 1883
Albert and Gaston Tissandier fly their electrically powered airship for one hour, landing near Saint-Germain, Paris.

August 9, 1884
French Army engineers Captains Charles Renard and Arthur Krebs make a controlled circular flight at Chalais-Meudon.

June 12, 1897
Taking off from Berlin's Tempelhof Field, Karl Wölfert flies the first airship powered by an internal combustion engine to an altitude of 3,000 feet, at which point flame from the engine ignites escaping hydrogen. Wölfert and mechanic Robert Knabe perish in the crash.

July 11, 1897
Swedish engineer Salomon August Andrée and two companions ascend from Spitsbergen aboard the balloon *Örnen* ("The Eagle") in an attempt to fly to the North Pole. The party vanishes into the Arctic mist. Their bodies, diaries, and undeveloped photographic plates are eventually found on White Island in the Arctic Ocean.

November 7, 1897
Ernst Jägels flies the first aluminum rigid airship, designed by David Schwarz, from Berlin Tempelhof. He survives a hard landing that destroys the craft.

July 2, 1900
Count Ferdinand von Zeppelin flies his first dirigible from Lake Constance, near Friedrichshafen, Germany.

October 19, 1901
Alberto Santos-Dumont flies in his dirigible *No. 6* from the suburb of Saint-Cloud to the Eiffel Tower and back in half an hour to win the Deutsch de la Meurthe prize.

November 13, 1902
Georges Juchmès pilots the airship *Le Jaune*, designed by French engineer Henri Julliot, on its maiden flight. It was the first of a series of airships, ranging in capacity from 115,000 to 700,000 cubic feet, that would be delivered to the French Army by 1914.

May 1906
German Army Major August von Parseval flies his first non-rigid airship. In all, twenty-seven Parseval airships were built and served in military as well as in commercial roles. They ranged in size from 140,000 to approximately 1,000,000 cubic feet.

August18, 1908
Glenn Curtiss and Thomas Scott Baldwin demonstrate the airship SC-1 to officials of the U.S. Army Signal Corps at Fort Meyer, Virginia. The craft is accepted as the first powered flying machine in the Army inventory.

1909
Marine architect Professor Johann Schütte establishes Luftschiffbau Schütte-Lanz, a firm that will supply rigid airships to the German military during World War I.

October 16, 1909
Count von Zeppelin founds DELAG, the world's first commercial passenger airline.

June 4, 1910
British airship pioneer Ernest T. Willows ascends from near Cardiff in his non-rigid airship *Willows II* and lands at Cardiff's city hall. He then returns to his starting point. Five of his airships were used by the Royal Navy for pioneering anti-submarine patrol missions during World War I.

October 15, 1910
After two failed attempts to reach the North Pole in 1907 and 1909, American newspaperman Walter Wellman fails in his attempt to fly the dirigible *America* across the Atlantic. The crew members are rescued by the British steamer *Trent*.

September 24, 1911
The British Royal Navy's first dirigible *Mayfly* breaks in half during its second flight attempt. It was 512 feet long and had a gas capacity of 664,000 cubic feet.

July 2, 1912
Melvin Vaniman, Walter Wellman's chief engineer, dies in a fiery crash attempting to fly from Atlantic City across the Atlantic Ocean in the Goodyear-built airship *Akron*.

1915–1917
German Zeppelins conduct the world's first strategic bombing campaign against Great Britain.

November 1917
L 59 (LZ 104), the Africa Zeppelin, flies 4,163 miles from Sofia, Bulgaria, to the Sudan and back in an unsuccessful attempt to re-supply German forces in East Africa.

1917–1918
The U.S. Navy buys 16 B Class and 10 C Class Blimps to be used for anti-submarine patrol and convoy escort duties. C-7 was the first Blimp to be inflated with helium.

July 2–13, 1919
The British airship R34 flies 4,700 miles from Pulham, England, to Roosevelt Field, Long Island, in 108 hours and returns to England in 75 hours with the prevailing wind.

August 21, 1921
The U.S. Navy ZR-2, the British-built R38, catches fire and burns on its fourth test flight in England with the loss of 41 persons, fifteen of whom were U.S. Navy personnel.

February 21, 1922
The U.S. Army's Italian-built airship *Roma* hits high tension lines near Langley Field, Virginia, and burns, killing 34 of its 45 crew members.

September 4, 1923
The ZR-1 *Shenandoah* makes its maiden flight at the Lakehurst, New Jersey, Naval Air Station.

December 22, 1923
The French dirigible *Dixmude* is lost at sea off the coast of Sicily. Originally built as LZ 114, it was given to France as World War I reparations payment in July 1920.

October 12, 1924
LZ 126 flies from Friedrichshafen, Germany to Lakehurst, New Jersey, a distance of 4,660 miles in 81 hours. Renamed the USS *Los Angeles* (ZR-3), she will serve longer than any other U.S. rigid airship.

May 15, 1925
The Goodyear airship *Pilgrim* begins its career as the first of a long line of advertising blimps.

September 3, 1925
Shenandoah (ZR-1) breaks up in a storm over Noble County, Ohio. Fourteen crew members, including Captain Lansdowne,

are lost; twenty-nine officers and men survive.

May 11–13, 1926
Roald Amundsen and American Lincoln Ellsworth fly the Italian semi-rigid airship *Norge* (N-1), commanded by the designer, Col. Umberto Nobile, from Spitsbergen over the Pole to a safe landing in Nome, Alaska.

November 4, 1927
U.S. Army Air Corps balloonist Captain H. C. Gray dies on a high-altitude flight.

May 25, 1928
Returning to Spitsbergen following a flight to the North Pole, the Italian semi-rigid airship *Italia* (N-4) is forced down on the ice. Seven crew members are lost during the disaster. Nine, including the commander, Gen. Umberto Nobile, survive and are eventually rescued as a result of a massive air-sea effort.

August 1929
Graf Zeppelin (LZ-127) circles the world in twenty-one days.

August 19, 1929
The metalclad airship ZMC-2 makes its maiden flight. The experimental U.S. Navy craft remains in active service until 1939.

July 1930
The British airship R100 flies from Cardington, England, to Montreal, Canada, a distance of 3,592 miles in 79 hours.

May 27, 1931
Launching from Augsburg, Germany, in a balloon using the first pressurized spherical gondola, Swiss physicist Auguste Piccard and Paul Kipfer reach a record altitude of 51,784 feet before landing safely in the Bavarian Alps.

September 27, 1931
The USS *Akron* (ZRS-4) makes its maiden flight.

October 5, 1931
British passenger airship R101 crashes and burns near Beauvais, France, on its inaugural flight to establish a passenger service from England to India. Only eight of the 56 passengers and crew survive.

April 4, 1933
The U.S. Navy airship USS *Akron* crashes near Barnegat Inlet, off the coast of New Jersey. Only three of the 76 officers and men on board survive.

April 21, 1933
The U.S. Navy's USS *Macon* (ZRS-5) makes its first flight.

September 1933
Three Soviet balloonists reach a record altitude of 58,700 feet in the stratostat *USSR*.

November 1933
Ascending from the Akron, Ohio, Municipal Airport, Lt. Cmdr. Thomas Settle and Marine Major Chester Fordney fly the balloon *Century of Progress* to a new altitude record of 61,221 feet.

January 19, 1934
Three Soviet Russian balloonists reach an altitude of 72,178 feet but die when their pressurized gondola breaks free during the descent.

July 1934
Major William Kepner and Captains Albert Stevens and Orvil Anderson of the U.S. Army Air Corps rise to an altitude of 60,500 feet following the launch of *Explorer I* from the Stratobowl, near Rapid City, South Dakota. All three parachute to safety when the envelope fails.

October 18, 1934
Jeannette Piccard, flying the *Century of Progress* balloon with husband Jean, reaches an altitude of 61,238 feet, becoming the first woman to reach the stratosphere.

February 12, 1935
The USS *Macon* crashes off the California coast with the loss of two lives.

November 11, 1935
Captains Stevens and Anderson fly *Explorer II* to a record altitude of 72,395 feet.

March 4, 1936
The new German passenger dirigible airship *Hindenburg* (LZ-129) makes its first flight from the Luftschiffbau Zeppelin's Friedrichshafen facility near Lake Constance.

May 6, 1937
Hindenburg (LZ-129) burns and crashes as it approaches the mooring mast at Lakehurst, NJ, Naval Air Station. Thirty-five of the ninety-six persons aboard and one ground crewman die.

December 1938–August 1945
U.S. Navy blimps play an important role

in protecting the sea approaches to the U.S., guarding convoys against submarine attack, and rescuing downed airmen and sailors. One hundred thirty-five K Ships, the standard wartime blimp model, were built, making it the single largest airship production run in history.

December 1944–May 1945
Japanese FUGO balloon bombs impact the western US and Canada. In May 1945, an Oregon woman and five children are killed when they investigate a downed FUGO bomb.

1946–1947
Goodyear restarts its airship advertising program with surplus military training airships.

September 25, 1947
An early Project Skyhook plastic envelope carries a scientific payload to an altitude of 31,000 feet.

1947–1960s
Balloons perform a variety of functions during the Cold War, from delivering propaganda leaflets to carrying cameras and other sophisticated sensors across the Soviet Union.

1948–1961
The U.S. Navy awards Goodyear a contract for the ZPN-1 airship, later to become the ZPG-2/3 ASW and Airborne Early Warning (AEW) series of production airships. The series culminates in the 1.5 million cubic foot ZPG-3W AEW airship, which is 403 feet long.

1954–1957
In May 1954, a ZPG-2W airship completes a flight from Lakehurst to Key West by way of Bermuda and Puerto Rico in eight hours. In March 1957, another airship completed an eleven-day, 8,216-mile flight from Weymouth, Massachusetts to Key West by way of Europe, North Africa, and the south Atlantic.

May 31, 1954
The French aeronaut Charles Dollfus ascends to almost 23,000 feet to enable his astronomer son Audouin to search for water vapor in the Martian atmosphere.

November 8, 1956
The Navy's *Strato-Lab I* balloon with Lt. Cmdrs. Ross and Lewis aboard ascends

to 76,000 feet, breaking the pre–World War II record set by *Explorer II*.

August 19–20, 1957
Flight surgeon Major David Simons reaches an altitude of 101,516 feet on the second *Manhigh* flight.

1957–1961
In the post-war era the K series airship was stretched through several variants which ended in an essentially new airship—the ZSG-4. The cumulative knowledge in ASW airship design was applied in the design of the all new ZS2G-1, which was an excellent airship. The ZPG-3W, the final non-rigid Navy fleet airship, serves as a long endurance AEW platform until the Navy's LTA cancellation order in 1961.

1957–1991
Balloons carry special telescopes and infrared sensors to high altitudes in order to study solar radiation, planetary surfaces, and atmospheric characteristics in the nearly distortion-free stratosphere.

August 16, 1960
Air Force Captain Joe Kittinger rides the *Excelsior III* balloon to 102,800 feet and parachutes to earth, establishing the world record highest altitude parachute jump.

May 4, 1961
Launched from a Navy ship in the Gulf of Mexico, Cmdr. Ross and Lt. Cmdr. Prather ride *Strato-Lab V* to a world record altitude of 113,740 feet. Tragically, Prather drowns during the landing when his pressure suit fills with water.

August 11–17, 1978
Flying from Presque Isle, Maine, Maxie Anderson, Ben Abruzzo, and Larry Newman fly *Double Eagle II* to Miserey, France, becoming the first balloonists to cross the Atlantic Ocean. Their flight of 2,700 miles in 137 hours sets the free balloon records for distance and endurance.

November 10–12, 1981
Ben Abruzzo, Larry Newman, Ron Clark, and Rocky Aoki fly *Double Eagle V* from Nagashima, Japan to Covelo, California, a distance of 5,768 miles, in 84 hours and 31 minutes, completing the first balloon crossing of the Pacific.

September 15–18, 1984
Joe Kittinger flies from Maine to Savona, Italy, a distance of 3,700 miles, becoming

the first person to solo a balloon across the Atlantic Ocean.

1984–2006
Tethered surveillance balloons make a comeback with TCOM's Low Altitude Surveillance System (LASS). Carrying a powerful radar to an altitude of 10,000 feet, the balloons allow the U.S. Coast Guard to guard against aerial intrusion into U.S. air space.

January 15–17, 1991
Richard Branson and Per Lindstrand make the first hot air balloon crossing of the Pacific Ocean in the 220-foot high *Pacific Flyer*, the largest hot air balloon flown to date.

February 18–21, 1995
Steve Fossett makes the first Pacific solo balloon flight from Seoul, Korea, to Saskatchewan, Canada, a distance of 5,340 miles.

January 14–20, 1997
Steve Fossett sets the solo endurance record in *Solo Spirit* flying from St. Louis, Missouri, to Sultanpur, India, for a record 10,361 miles in 6 days, 2 hours, and 44 minutes.

February 17–March 7, 1999
Colin Prescot and Andy Elson set a new endurance record of nearly 18 days in their balloon *Cable & Wireless*. They lift off from Spain on February 17 and terminate their flight when they ditch off the coast of Japan on March 7.

March 1–21, 1999
Bertrand Piccard and Brian Jones make the first non-stop around-the-world balloon flight, circling the globe aboard *Breitling Orbiter 3* in 20 days. Traveling 25,361 miles, they surpass all previous duration and distance records. Launching from Switzerland on March 1, they land in the Egyptian desert on March 21, earning the Budweiser Cup and a one million dollar prize.

June 19–July 4, 2002
Steve Fossett completes the first solo non-stop balloon flight around the world. Launching from Northam, Australia, he flies the *Bud Light Spirit of Freedom*, a hybrid helium/hot air balloon, around the world, covering 20,521 miles in 14 days 19 hours.

APPENDIX 2
AIRSHIPS OF THE WORLD: A SELECTION

NON-RIGID AIRSHIPS

Name	Year	Volume, cu. ft.	Length, ft.	Diameter, ft.	Engines	Max speed, mph
(Fr.) Henri Giffard	1852	88,300	144	40	1 steam, 3 hp	Less than 10
(Fr.) Chalais-Meudon *La France*	1884	65,817	165.3	27.5	1 Gramme Electric, 9 hp	12
(Fr.) Tissandier	1888	37,100	91.8	49.8	1 Siemens electric	Less than 10
(Fr.) Santos-Dumont *No. 6*	1901	22,238	108.9	19.8	1 Buchet, 12 hp	Unknown
(Fr.) Astra *Ville de Paris*	1907	114,757	196.1	34.6	1 Chenu, 60 hp	22.3
(U.S.) Goodyear *Akron* (1)	1912	345,940	260	47	—	Unknown
(Fr.) Astra-Torres, Nos. 1–4	1916	229,515	223.1	44.5	2 Renault, 150 hp	50
(U.S.) Goodyear *Wingfoot Express*	1919	95,000	162	33.44	2 Gnome	Unknown
(U.S.) Goodyear *Pilgrim*	1925	47,700	105.5	31	1 Lawrence, 60 hp	50
(U.S.) Goodyear *Puritan*	1928	86,000	128	36	2 Siemens, 70 hp	Unknown
(U.S.) Goodyear U.S. Navy, K-14	1943	425,000	251.7	57.8	2 Pratt & Whitney, 425 hp	77
(U.S.) Goodyear ZPG-3W	1958	1,516,300	403	85	2 Curtiss-Wright, 1,500 hp	80
(U.S.) Goodyear *Columbia IV*	1975	202,700	192	45.92	2 Continental, 210 hp	50

SEMI-RIGID AIRSHIPS

Name	Year	Volume, cu. ft.	Length, ft.	Diameter, ft.	Engines	Max speed, mph
(It.) T-34 (U.S. *Roma*)	1919	1,204,000	410.1	74.6	6 Ansaldo, 500 hp	68.3
(It.) N-1 *Norge*	1924	654,000	347.8	63.9	3 Maybach, 250 hp	70.2
(It.) N-2 *Italia*	1924	654,000	347.8	63.0	3 Maybach, 250 hp	70.2
(USSR) V6 *Osoaviakhim*	1934	685,000	49.5	61	3 Osoaviakhim, 265 hp	Unknown

RIGID AIRSHIPS

Name	Year	Volume, cu. ft.	Length, ft.	Diameter, ft.	Engines	Max speed, mph
(Ger.) Schwarz *Metallballon*	1897	130,541	156	47.5	1 Daimler, 12 hp	Unknown
(Ger.) LZ 1	1900	399,003	420	38.2	2 Daimler, 14.7 hp	17
(Ger.) LZ 3	1906	430,782	446	38.4	2 Daimler, 80 hp	27
(Ger.) LZ 6	1909	564,960	472	42.6	1 Maybach, 145 hp; 2 Daimler, 115 hp	34
(Ger.) LZ 17 *Sachsen*	1913	793,239	518.12	48.7	3 Maybach, 180 hp	47
(Ger.) LZ 46	1915	1,126,389	536.2	61.3	4 Maybach, 210 hp	60
(Ger.) Schütte-Lanz 8	1916	1,366,497	570.1	65.11	4 Maybach, 240 hp	58
(Ger.) LZ 89	1917	1,950,112	649.4	78.4	6 Maybach, 64 hp	64
(UK) R34	1919	1,958,000	643	78.75	5 Sunbeam Maori, 250 hp	60
(U.S.) ZR-1 *Shenandoah*	1923	2,151,200	680.5	78.75	6 Packard, 300 hp	62.63
(Ger./U.S.) ZR-3 *Los Angeles*	1924	2,472,028	656.6	90.5	5 Maybach, 500 hp	68
(UK) R101	1929	5,509,753	722	132	5 Beardmore diesels, 580 hp	72
(Ger.) LZ 127 *Graf Zeppelin*	1928	3,700,000 hydrogen; 1,226,080 *blaugas*	775	100	5 Maybach, 550 hp	79
(U.S.) ZRS-4 *Akron*	1931	6,850,000	785	133	8 Maybach, 870 hp	84
(Ger.) LZ 129 *Hindenburg*	1936	7,063,000	804	136	4 Mercedes-Benz diesels, 1,200 hp	78

NOTES

CHAPTER ONE

1 Joseph Needham, *Science and Civilization in China*, vol. 4, pt. II (Cambridge, UK: Cambridge University Press), 596–97.

2 For more information on the Condor project, see Jim Woodward, *Nazca: Journey to the Sun* (New York: Pocket Books, 1977); Julian Nott, "History Revisited: Julian Nott Reprises His Flight Over the Plains of Nazca," *Ballooning* (March–April 2003), 16.

3 Robert Boyle, *New Experiments Physico-Mechanical, touching the Spring of the Air and its Effects* (London: 1660)

4 Francesco Lana de Terzi, *Prodromo* (Brescia: Rizzardi, 1670)

5 For a fascinating and entertaining fictional look at Father Bartolomeu Lourenço de Gusmão by a Nobel Prize-winning novelist, see José Saramago, *Baltasar and Bliminda* (New York: Harcourt, Inc, 1987).

6 Colonel Edgar Cardoso, "Bartolomeo de Gusmão," *air BP* 53 (n.d.), 11–13; Charles Dolfuss and Henri Bouché, *Histoire de l'aéronautique* (Paris: L'Illustration, 1932), 8–9.

7 Charles Harvard Gibbs-Smith, *Aviation: An Historical Survey from its Origins to the End of World War II* (London: HMSO, 1970), 14.

8 At the time of the first public balloon flights in France, a Paris newspaper published a letter from Lisbon, dated February 10, 1784, calling attention to the 1709 experiments of Father Gusmão. Tiberius Cavallo, a Fellow of the Royal Society and one of the earliest historians of the balloon, suggests that this was the first time that he and other knowledgeable balloon aficionados had heard of the Portuguese Jesuit. Because Bartolomeu Lourenço added the patronymic Gusmão to honor a wealthy sponsor, Cavallo mistakenly identifies him as two separate individuals. He also notes a story, which he does not believe, to the effect that Gusmão flew to an altitude of some 200 feet in 1736; Tiberius Cavallo, *The History and Practice of Aerostation* (London: C. Dilly, 1785), 23.

9 Cavallo, *History and Practice of Aerostation*, 30. The radical British cleric and brilliant chemist Joseph Priestley described "dephlogisticated air" in 1775. Lavoisier would rename that gas, oxygen. Phlogiston was thought to be a quality of these gases related to their ability to support combustion and oxidation.

10 Cavallo, *History and Practice of Aerostation*, 36.

11 Charles Coulston Gillispie, *The Montgolfier Brothers and the Invention of Aviation, 1783–1784* (Princeton, N.J.: Princeton University Press, 1983), 7–10.

12 *Mémoires secrets pour servir à l'histoire de la république des lettres en France depuis 1762*, quoted in James Glaisher, Camille Flamarion, W. De Fonvielle, and Gaston Tissandier, *Travels in the Air* (Philadelphia: J. B. Lippincott, 1871), 159. Several years after the brothers had achieved fame, Étienne claimed that early in 1783 they had considered the possibility of filling a balloon with Henry Cavendish's "inflammable air," but gave it up as too expensive and difficult.

13 L. T. C. Rolt, *The Aeronauts: A Dramatic History of the Great Age of Ballooning* (New York: Walker and Company, 1976), 29.

14 Cavallo, *History and Practice of Aerostation*, 42. In more precise terms, the first balloon was shaped like a parallelepiped—a six-faced polyhedron in which all faces are parallelograms lying in pairs of parallel planes.

15 Gillispie, *The Montgolfier Brothers*, 17.

16 Ibid., 20–21.

17 Ibid., 3.

18 Cavallo, *History and Practice of Aerostation*, 11.

19 Ibid., 48.

20 Gaston Tissandier, *Histoire des ballons et des aéronauts célèbres, 1783–1800* (Paris, 1887), 3. It is not clear which edition of Franklin's book Charles read. The first edition was Benjamin Franklin, *Expériences et observations sur l'électricité faites à Philadelphie en Amerique, par Benjamin Franklin* (Paris: Chez Durand, 1752).

21 B. Franklin to J. Banks, August 30, 1783, in A. L. Rotch, *Benjamin Franklin and the First Balloons* (Worcester, Mass., 1907); I. Bernard Cohen, "Benjamin Franklin and Aeronautics," *Journal of the Franklin Institute* (August 1941), 103–4.

22 Rolt, *The Aeronauts*, 36.

23 B. Franklin to R. Price, September 16, 1783, in A. H. Smyth, ed., *The Writings of Benjamin Franklin* (New York, 1907–10), 9:85; Baron Grimm, *Correspondence, littéraire, philosophique, et critique* (Paris, 1877–82), 13:351.

24 A. B. LeRoy to B. Franklin, Library of the American Philosophical Society, Franklin Papers, 44:146. Franklin to J. Banks, October 8, 1783, Rotch, *Benjamin Franklin*, 8.

25 Franklin to R. Price, September 16, 1783, in Smythe, *Writings*, 9:85; M. Deschamps to W. T. Franklin, abstract in I. Minis Hays, *Calendar of the Papers of Benjamin Franklin in the Library of the American Philosophical Society* (Philadelphia, 1908), 18:79.

26 David Grayson Allen and others, eds., *The Diary of John Quincy Adams* (Cambridge, Mass.: Harvard University Press, 1981), 1:192.

27 The dimensions usually given, seventy feet tall by forty-six feet in diameter, represent contemporary French measurements. The dimensions provided in this text are corrected to match modern American feet and inches.

28 Rolt, *The Aeronauts*, 52.

29 J. A.-C. Charles quoted in an undated eighteenth-century news article in the Upcott Scrapbook, held in the Ramsey Rare book room of the National Air and Space Museum Library.

30 Gillispie, *The Montgolfier Brothers*, 62.

31 The story appears in an undated nineteenth-century news article in the Upcott Scrapbook.

CHAPTER TWO

1 For a full account of the early history of British ballooning, see John Edmund Hodgson, *A History of Aeronautics in Great Britain from the Earliest Times to the Latter Half of the Nineteenth Century* (London: Oxford University Press, 1924).

2 John Jay to Robert Livingston, September 12, 1783, in H. P. Johnson, ed., *The Correspondence and Published Papers of John Jay* (New York, 1891), 3:78–80.

3 L. T. C. Rolt, *The Aeronauts: A History of Ballooning, 1783–1903* (New York: Walker and Company, 1966), 73.

4 Quoted in Kurt Stehling, *Bags Up!* (Chicago, 1975), 107.

5 John Jeffries, *A Narrative of the Two Aerial Voyages of Doctor Jeffries and Mons. Blanchard …* (London: J. Robson, 1786), 45.

6 Ibid., 47–48.

7 *National Gazette* [Philadelphia], January 5, 1793; *National Gazette*, January 19, 1782; *American Mercury* [Hartford, Conn.], February 25, 1793.

8 Carroll Frey, *The First Air Voyage in America* (Philadelphia: Penn Mutual Life Insurance Company, 1943); and Jean-Pierre Blanchard, *Journal of my Forty-Fifth Ascension, Being the First Performed in America, on the Ninth of January 1793* (Philadelphia: Charles Cist, 1793).

9 Rolt, *The Aeronauts*, 120.

10 Donald Dale Jackson, *The Aeronauts* (Alexandria, Va.: Time-Life Books, 1980), 53.

11 Monck Mason, *Account of the Late Aeronautical Expedition from London to Weilburg* (London: F. C. Westley, 1836).

12 Ibid., 62; see also *The Romance of Ballooning: The Story of the Early Aeronauts* (New York: The Viking Press, 1971), 89–92.

13 For the text of the Balloon hoax articles, see: http://www.worldwideschool.org/library/books/lit/horror/TheWorksofEdgarAllenPoeVolume1/chap16.html.

14 John Wise, *Through the Air: A Narrative of Forty Years' Experience as an Aeronaut* (Philadelphia: To-Day Printing and Publishing Company, 1873).

15 Tom D. Crouch, *Eagle Aloft: Two Centuries of the Balloon in America* (Washington, D.C.: Smithsonian Institution Press, 1983) is the standard history of ballooning in America. On the era of the antebellum aerial showmen in the U.S., see also Munson Baldwin, *With Brass and Gas: An Illustrated and Embellished Chronicle of Ballooning in Mid-Nineteenth Century America* (Boston: Beacon Press, 1967); and Jeremiah Milbank, Jr., *The First Century of Flight in America* (Princeton: Princeton University Press, 1943).

16 B. Franklin to J. Banks, November 21, 1783.

17 Musée de l'air et de l'éspace, *Des Ballons pour la République* (Paris: Orangerie de Meudon, 1989).

18 Frederick Stansbury Haydon, *Aeronautics in the Union and Confederate Armies* (Baltimore: Johns Hopkins Press, 1941), 75. Haydon offers the best account of the early history of balloon activity in the Civil War.

19 Tom D. Crouch, *Eagle Aloft*, 382.

20 Tom Kelly, ed., *The Personal Memoirs of John Thomas Scharf of the First Maryland Artillery* (Baltimore: Butternut and Blue, 1992), 13.

21 For an account of Confederate ballooning, see Joseph J. Cornish, *The Air Arm of the Confederacy* (Richmond, Va.: Richmond Civil War Centennial Committee, 1962).

22 Tom D. Crouch, *Eagle Aloft*, 520.

23 For a technical treatment of tethered observation balloons, see Ralph Upson and Charles DeForest Chandler, *Free and Captive Balloons* (New York: Roland Press, 1926).

24 Tom D. Crouch, *Eagle Aloft*; M. L. Amick, *A History of Donaldson's Balloon Ascensions* (Cincinnati, Ohio: Cincinnati News Company, 1875).

25 *Andrée's Story: The Complete Record of his Polar Flight …* (New York: Viking Press, 1930).

26 For more on smoke ballooning, see Tom D. Crouch, *Eagle Aloft*, 465–84.

27 Ibid., 469.

28 "The Promotion of Aerial Navigation," *New York Herald* (January 27, 1907).

CHAPTER THREE

1 James Boswell, *The Life of Samuel Johnson, LLD* (New York: The Modern Library, 1939(?)).

2 *Opinions of Thirty-Two Scientific Gentlemen on the Invention of Muzio Muzzi* (New York: NP, 1845)

3 M. David Bourgeois, *Recherches sur l'art de voler, depuis la plus haute antiquité* (Paris: 1784), 89.

4 Edmund C. Stedman, "Aerial Navigation," *Scribner's Monthly*, Vol. XVIII, November 1887.

5 Peter W. Brooks, *Zeppelin Rigid Airships, 1893–1940* (Washington, D.C.: Smithsonian Institution Press, 1992), 27–29; L. T. C. Rolt, *The Aeronauts: A History of Ballooning, 1783-1903* (New York: Walker and Company, 1966), 223.

6 Ferdinand von Zeppelin, "Report to the King of Württemberg, 1887," in Robert Hedin, *The Zeppelin Reader: Stories, Poems and Songs From the Age of the Airship* (Iowa City: University of Iowa Press, 1998), 3.

7 F. von Zeppelin to Count von Zeppelin, August 19, 1863, quoted in Rhoda Gilman, "Zeppelin in Minnesota: A Study in Fact and Fable," *Minnesota History* (Fall 1965); see also Gilman, "Zeppelin in Minnesota: The Count's Own Story," *Minnesota History* (Summer 1967); see also Tom D. Crouch, *Eagle Aloft: Two Centuries of the Balloon in America* (Washington, D.C.: Smithsonian Institution Press, 1983), 281–85.

8 Gilman, "A Study in Fact and Fable," 285.

9 Douglas Botting, *The Giant Airships* (Alexandria, Va.: Time-Life Books, 1980), 31.

10 Douglas Botting, *Dr. Eckener's Dream Machine* (New York: HarperCollins, 2001), 39.

11 Tom Crouch, "The Gasbag Era in America," *Aviation Quarterly* (Summer 1977).

12 Paul Hoffman, *Wings of Madness: Alberto Santos-Dumont and the Invention of Flight* (New York: Theia, 2003).

13 Botting, *The Giant Airships*, 39.

14 For information on the Zeppelin Company, see Henry Cord Myer, *Airshipmen, Businessmen and Politics, 1890–1940* (Washington, D.C.: Smithsonian Institution Press, 1991); *Hugo Eckener* (Stuttgart, 1938); Rolf Italiander, *Ferdinand Graf von Zeppelin* (Konstanz, 1980); Douglas Robinson, *Giants in the Sky: A History of the Rigid Airship* (Seattle: University of Washington Press, 1973).

15 Botting, *The Giant Airships*, 43.

16 Guillaume de Syon, *Zeppelin: Germany and the Airship, 1900–1939* (Baltimore: Johns Hopkins University Press, 2007), provides the best treatment of the impact of the airship on German culture.

CHAPTER FOUR

1 John R. McCormick, "Out of the Blue," *American Heritage* (December 1989).

2 W. David Lewis, *Eddie Rickenbacker: An American Hero in the Twentieth Century* (Baltimore: Johns Hopkins University Press, 2005), xi.

3 Anne Chotzinoff Grossman, "I Will not Chase the Hindenburg," in Robert Hedin, ed., *The Zeppelin Reader: Stories, Poems and Songs from the Age of the Airship* (Iowa City: University of Iowa Press, 1998), 262.

4 Hugo Eckener, *My Zeppelins*, translated by Douglas Robinson (London: Putnam and Company, 1958).

5 *Daily Mail* (11 July 1908); ibid. (9 October 1908).

6 H. G. Wells, *The War in the Air* (London: George Bell and Sons, 1908), 240.

7 Aaron Norman, *The Great Air War* (New York: Macmillan, 1968), 51.

8 The number of airships produced by each company, operated by the Army and Navy and the loss statistics are all drawn from Douglas Robinson, *Giants in the Sky* (Seattle: University of Washington Press, 1973), Appendix A. Significantly different figures appear in other sources. The author regards Robinson as the authority in this area.

9 Douglas Botting, *The Giant Airships* (Alexandria, Va.: Time-Life Books, 1980), 58.

10 Lady Ottoline Morrell to D. H. Lawrence, September 9, 1915, in Harry Moore, ed., *The Collected Letters of D. H. Lawrence* (London: Heinemann, 1962), reprinted in

Robert Hedin, ed., *The Zeppelin Reader: Stories, Poems and Songs from the Age of the Airship* (Iowa City: University of Iowa Press, 1998), 92.

11 Mrs. Holcombe Ingleby, from "A Letter to Her Son, August 1915", in Hebron, *The Zeppelin Reader*, 91.

12 George Bernard Shaw to Beatrice and Sidney Webb, in Hebron, *The Zeppelin Reader*, 65.

13 Ernst Lehmann, *Zeppelin: The Story of Lighter-than-Air Craft* (London: Longmans, Green & Co., 1937), 56.

14 August Seim, in Hebron, *The Zeppelin Reader*, 78.

15 Lehmann, *Zeppelin*, 57.

16 August Seim, in Hebron, *The Zeppelin Reader*, 78.

17 J. Gordon Vaeth, *Blimps & U-Boats: U.S. Navy Airships in the Battle of the Atlantic* (Annapolis, Md.: Naval Institute Press, 1992), 1.

18 Both the U.S. and Royal Navies did develop B-class pressure airships, but there is no indication that either of them had a B-limp classification. Moreover, the first appearance of the word Blimp in 1916, according to the *Oxford English Dictionary*, precedes the appearance of class B airships in either service by at least a year.

19 A. D. Topping, "Etymology of 'Blimp,'" *Journal of the American Aviation Historical Society* (Winter 1963).

20 P. J. Capelotti, *By Airship to the North Pole* (New Brunswick, N.J.: Rutgers University Press, 1999); Edward Mably, *The Motor Balloon America* (Brattleboro, Vt.: Stephen Green Press, 1969).

21 For a broad history of Goodyear and aeronautics, see Hugh Allen, *The House of Goodyear* (Cleveland: The Corday & Gross Co., 1943).

22 "Blazing Blimp Falls 500 Feet Into Bank in Chicago, Injuring 27 and killing 10 [sic]," *Boston Daily Globe* (July 22, 1919), 1; "11 Witnesses Say Fire Began in Blimp's Nose," *Chicago Daily Tribune* (July 26, 1919), 5.

23 For information on the early Goodyear commercial blimp operation, see Hugh Allen, *The Story of the Airship* (Akron, Ohio: Tire and Rubber Co., 1932).

24 "Huge Aircraft Burns, 34 Dead," *Boston Daily Globe* (February 22, 1922), 1.

25 Wilbur Cross, *Ghost Ship of the Pole: The Incredible Story of the Airship Italia* (London: Heinemann, 1960).

26 For an account of the Zeppelin Corporation, before and after the war, see Harry Vissering, *Zeppelin: The Story of a Great Achievement* (Chicago: privately printed, 1922).

27 Thom Hook, *Shenandoah Saga* (Annapolis, Md.: Air Show Publishers, 1973).

28 Ian Bunyan, *R34: Twice Across the Atlantic* (Edinburgh: National Museums of Scotland, 1989).

29 For details on the Airship Development Corporation, see Henry Cord Meyer, *Airshipmen, Businessmen and Politics, 1890–1940* (Washington, D.C.: Smithsonian Institution Press, 1991), 140–54.

30 William F. Althoff, *The USS Los Angeles: The Navy's Venerable Airship and Airship Technology* (Annapolis, Md.: Naval Institute Press, 2004).

31 The definitive work on the subject is Richard K. Smith, *The Airships Akron and Macon: Flying Aircraft Carriers of the United States Navy* (Annapolis, Md.: Naval Institute Press, 1965).

32 On the question of the U.S. sale of helium to Germany, see Hans G. Knäusel, *Zeppelin and the United States of America* (Friedrichshafen, 1981).

33 For an account of the life of the crew on *Graf Zeppelin* and *Hindenburg*, see Harold G. Dick, with Douglas Robinson, *The Golden Age of the Great Passenger Airships, Graf Zeppelin and Hindenburg* (Washington, D.C.: Smithsonian Institution Press, 1985).

34 Webb Miller, in Hedin, *The Zeppelin Reader*, 254.

35 Quoted in Douglas Robinson, *LZ 129 "Hindenburg"* (New York: Arco Publishing Co., Inc., n.d.); the book is unpaginated, but, by my count, the quote appears on page 33.

36 Rick Archbold, *Hindenburg: An Illustrated History* (New York: Warner Books, 1994).

37 For a social and cultural overview of the Zeppelin, see Guillaume de Syon, *Zeppelin: Germany and the Airship, 1900–1939* (Baltimore: Johns Hopkins University Press, 2007).

38 The best secondary source for the U.S. Navy blimp program in World War II is J. Gordon Vaeth, *Blimps and U-Boats: U.S. Navy Airships in the Battle of the Atlantic* (Annapolis, Md.: Naval Institute Press, 1992).

39 Zenon Hansen, *The Goodyear Airships* (Bloomington, Ill.: Airship International Press, 1979), 39.

40 Vaeth, *Blimps and U-Boats*, 37.

41 Ibid., 159.

42 *Jane's Pocket Book of Airships* (New York: Macmillan, 1976), 211.

43 "Navy Orders an End to Blimp Program," *New York Times* (June 27, 1961), 18.

CHAPTER FIVE

1 Glaisher provided a classic account of this flight, and a lifetime of aerial adventures, in *Travels in the Air* (London: R. Bentley, 1871). Quoted material on pages 50–54.

2 See http://thosemagnificentmen.co.uk/balloons/zenithg.html.

3 Charles Ziegler, "Ballooning and the Birth of Cosmic Ray Physics," *National Air and Space Museum Research Report for 1986* (Washington, D.C.: Smithsonian Institution Press, 1986), 69–90.

4 These early electrometers made use of two thin strips of gold leaf attached to an insulated electrode in an ionization chamber. When electrostatically charged, the leaves would separate. The presence of ionization would reduce the charge

and allow the leaves to come together again. A strip watch and a microscope equipped with a micrometer for measuring the angular separation enabled the observer to take readings.

5 Tom D. Crouch, *Eagle Aloft: Two Centuries of the Balloon in America* (Washington, D.C.: Smithsonian Institution Press, 1983), 19.

6 Ziegler, "Ballooning and the Birth of Cosmic Ray Physics," 81–82.

7 Auguste Piccard, *Au-dessus des nuages* (Paris: Éditions Bernard Grasset, n.d.); see also Alan Honour, *Ten Miles High, Two Miles Deep: The Adventures of the Piccards* (New York: Whittlesey House, 1957).

8 "Tex" Settle had conceived of the notion of a sealed, pressurized gondola for high-altitude flights, a tiny one-person "flying coffin," even before Auguste Piccard. His project had been rejected by his military superiors, frightened by the tragic death of H. C. Gray, and chastened by Congressional committees who cautioned against publicity stunts aimed at achieving increased public visibility and increased funding.

9 "Captain Stevens," "Captain Anderson," *Air Corps Newsletter* 18, no. 7 (April 15, 1935), 167–68.

10 See for example: "Creation continues, Millikan's Theory," *New York Times* (March 18, 1928), 1; "Super X-Rays Reveal the Secret of Creation," *New York Times* (March 25, 1928), 143; "Millikan Sees Rays as Clue to Creation," *New York Times* (November 21, 1929), 26; "Cosmic Radiation Foes Battle Over Cosmic-Ray Origins," *Pasadena Star News* (December 30, 1932). For detailed coverage of the issues involved, see David DeVorkin, *Race to the Stratosphere: Manned Scientific Ballooning in America* (New York: Springer-Verlag, 1989).

11 David DeVorkin, *Race to the Stratosphere*, 138.

12 For information on the lesser-known Soviet and Polish flights, see James Winker, "Manned Stratosphere

Balloon Flights: The Untold Stories," AIAA-2003-6712, copy in the author's collection. For rare photos of the Soviet and European flights, see Sixten Rönno, *Mot Svarta Himlar* (Malmö: A. B. Allhems Förlag, 1946).

13 The Dryden and Arnold quotations are from Kevin L. Cook, "Space Shot: 1935," *American Heritage of Invention and Technology* 22:2 (Fall 2006), 36.

14 Ziegler, "Ballooning and the Birth of Cosmic Ray Physics," 80.

15 Curtiss Peebles, *The Moby Dick Project: Reconnaissance Balloons over Russia* (Washington, D.C.: Smithsonian Institution Press, 1991), 52–57.

16 James McAndrew, *The Roswell Report: Case Closed* (Washington, D.C.: USAF, 1997).

17 Peebles, *Moby Dick*, 100.

18 Ibid., 187.

19 Shirley Thomas, "Malcolm D. Ross," *Men in Space* (Philadelphia: Chilton Company, 1972), 149.

20 Ibid., 149–50.

21 *U.S. News and World Report* (November 2, 1956), 20.

22 Otto Winzen, "Bridgehead in Space," *Interavia* 12 (1957), 1040–41.

23 Joseph Kittinger, Jr., with Martin Caiden, *The Long, Lonely Leap* (New York: Dutton, 1961), 73.

24 "Officer Nearly Baked in AF Balloon Error," *Washington Star* (October 10, 1958); see also David G. Simons, *Man High* (Garden City: Doubleday, 1960).

25 For a good account of manned high-altitude ballooning after World War II, see Craig Ryan, *The Pre-Astronauts: Manned Ballooning on the Threshold of Space* (Annapolis, Md.: Naval Institute Press, 1995).

26 Craig Ryan, *Magnificent Failure: Free Fall from the Edge of Space* (Washington, D.C.: Smithsonian Institution Press, 2003).

CHAPTER SIX

1 Robert J. Dunphy, "Travel Notes: Fast-Rising Sport," *New York Times* (April 15, 1973), 500.

2 Waldemar Kaempfert, "The Week in Science," *New York Times* (February 25, 1935), X1B; Waldemar Kaempfert, "The Week in Science," *New York Times* (August 16, 1936), XX4; "Ooops! Some embarrassing Moments in LTA," *Gasbag Journal* 10 (December 1981), back cover.

3 Ed Yost, quoted in George Denniston and Glen Moyer, "The Maiden Flight," *Balloon Life* (October 1990), 12.

4 Denniston and Moyer, "The Maiden Flight," 14.

5 Peter Stekel, "Don Piccard—50 Years of Ballooning Memories," http://www.piccard.info/don_piccard.htm. Accessed by the author on 5/11/2007.

6 Ibid.

7 Earl Gustkey, "County Firm Takes a Flier on Hot air Balloons," *Los Angeles Times* (May 9, 1974), OC_B1.

8 http://www.bfa.net/news.php?subaction=showcomments&id=1169499676&archive=&start_from=&ucat=&. Accessed by the author on 05/11/2007.

9 Andrew Eiloart, *The Flight of the Small World* (New York: W. W. Norton, 1959)

10 Carter B. Horsley, "3 in a Balloon Leave for France," *New York Times* (September 21, 1970), 45; Robert Lindsey, "Debris Spotted in Balloon Hunt," *New York Times* (September 26, 1970), 40.

11 J. Y. Smith, "Unlikely Adventurer," *Washington Post* (February 28, 1944), B1.

12 For a solid account of Tom Gatch and the flight of the *Light Heart*, see William G. Armstrong, *Just Wind: The Story of Two Pilots under Pressure* (Lincoln, Neb.: iUniverse, 2003).

13 Laura A. Kiernan, "Balloonist's Failure Tied to Weather," *Washington Post* (May 20, 1974), C1; Judith Cummings, "Philadelphia Balloonist Is Killed in Crash Off Jersey," *New York Times* (August 7, 1974), 10.

14 "Forbes's Flight," *New York Times* (February 27, 1977), 33.

15 "Balloonist Rescued, but his craft flies on," *Chicago Tribune* (August 10, 1973), 3.

16 "Troubles Beset Balloonist," *Washington Post* (August 22, 1975), A7.

17 "Soviet Freighter Rescues U.S. Balloonist," *New York Times* (July 2, 1976), 41.

18 Jane Seabury, "Down …750 miles Short of Dream, Ed Yost Sets 2 Records," *Washington Post* (October 11, 1976), C1.

19 Charles McCarry, *Double Eagle* (Boston: Little, Brown and Company, 1979) provides the most complete account of the *Double Eagle* story.

20 Paul Hendrickson, "Daredevils," *Washington Post* (October 11, 1977); "Balloonists Dunk Safely Off Halifax," *Los Angeles Times* (October 13, 1977), D2.

21 McCarry, *Double Eagle*, 193.

22 "Balloonists Set New Goal," *Chicago Tribune* (August 19, 1978), W1.

23 For a general account of the *Earthwinds* project, see William G. Armstrong, *Just Wind: The Story of Two Pilots under Pressure* (Lincoln, Neb.: iUniverse, 2003).

24 For Steve Fossett's own account of his aerial adventures, see Steve Fossett, *Chasing the Wind* (Virgin Books, 2006).

25 Malcolm Browne, "Undaunted by Failure, Balloonists Vow to Try Again," *New York Times* (January 28, 1997), C1.

26 Malcolm Browne, "Though Global Flight Falters, Balloonist Still Sets Record," *New York Times* (January 20, 1997), A2.

27 Alessandra Stanley, "U.S. Balloonist Falls About Three-Quarters of a Globe Short," *New York Times* (January 6, 1998), A1.

28 "With No Competition, Balloonist Aims for Europe and the World," *New York Times* (January 2, 1998), A10.

29 Bertrand Piccard, "Around at last!" *National Geographic* (September 1999), 32; see also Bertrand Piccard, *Around the World in Twenty Days: The Story of our History Making Balloon Flight* (New York: J. Wiley, 1999).

30 Steve Fossett, *Chasing the Wind* (Virgin Books, 2006).

31 "Role of Airships," *New York Times* (May 14, 1945), 16; "Eckener Foresees Speedy Airships," *Christian Science Monitor* (May 3, 1947), 8.

32 "Rosendahl Urges Dirigible Service," *New York Times* (May 15, 1947), 51.

33 "House Favors Dirigible Development," *Washington Post* (June 9, 1948), Pg. 3; see also Paul Litchfield and Hugh Allen, *Why Has America No Rigid Airships* (Cleveland: Corday & Gross Co., 1945).

34 John McPhee, *The Deltoid Pumpkin Seed* (New York: Farrar, Straus and Giroux, 1992).

35 Ward Sinclair, "Boon or Boondoggle, It's Called Helistat," *Washington Post* (January 3, 1983), A11; "Airship Crashes at Base in Jersey," *New York Times* (July 2, 1986), A1.

36 http://www.jpaerospace.com/atohandout.pdf.

37 http://www.tcomlp.com/overview.htm. Special thanks to Mr. Peter D'Anna, a friend and NASM volunteer who held a number of key engineering positions in the field during these years.

38 Ahmed K. Noor, James A. Cutts and Tibor S. Balint, "Platforms for Discovery: Exploring Titan and Venus," *Aerospace America* 45:6 (June 2007), 32–37.

39 Ibid.

ADDITIONAL READINGS

BALLOONS

Baldwin, Munson, *With Brass and Gas: An Illustrated and Embellished Chronicle of Ballooning in Mid-Nineteenth Century America* (Boston: Beacon Press, 1967)

Crouch, Tom D., *Eagle Aloft: Two Centuries of the Balloon in America* (Washington, D.C.: Smithsonian Institution Press, 1983)

DeVorkin, David, *Race to the Stratosphere: Manned Scientific Ballooning in America* (New York: Springer-Verlag, 1989)

Dollfus, Charles, and Henri Bouché, *Histoire de l'aéronautique* (Paris: L'Illustration, 1932)

Gillispie, Charles Coulston, *The Montgolfier Brothers and the Invention of Aviation, 1783–1784* (Princeton, N.J.: Princeton University Press, 1983)

Rolt, L. T. C., *The Aeronauts: A Dramatic History of the Great Age of Ballooning* (New York: Walker and Company, 1976)

AIRSHIPS

Althoff, William F., *Sky Ships: A History of Airships in the United States Navy* (New York: Orion, 1990)

Botting, Douglas, *The Giant Airships* (Alexandria, VA: Time-Life Books, 1980)

Brooks, Peter W., *Zeppelin: Rigid Airships, 1893–1940* (Washington, D.C.: Smithsonian Institution Press, 1992)

Hedin, Robert, *The Zeppelin Reader: Stories, Poems and Songs from the Age of the Airship* (Iowa City: University of Iowa Press, 1998)

Myer, Henry Cord, *Airshipmen, Businessmen and Politics, 1890–1940* (Washington, D.C.: Smithsonian Institution Press, 1991)

Robinson, Douglas, *Giants in the Sky: A History of the Rigid Airship* (Seattle: University of Washington Press, 1973)

Smith, Richard K., *The Airships Akron and Macon: Flying Aircraft Carriers of the United States Navy* (Annapolis, Md.: Naval Institute Press, 1965)

Syon, Guillaume de, *Zeppelin: Germany and the Airship, 1900–1939* (Baltimore: Johns Hopkins University Press, 2007)

INDEX